How to Draw and Paint

Watercolors

Copyright © 1991 by Walter Foster Publishing
First published in the United States of America
in 1991 by Walter Foster Publishing, Inc.
ISBN: 1-56010-187-3
All rights reserved

How to Draw and Paint
Watercolors

WALTER FOSTER PUBLISHING, INC.

Tustin, California

Contents

Introduction
TO WATERCOLOR

Watercolor is a versatile medium. It is usually applied using a transparent technique. This technique uses the white of the paper for the lights in the painting; there is no mixing of colors with white pigment to obtain a tint. This allows for a number of transparent color glazes to be applied and built-up in order to achieve a particular color. The white of the paper is more brilliant where the glazes are fewer and thinner.

Watercolor paint is less complex than oil paint, but it can also be less forgiving of mistakes. Because of the transparency of watercolors, it is sometimes difficult to hide them. But this does not mean that watercolors cannot be corrected. Depending on the color used, they can sometimes be removed with a wet sponge. Each color has a certain degree of staining or non-staining ability—some will wipe off; others cannot be removed by any means. The artist must become familiar with the qualities of each color.

The works in this edition are a collection of pages from some of the finest books published by Walter Foster Publishing. The artists and subjects have been carefully selected to bring together a fine representation of what watercolor will do. The exercises in this book are intended not only to present the various subject matter, but to teach methods and techniques as well. There are numerous demonstrations and step exercises to assist in practicing watercolor. After trying some of these, select some subjects of your own and apply the same theory and technical skills demonstrated in this book to create some compositions of your own.

We hope that you enjoy this book and that you find it to be a continuing source of guidance in the wonderful experience of watercolor painting.

WATERCOLOR
Materials
& Techniques by William F. Powell

ABOUT THE AUTHOR

Bill Powell was born in Huntington, West Virginia. He has studied in New York at the Art Student's Career School, the Harrow Technical College in England and the Louvre Free School of Art in Paris, France.

Bill has been an artist for over 35 years specializing in commercial art, technical illustration, and fine art. He has taught classes in oil, acrylic, watercolor and pastel, with subjects ranging from landscapes and seascapes to portraiture and wildlife studies. He also conducts art workshops and produces videos which employ unique methods of in-depth presentations and demonstrations.

Bill is accomplished in a wide variety of media and is known for his dramatic, yet sensitive use of color. His use of selective compositions combined with attention to detail make Bill's paintings a collecting and viewing pleasure.

Bill is the author of several Walter Foster books: *Understanding Color*, #154; *Color Thick And Thin*, #182; *Clouds and Skyscapes*, #206; *Color And How To Use It*, #AL05; *Perspective*, #AL13; *Oil Painting Materials And Their Uses*, #AL17 and *Watercolor and Acrylic Materials*, #AL18.

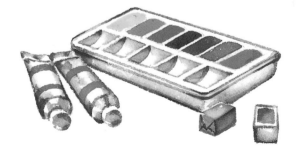

SECTION 1

Tools And Materials

Butcher's Tray — An enameled butcher's tray makes an excellent palette. They have a high spot in the center and pools of color collect around the edges. They are good for mixing large amounts of color.

Plastic Palettes — These palettes are available in a variety of shapes. The model with an open area in the middle is the most popular. Colors are placed in the wells around the edges; color mixing is done in the center.

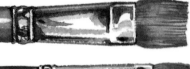

Watercolor Paints — Watercolors are available in several forms — tubes (the most popular), pans, and individual cakes. Tubed colors can be squeezed into the wells of a palette.

Brushes — The brushes shown here are those most commonly used. Natural hair, fine synthetic hair, or a combination of both work well, but pure red sable hair is best.

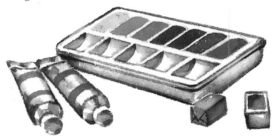

2" Flat Wash Brush — Natural hair is recommended, but an inexpensive varnish brush will suffice for beginners.

1" Watercolor Flat — The most useful brush, especially if the handle has a chiseled end.

1/2" Flat — A soft hair brush used for smaller masses of color and some types of detail.

#10 or #12 Round — Used for a variety of strokes and small washes. They should have a fine point and good spring-back when wet.

#6 Round — Used for details and small areas. It is used for fine lines and lines of varying widths. It should have a fine point and good spring-back.

Rigging Brush — A fine-line brush for painting long, thin lines, twigs and signatures.

Toothbrush — Used to spatter paint for textural effects, and to scrub out areas of paint or to apply paint for special textures.

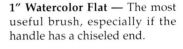

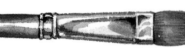

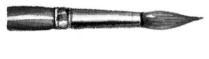

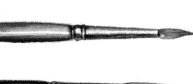

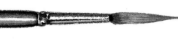

Sponges — Both natural and synthetic can be used. Large sizes are used to mop up, or to apply masses of color and water. They are also used for objects such as bushes and grasses.

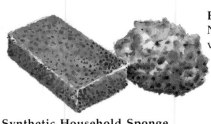

Elephant Ear Sponge — Named for their shape, these vary in size and texture.

Synthetic Household Sponge — These are inexpensive and very useful. They are available in many sizes and colors.

Silk Sponge — A silk sponge can absorb or lay down large quantities of liquid. They vary in size and texture.

Razor Blades and Craft Knives — Used to scrape off paint for highlights and special effects, or to cut tape or masking papers.

Water Containers — Two containers are needed: one for clearing the brush of color, and the other for color mixing.

Watercolor Paper — Watercolor paper is available in sheet, block and pad forms, and in a variety of weights. (The heavier the weight, the thicker the paper.) Thick papers, such as 300 lb., can be used without preshrinking, and they will not wrinkle as much as the lighter weights.

Tape — Masking tape is used to secure the paper to the support board. Frosted plastic tape can be used to mask clean edges.

Support Board — A sheet of thick plastic or pressed wood makes a fine board. These supports should be very smooth so they will not blemish lighter weight papers. A lightweight wood drawing board also makes a good support.

Pencils — An HB is used for sketching and for drawing the subject on the watercolor paper. This lead can be used for light or dark blends.

Felt-Tip Pens — Waterproof felt-tip pens are available in various sizes and colors. They are used for line and texture drawing. Note — only pens that are not affected by water should be used.

Ink Erasers — These are used to rub away paint for light effects. They must be used very gently or they might mar the watercolor paper.

Kneaded Eraser — Kneaded erasers are soft and will not damage the paper. They can be molded into a point to erase small areas of a drawing.

Liquid Frisket — This solution is used to mask certain areas of the paper. These areas will remain white, then after the frisket is removed, fresh color can be applied. Soak your brush in detergent to prevent the solution from ruining the brush.

Rubber Cement Pickup — This is used to remove dried liquid frisket from the paper.

Paper Frisket — This is an adhesive-backed paper that is placed over the painting and shapes are cut out where paint is desired (similar to a stencil). The paint is applied over it and allowed to dry, then the frisket is removed, saving the whites of the paper.

Electric Hair Dryer — These are used to speed the drying time between steps. Note — if the dryer is too hot or too close to the surface the colors may lose some of their brilliance and dry unevenly.

Sketch Pad — A medium size sketch pad is a must for recording scenes, color notes and subject detail on location.

Tracing Paper — This is used to transfer drawings to the painting surface. This eliminates the damage caused by erasers when composing directly on the watercolor paper.

Transfer Paper — This paper is used like carbon paper. By placing it against the watercolor paper with the tracing on top, you can draw outlines of the subject with a fine pencil. (NEVER use carbon paper — it is too oily and dark and it will destroy the painting.)

Salt — Salt creates some very interesting patterns in the paint. There are many kinds of salt on the market; each will affect the damp watercolor in a different way.

Paraffin Wax — Wax is used as a masking solution to keep the paper free of color. Rubbing the wax onto the paper creates a surface that watercolor paint will not adhere to. Once the paint is dry, the wax is removed, leaving the paper clean and white.

Paper Towels and Facial Tissue — Paper towels and facial tissue are used to lift color off the painting and to create interesting textures.

Cloth Rags — Rags should be free of oily residue. They are used to lift color, wipe tools and create textural effects.

Spray Bottles —Used to keep the paper wet or to rewet an area for further paint application or blending. They can be used to continue a wet-in-wet technique when the paper has dried, or to wet a dried palette for cleaning. It is good to have two bottles — one with a very fine mist and one with a larger spray.

Color And The Color Wheel

The basic color wheel is made up of twelve colors, all originating from the three primaries: YELLOW, RED, and BLUE. All color originates from white light. In oil painting, you think of white paint as the white light, but in watercolor painting, you must think of the white of the paper as the white light. By laying the watercolors down in a transparent manner, the white of the paper shows through the layers of color and the result is a visual mixing of colors.

In the study of color there are several things to be considered:

Hue — The color itself, such as blue, red, orange, or yellow-green.

Value — The relative lightness or darkness of a color. In painting, values are used to portray depth and color composition.

Intensity — The strength of a color, from its pure state to one that is grayed or diluted.

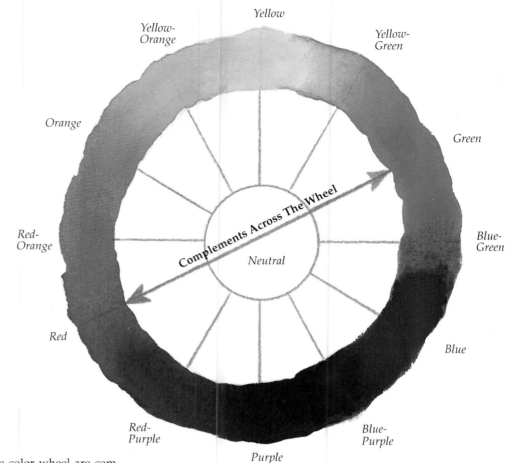

Mixing Or Graying With Complements

Colors directly across from one another on the color wheel are complementary. For example, red and green are complements; yellow-green and red-purple are complements. Direct complementary colors have more ability to "devour" each other than any other colors on the wheel. Experiment with complements and you will see a fantastic world of mixtures. Note — When colors are complementary there is always one warm and one cool.

Direct Complements

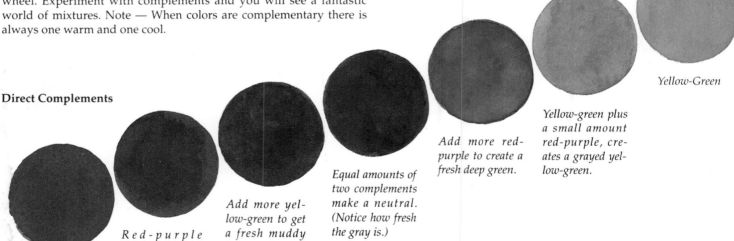

Red-Purple

Red-purple mixed with yellow-green, makes a brownish red.

Add more yellow-green to get a fresh muddy brown color.

Equal amounts of two complements make a neutral. (Notice how fresh the gray is.)

Add more red-purple to create a fresh deep green.

Yellow-green plus a small amount red-purple, creates a grayed yellow-green.

Yellow-Green

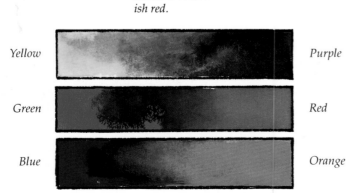

Yellow	Purple
Green	Red
Blue	Orange

These examples show how beautifully complementary colors perform when mixed loosely on the white paper. (Color mixing does not have to be done on the palette.)

Analogous Colors

Analogous colors are related to one another by being near and similar to each other. For example, three colors next to each other on the color wheel are analogous, and complementary in likeness. In the example, yellow is the dominant color as it is contained in the other two — yellow-orange and yellow-green. These are all analogous. If you move further from yellow to the next color, you would have a new color. For example, the color next to yellow-orange is orange — a color containing red. Therefore, orange is not analogous to yellow.

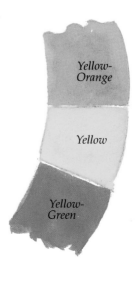

Using Split-Complements

Select a color, then draw a straight line across the color wheel to find its direct complement. The color above the direct complement and the color below the direct complement are the first color's split-complements. Split-complements will gray each other in a slightly different way than the direct complement. They can be used to create subtle color changes and they allow for greater color planning and mixing.

Painting Transparent Color Glazes

Colors can be changed or planned by building up thin layers of transparent glazes. If you paint the paper yellow, allow it to dry, and then paint a thin layer of another color over it we will alter the yellow. For instance, a glaze of blue over yellow creates green because the light strikes the white of the paper and is sent back to the eye through the two layers, giving the viewer a visual mixing of color. Multiple layers can be used to achieve color control and depth.

The exercises shown here show three blocks of dried color. After the colors dried, single glazes of three different colors were painted over without disturbing the dry undercolors. Notice the different results. The possibilities in glazing are endless — try glazing with other colors and you will discover the beauty of glazing.

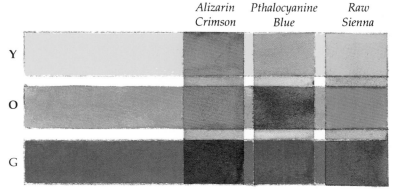

Selecting The Proper Colors

When planning a painting select a palette of colors that will fit the subject. For instance, a snow scene usually requires a palette of cool colors, such as blues, with their complement, orange, for accents and graying. On the other hand, an autumn scene would require warm reds and oranges as the main colors with greens and purples to complement and gray. Each subject requires thought and color planning.

Color Creates Moods

Color can create moods and generate emotional responses. Colors that are considered soothing are often used in work areas, schools, and hospital rooms. Color is also frequently used in product sales presentations. Pay attention to the commercials on T.V. and you will notice that they use warm, cheery colors to catch your interest. Grays or other dull colors would not enhance the presentation as well.

Whatever subject you choose to paint, your choice of colors will cause an emotional reaction in the viewer. You can control the mood response through color and the way you present it. By maintaining a lot of white in a painting we create a "high key" painting which gives a soft, light, airy feeling. By using dark colors, we create a "low key" painting which is often more somber. Bright, raw colors catch the eye quickly, but they can sometimes be uncomfortable to view. By graying some of the colors, you introduce a certain quietness to the painting that makes it far more acceptable to the senses. On the right are four examples of color controlling and portraying moods.

Noise — Pure complementary colors used next to each other are loud and unsettling.

Mystical — Purples and blues create a mood of mystery and foreboding. They can also create nice moonlit snow scenes.

Coolness — By lightening colors from the cool side of the color wheel, the result is a feeling of cool softness.

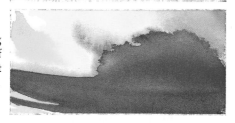

Warmth — Yellows, reds and oranges are warm colors. Reds suggest danger.

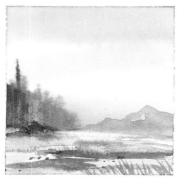

High Key painting is light.

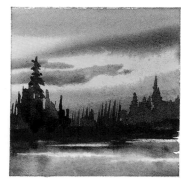

Low Key painting is dark.

Drawing Techniques

Drawing is an art in itself. It is also a very important part of painting — especially watercolor painting. A light guideline of the shape and form of the subject is often required to start an organized watercolor painting. (An unorganized form of painting would be the free flow of color in non-representational masses.) Drawings need not be tight and precise as far as geometric perspective goes, but they should be within the boundaries of these rules for a realistic portrayal of the subject.

Sketch the shapes and the masses you see. Sketch loosely and freely in order to give the object character and to keep the drawing fresh. If you discover something wrong with the shapes, refer to the exacting rules of perspective to make corrections.

Practice is the only way to improve your drawing and to polish your hand-eye relationships. Sketch everything you see and keep all your drawings in a sketch book so you can see the improvement.

Light pencil guidelines are normally all that is required in watercolor drawing. Work your composition out on a separate piece of paper, then transfer it to the watercolor paper using a piece of transfer paper (described on page 9). Any unwanted pencil lines can be erased when the painting is dry.

Following are a few exercises to introduce the basic elements of drawing in perspective. Begin with the one-point exercise.

One-Point Perspective

In one-point perspective the face of a box is the closest part to the viewer and it is parallel to the horizon line (eye level). The bottom, top and sides of the face are parallel to the picture plane.

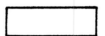

A. Draw a horizontal line and label it "eye level" or "horizon line." Draw a box below this line.

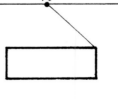

B. Now draw a light guideline from the top right corner to a spot on the horizon line. Place a dot there and label it VP (vanishing point). All side lines will go to the same VP.

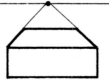

C. Next, draw a line from the other corner, as shown, then draw a horizontal line to establish the back of the box.

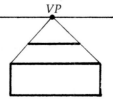

D. Finally, darken all lines, as shown, and you will have drawn a perfect box in one-point perspective. This box may become a book, a chest, a building, etc.

Two-Point Perspective

In two-point perspective the corner of the box is closest to the viewer, and two VPs are needed. Nothing is parallel to the horizon line in this view. The vertical lines are parallel to the sides of the picture plane.

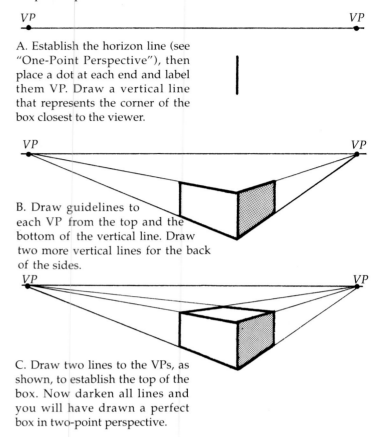

A. Establish the horizon line (see "One-Point Perspective"), then place a dot at each end and label them VP. Draw a vertical line that represents the corner of the box closest to the viewer.

B. Draw guidelines to each VP from the top and the bottom of the vertical line. Draw two more vertical lines for the back of the sides.

C. Draw two lines to the VPs, as shown, to establish the top of the box. Now darken all lines and you will have drawn a perfect box in two-point perspective.

Finding The Proper Peak And Angle Of A Roof

A. Draw a box in two-point perspective.

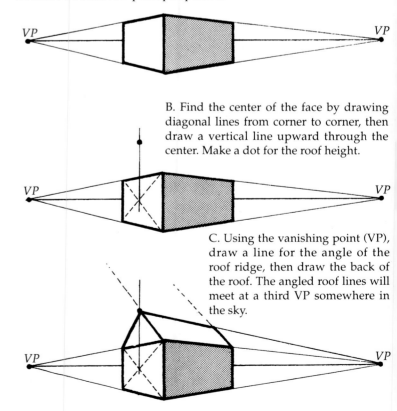

B. Find the center of the face by drawing diagonal lines from corner to corner, then draw a vertical line upward through the center. Make a dot for the roof height.

C. Using the vanishing point (VP), draw a line for the angle of the roof ridge, then draw the back of the roof. The angled roof lines will meet at a third VP somewhere in the sky.

Basic Shapes

There are four basic shapes you should know: the cube, the cone, the cylinder, and the sphere. Each of these shapes can be an excellent guide for beginning a complex drawing or painting. Shown are some examples of these shapes in simple use.

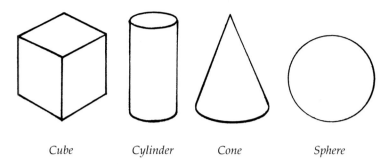

Cube *Cylinder* *Cone* *Sphere*

Ellipses

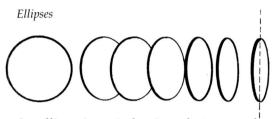

An ellipse is a circle viewed at an angle. Looking across the face of a circle, it is foreshortened and we see an ellipse. The axis of the ellipse is constant and it is represented as a straight centerline through the longest part of the ellipse. The height is constant to the height of the circle. Above is the sequence we might see in a spinning coin.

Foreshortening

As defined in Webster's Dictionary, to foreshorten is, "to represent the lines (of an object) as shorter than they actually are in order to give the illusion of proper relative size, in accordance with the principles of perspective." Here are a few examples of simple foreshortening to practice.

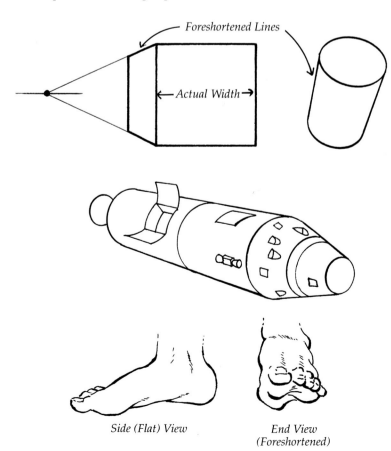

Side (Flat) View *End View (Foreshortened)*

Creating Depth With Shading

To create the illusion of depth when the shapes are viewed straight on, shading must be added. Shading creates different values and gives the illusion of depth and form. The examples below show a cylinder, a cone, and a sphere in both the line stage and with shading for depth.

Line

Shaded

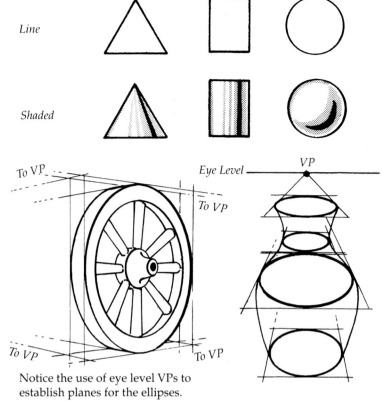

Notice the use of eye level VPs to establish planes for the ellipses.

Cast Shadows

When there is only one light source (such as the sun), all shadows in the picture are cast by that single source. All shadows read from the same vanishing point. This point is placed directly under the light source, whether on the horizon line or more forward in the picture. The shadows follow the plane on which the object is sitting. Shadows also follow the contour of the plane on which they are cast.

Light rays travel in straight lines. When they strike an object, the object blocks the rays from continuing and creates a shadow relating to the shape of the blocking object. Shadow shapes can sometimes be very strange. Here is a simple example of the way to plot the correct shape and length of a shadow for the shape and the height of the light.

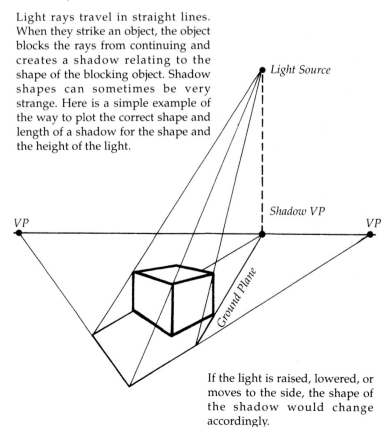

If the light is raised, lowered, or moves to the side, the shape of the shadow would change accordingly.

Painting Techniques

Water Control

Watercolor painting is often begun by wetting the paper with water. This is done to allow the colors to flow and to be absorbed by the paper. The amount of moisture in the paper determines how the color will perform. The amount of color and moisture to use in the brush depends on how much is on the paper. If both are very wet, it is more difficult to control the color. However, this is a good way to obtain some beautiful free-floating and merging color effects.

By placing color on a dry surface, sharp-edge control is possible. Individual brush strokes are crisp and can be used for detail or for creating wash areas.

At the right are some examples of color reacting to different degrees of paper wetness.

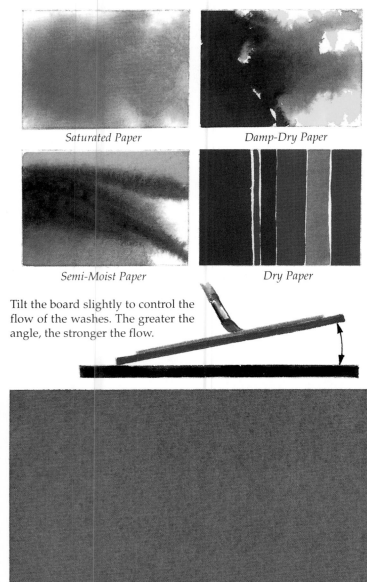

Saturated Paper *Damp-Dry Paper*

Semi-Moist Paper *Dry Paper*

Washes — Washes are diluted colors that are applied over a given area. They are usually applied on dry paper for better control. They can be the same value and color or they can change for color blending. Following are some examples of the different types of washes. Practice making various washes with a 1" flat watercolor brush and different colors.

Tilt the board slightly to control the flow of the washes. The greater the angle, the stronger the flow.

Graded Wash — Load your 1" flat brush with color and make a horizontal stroke across the top of the area to be washed. Next, using water only, make another horizontal stroke, slightly overlapping the first stroke. (The color from the first stroke will flow downward into this stroke.) As the water strokes are repeated, the color becomes weaker, resulting in a beautifully blended graded wash. (Use a damp brush to pick up any beads of water.)

Flat Wash — Load your brush with color, then tilt the support board slightly and make a horizontal stroke. Quickly reload the brush and make another stroke below and slightly overlapping the first stroke. The color should flow downward evenly. Repeat this procedure and the result will be an overall wash of color. If the flow is too strong, change the elevation of the board. The color should be allowed to run evenly to get a true flat wash.

Wet-In-Wet — Color washes can be applied on wet paper or over another wet color. Here, the color has been applied to a surface wet with clear water on the left side and color on the right side. The colors are allowed to run freely. Notice the natural blending of colors.

Running (using gravity) — Here two colors have been applied to a wet surface and allowed to run in various directions by tilting the board in different angles. Allow some runs to be strong and some to be subtle by changing the angle and direction of the tilt.

Wet-On-Dry — Here, a wash of green was applied and allowed to dry. Then washes of yellow and blue were painted over portions of it to show how to use washes for color change and control.

Loose Dry Wash — A loaded brush is drawn very quickly over dry paper for this effect. The quick motion causes bubbles and leaves holes of bare paper. This technique is helpful for creating textures; it also makes a good first wash for rocks.

Brush Techniques

There are several types of brushes and many ways to manipulate them to achieve the desired results. Some brushes are round and some are flat. The pointed round brushes are used for fine and thick strokes. They may also be scrubbed sideways to create other effects. The flat brushes are generally used for more broad applications of paint. These may also be used with stamping or sideways strokes to obtain textural effects. All good watercolor brushes can be loaded with a great amount of paint for broad coverage. They should also be able to perform with a very light load of color. It is important to have a good point on the round and a chisel end on the flat. Here are some exercises that show various brush and color manipulations.

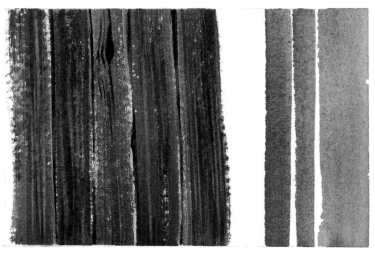

Dry Brush and Split-Brush — The dry brush technique is used for texture and effects, such as wood grains. To create the illusion of wood boards (left) load your flat brush with paint that is not too wet and drag it across the surface. To create a split-brush effect (right) separate the bristles with a toothpick or a piece of paper, then load the brush. The separated bristles will make an interesting pattern for boards, old logs, etc.

Streak Effect — This can be accomplished on saturated as well as dry paper by quickly applying streaks of color. The drier the paper, the more edge control and less color flow. The paper in the example was damp-dry.

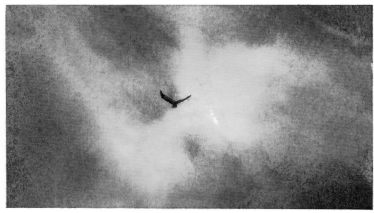

Background Wash (for light control) — This type of wash can be two or more colors. It is used to control the light in a painting and to draw the viewer's attention to a certain spot. Use a light warm color in the interest area surrounded by cooler, darker ones.

Round (line and scrubbed) — This brush is used to draw lines of various widths for detail, as shown, or it can be scrubbed sideways to create the illusion of trees. They are also used for washes and small areas of glazing.

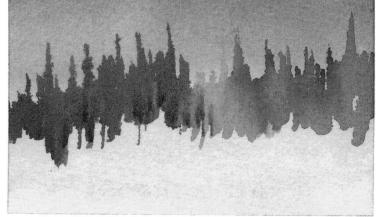

Wet-In-Wet — Applying wet paint to a wet surface causes the paint to run with very little control, but once the paper has lost its shine, the color can be easily controlled (as with these distant trees).

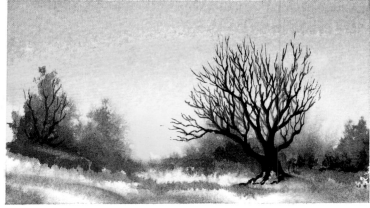

Dry-Over-Wet — The background was painted wet-in-wet and allowed to dry, then the tree details were painted over it. This shows the importance of color planning. Notice the "glow" area.

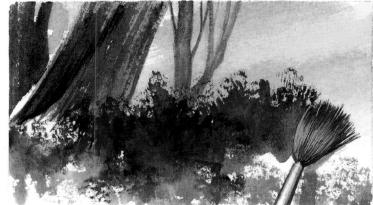

Rolling round brushes loaded with color will create grass and weed clumps. By changing angles and pressure on the brush, we create different shapes. Once dry, repeat as often as needed for more clumps.

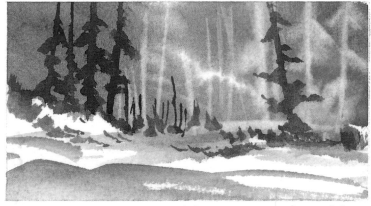

Damp-dry brushes have most of the water squeezed out of them. They can be used to draw color and moisture from the paper. This is useful for many effects. The white trees on the right were done by lifting wet paint with a flat brush. (Work quickly!)

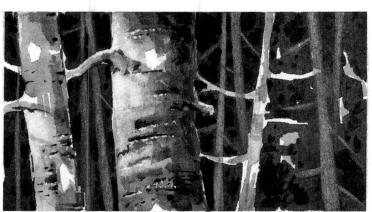

Moist brushes are slightly moister than damp-dry brushes. Moist brushes are used to pull paint from a dried surface — the distant trees in the shadows of the forest are a good example of this technique. By drawing paint out of the shadow, a trunk is formed.

Sponges And Knives

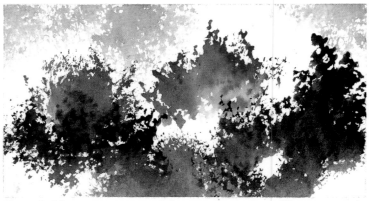

Household sponges are good for creating texture. They can create rocks, sides of buildings, etc., depending on how the sponge is handled. Here, the bushes were created by pressing and slightly turning the sponge.

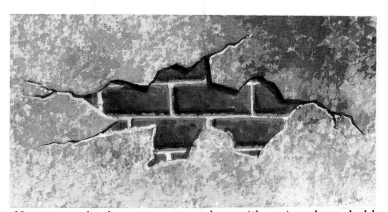

Here, several colors were stamped on with various **household sponges.** Allow each color to dry before going on to the next and work from light to dark. The bricks and cracks were painted with a pointed round brush.

Fine-grained natural sponges make nice textures for painting fine-grained rocks. A graded wash was applied first. When dry, several colors were stamped over it for texture. The cracks were made with a round brush.

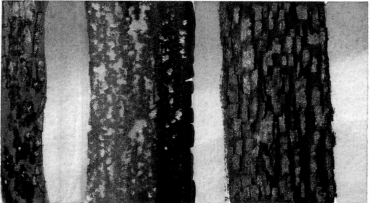

Razor Blades and Knives — The tree on the left was scraped with the knife handle while wet; the middle one was allowed to dry, scraped, then a thin wash was added; the one on the right was also scraped while wet.

Other Techniques

Watercolors are so versatile that many techniques are possible with them, and many tools besides a brush or a knife can be employed. Don't be afraid to experiment!

Spattering is accomplished by flicking paint onto your painting with a brush or a toothbrush. Combinations of colors create nice effects. Use paper towels to protect areas you do not want to spatter.

Masking off an area with **liquid frisket** keeps the area clean for later painting. The house on the left still has frisket on it. The one on the right has been cleaned and is ready to paint.

Salt is often used in snow scenes or backgrounds. It will only work on nonstaining colors. Here, blue is a staining color and brown is not — note the difference. Apply the salt while the paint is slightly wet.

A piece of **crumpled tissue** can be placed on a wet wash and left in place until the colors are dry. When removed, interesting patterns appear. It is always a surprise to see the texture, as there is no way to control the folds.

Paraffin Wax is a good masking and texturing tool as it prevents paint from adhering to the paper. Once the painting is finished, the wax is removed by placing paper towels over it and pressing with a hot iron.

Composition

There are many things to consider when planning a composition: 1) the comfortable arrangement of the parts; 2) the size and shape of the subject relative to the size and shape of picture area; 3) values of colors and the placement of strong and weak ones; 4) the elimination of objects that do not contribute to the composition; 5) the arrangement of color play so as to direct the viewer into the work; 6) the handling of the supporting objects and the background so they enhance the subject, the balance, etc.

Following are some basic types of compositions. Remember, these examples are meant to be used as guides, but they are not rules that cannot be successfully broken by a creative and thoughtful artist.

Golden section is possibly the best method of dividing an area into the most pleasing proportions and selecting the placement for the subject.

Triangular compositions tend to be comfortable for viewing; they have a slight pyramid feeling. Repeat the triangle several times to add interest.

Dividing the painting in the middle at the horizon creates an uninteresting balance of space; raise or lower the centerline to make it more pleasing.

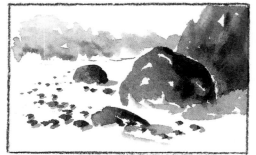

Vary the sizes and placement of the objects in the painting to cause the viewer to look from one object to another.

Use an "S" as a guide to create the illusion of depth and distance. The "S" can also be reversed to create more patterns of interest.

The **balance of the objects** is important. Use the objects to counterbalance each other. Here, the clouds counterbalance the trees on the left.

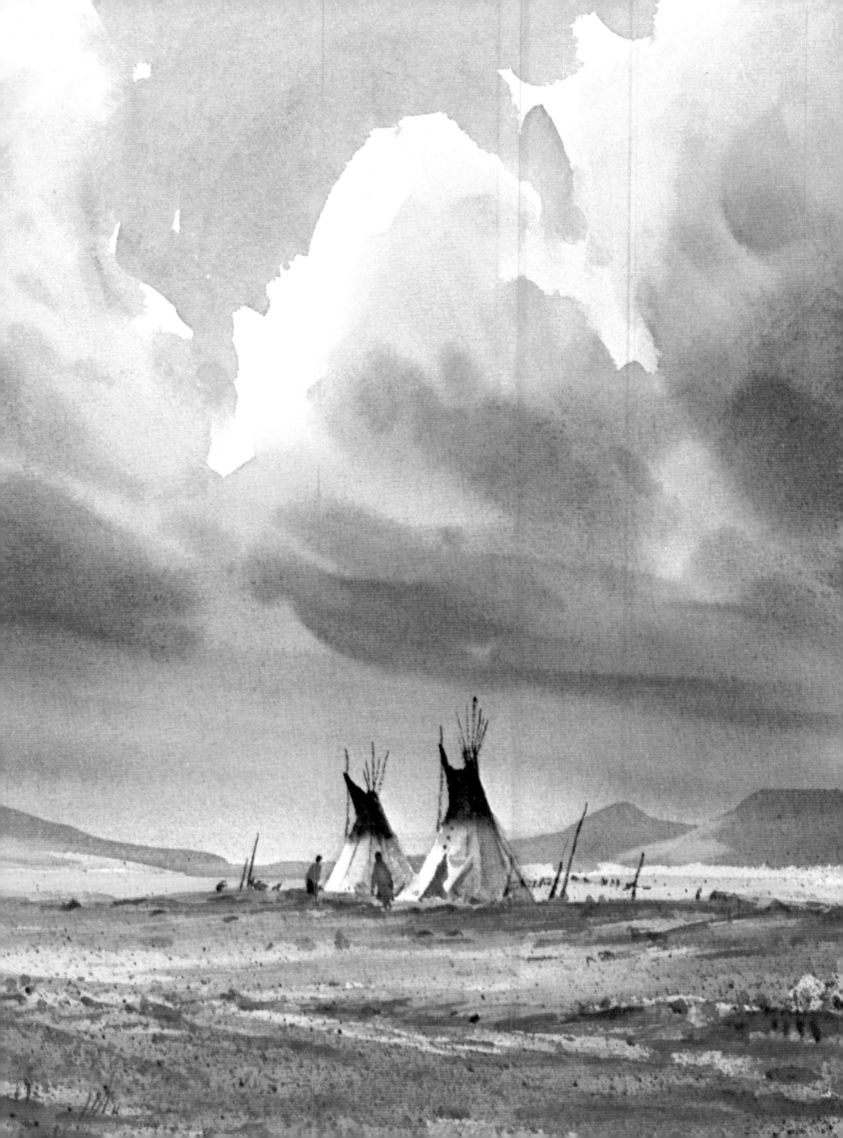

WATERCOLOR
Step-By-Step by Kolan Peterson

ABOUT THE AUTHOR

Kolan Peterson was born and raised in Utah. It was here in his childhood that he developed his love for the outdoors which he claims has been his greatest teacher and the inspiration for his paintings.

Kolan conducts summer workshops all along the west coast and in his native Utah for students from around the country. During the winter months he teaches his popular step-by-step watercolor approach throughout the southwest. He is sought after as a lecturer and a demonstrator, and he has served as a judge for watercolor exhibits throughout the southwest.

Kolan's control of the medium and his conscientious use of color result in realistic presentations of a variety of subjects. His control of color washes and delicate mist effects creates a jewel-like quality in many of his paintings.

SECTION 2

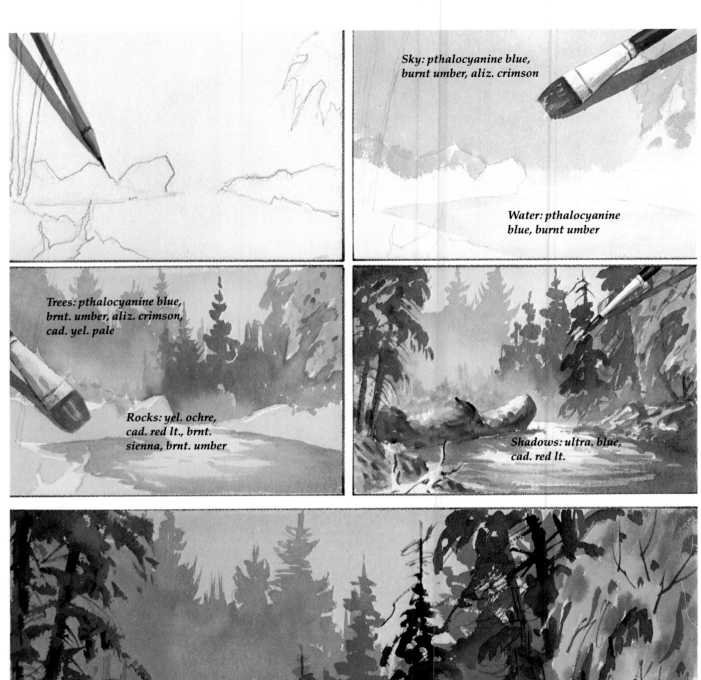

Sky: pthalocyanine blue,
burnt umber, aliz. crimson

Water: pthalocyanine
blue, burnt umber

Trees: pthalocyanine blue,
brnt. umber, aliz. crimson,
cad. yel. pale

Rocks: yel. ochre,
cad. red lt., brnt.
sienna, brnt. umber

Shadows: ultra. blue,
cad. red lt.

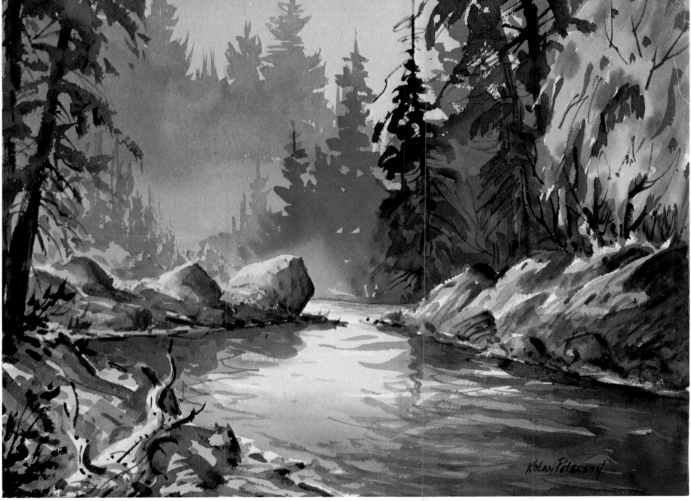

Misty River — Large masses of trees are a problem for many students, but the procedure is actually quite simple. Paint the overall mass, then pull out trees in the shadowy back area, increasing intensity as you come forward. Notice that the light on the rocks comes from the left. The trees in the foreground right are "shaded" into the picture with darker colors (this imparts distance). Water is introduced in lighter color; the glistening shadows and reflections make you "feel" the flow of the stream. If you wish, you can add fishermen to the picture.

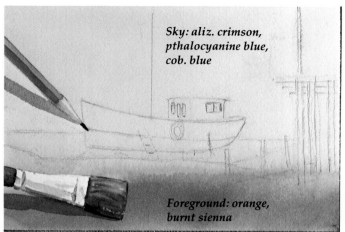

Sky: aliz. crimson, pthalocyanine blue, cob. blue

Foreground: orange, burnt sienna

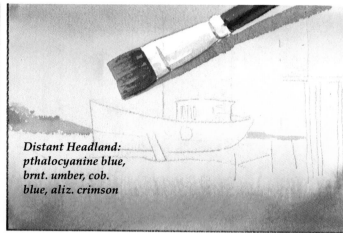

Distant Headland: pthalocyanine blue, brnt. umber, cob. blue, aliz. crimson

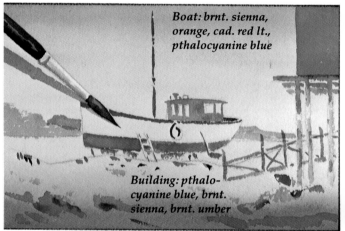

Boat: brnt. sienna, orange, cad. red lt., pthalocyanine blue

Building: pthalocyanine blue, brnt. sienna, brnt. umber

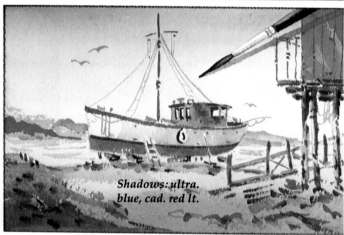

Shadows: ultra. blue, cad. red lt.

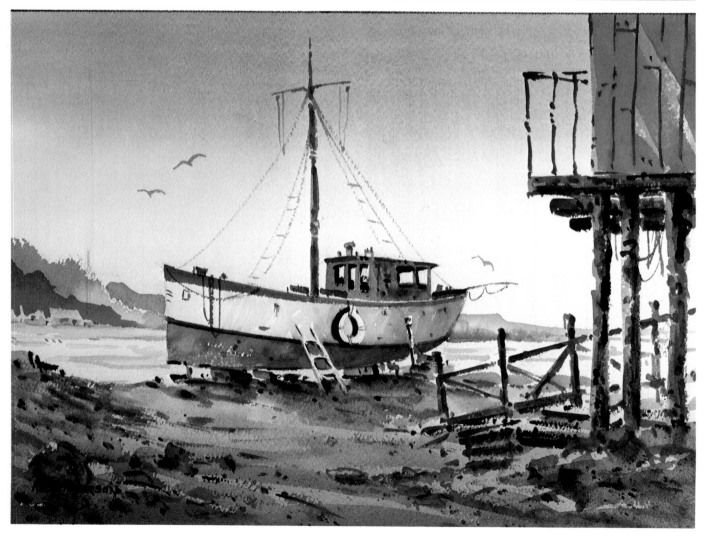

Snug Harbor — Notice that the sky and foreground are done in graded washes. The water is light with just a few indicated ripples. Note the graded wash that is applied to the hull of the boat; it shows that light is coming from the left. The structure on the right guides your eyes out to sea through the use of heavy colors. The trash and the old timbers (done in a form of dry brush) break up the beach mass. To add effect to the foreground, scatter it with rocks, plants and slanting shadows. Life is created through the introduction of gulls in flight.

21

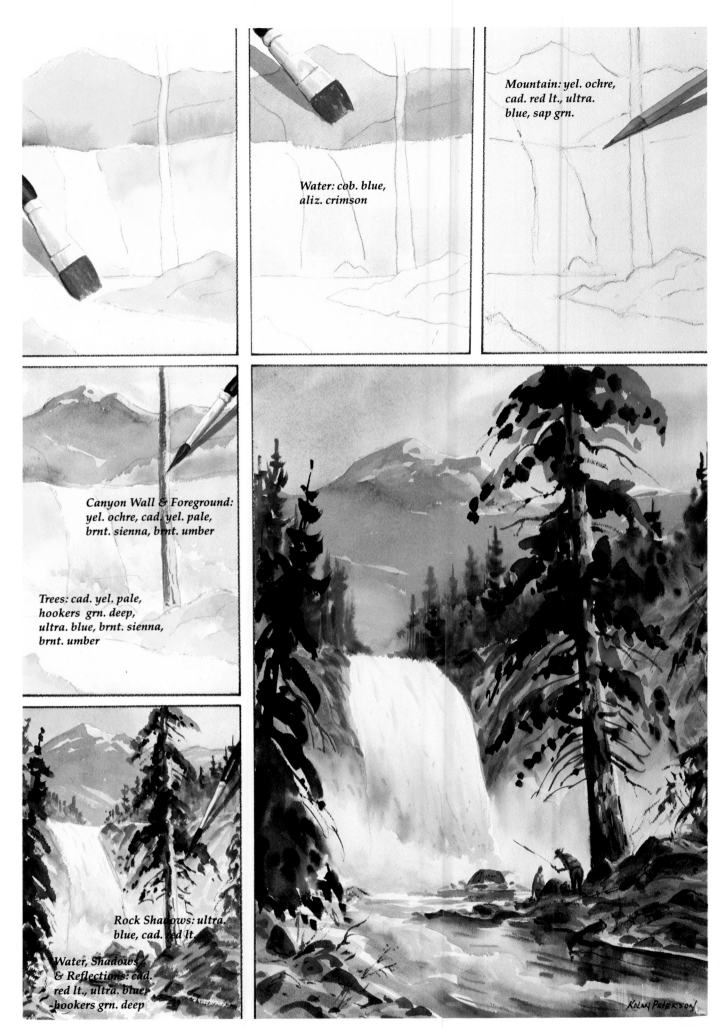

Water: cob. blue, aliz. crimson

Mountain: yel. ochre, cad. red lt., ultra. blue, sap grn.

Canyon Wall & Foreground: yel. ochre, cad. yel. pale, brnt. sienna, brnt. umber

Trees: cad. yel. pale, hookers grn. deep, ultra. blue, brnt. sienna, brnt. umber

Rock Shadows: ultra. blue, cad. red lt.

Water, Shadows, & Reflections: cad. red lt., ultra. blue, hookers grn. deep

Angler's Retreat — The most important feature of this picture is the waterfall. Its motion and lightness catch your eye immediately. Note the water's treatment on the stream below the falls. Tone the white paper just a little and add a few vertical lines to give movement to the falls. Mist was created by adding more clean water to the area behind the big tree. The mountain's big shape is a foil for the waterfall. Small branches are done with the rigger brush. You might want to remember the complementary color scheme of this picture for future paintings.

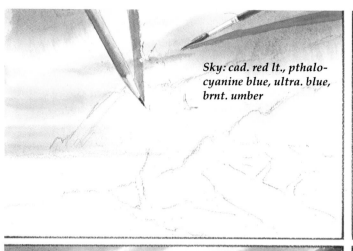

Sky: cad. red lt., pthalo-cyanine blue, ultra. blue, brnt. umber

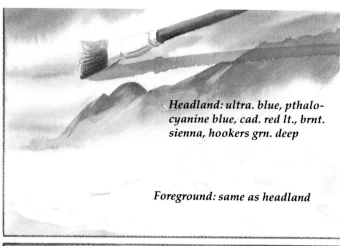

Headland: ultra. blue, pthalo-cyanine blue, cad. red lt., brnt. sienna, hookers grn. deep

Foreground: same as headland

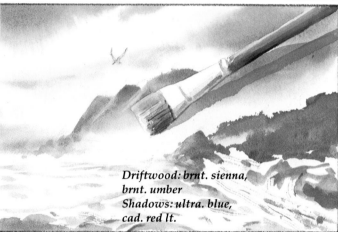

Driftwood: brnt. sienna, brnt. umber
Shadows: ultra. blue, cad. red lt.

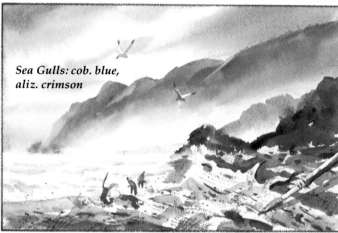

Sea Gulls: cob. blue, aliz. crimson

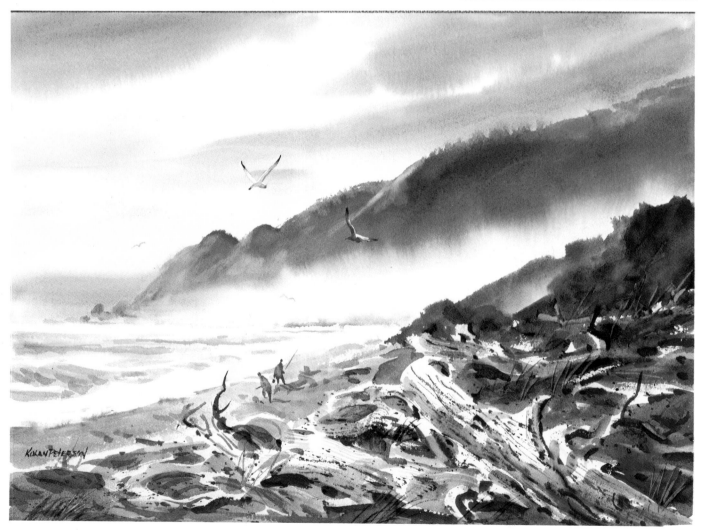

Cascade Head, Oregon — Yes! You can paint from slides and you can make vast improvements on the original. Painting the masses of driftwood is a challenge to the artist. The texture of the logs allows you to use a split brush procedure. This is a good example of adding clear water to the wash at the base of the headland to create a misty look. The birds were masked out with liquid frisket before the washes were applied. After the paint was dry, the frisket was rubbed off and details were added.

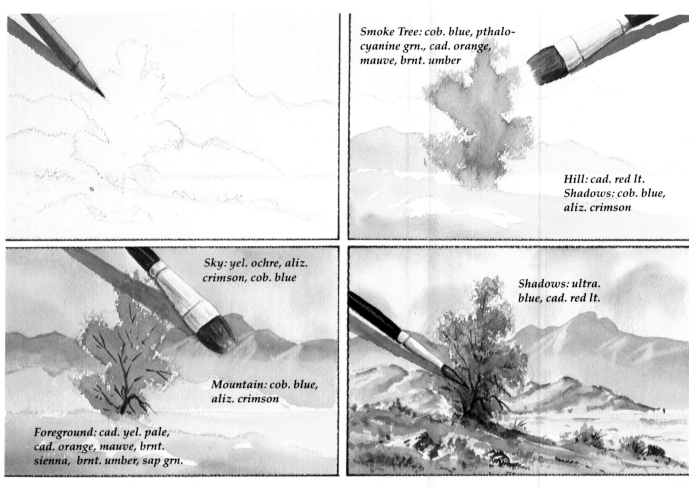

Smoke Tree: cob. blue, pthalo-cyanine grn., cad. orange, mauve, brnt. umber

Hill: cad. red lt. Shadows: cob. blue, aliz. crimson

Sky: yel. ochre, aliz. crimson, cob. blue

Mountain: cob. blue, aliz. crimson

Foreground: cad. yel. pale, cad. orange, mauve, brnt. sienna, brnt. umber, sap grn.

Shadows: ultra. blue, cad. red lt.

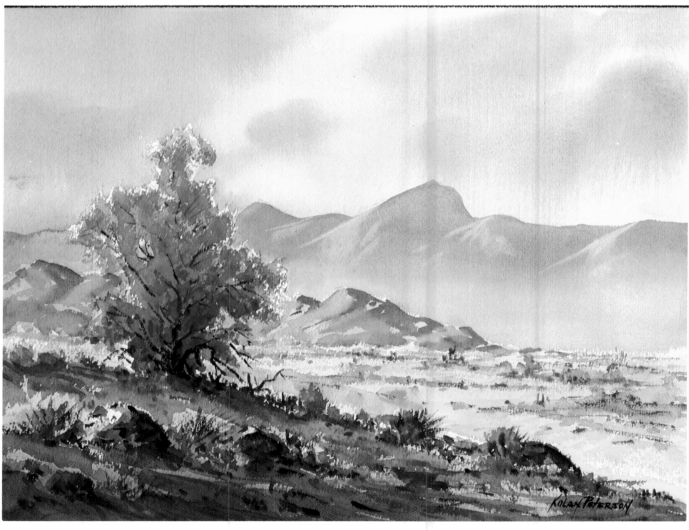

Near Palm Springs, California — The completed painting was made from several photos taken in the Palm Springs area. Most of the foreground was painted in shadow in order to create a back-lighted effect. The shadow color was painted around the trees and rocks leaving a sunlit area. Use your round and rigger brushes to bring out the tree limbs and the grasses. Notice that the trees are given a dark base to tie them to the ground.

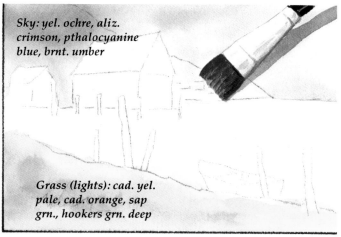

Sky: yel. ochre, aliz. crimson, pthalocyanine blue, brnt. umber

Grass (lights): cad. yel. pale, cad. orange, sap grn., hookers grn. deep

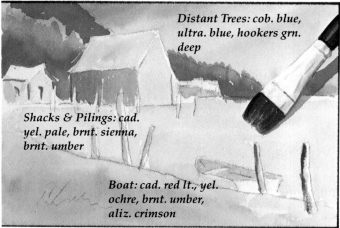

Distant Trees: cob. blue, ultra. blue, hookers grn. deep

Shacks & Pilings: cad. yel. pale, brnt. sienna, brnt. umber

Boat: cad. red lt., yel. ochre, brnt. umber, aliz. crimson

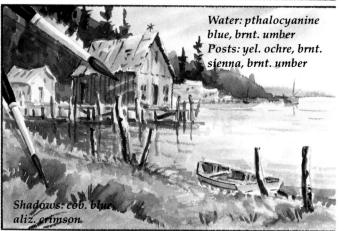

Water: pthalocyanine blue, brnt. umber
Posts: yel. ochre, brnt. sienna, brnt. umber

Shadows: cob. blue, aliz. crimson

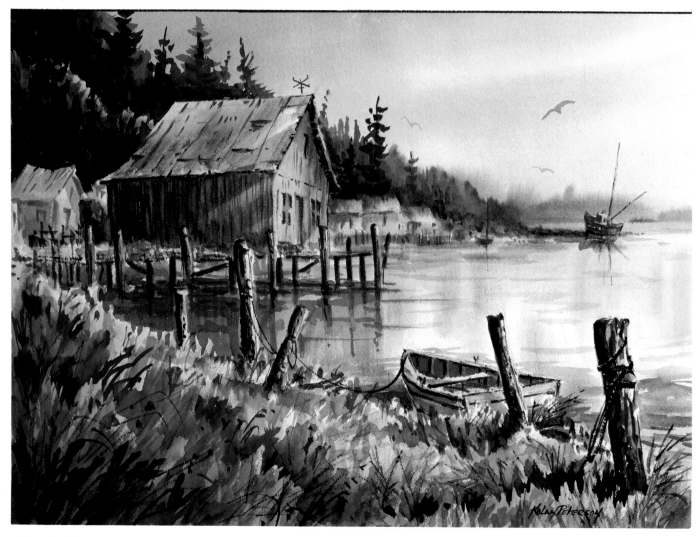

Sky: yel. ochre, aliz. crimson, pthalocyanine blue, brnt. umber

Coastal Inlet — You never paint a picture "all at once"; it is done in planned steps. In the third step (above) light washes were used to establish areas that will be developed later on. Cutting in the trees around the top part of the building makes the roof stand out. All lines, even the boat and the pilings, lead your eyes to the shack. The foreground uses light and dark contrasting grasses to bring out a pleasing effect. The posts, the boat and the reflections in the water give the painting a wet look.

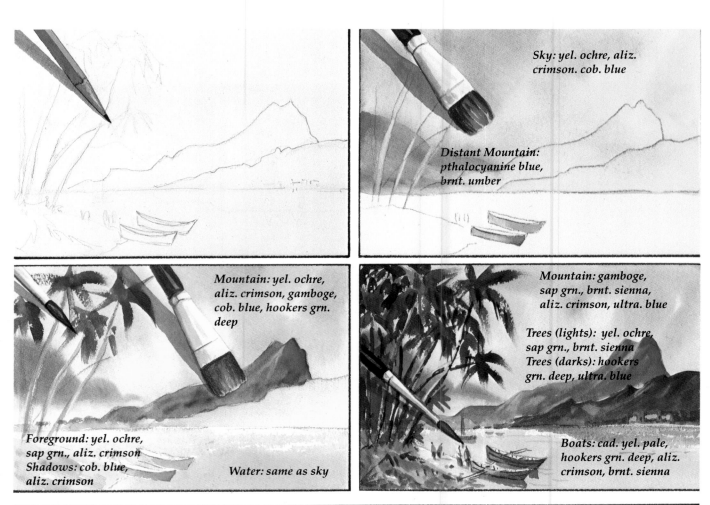

Sky: yel. ochre, aliz. crimson. cob. blue

Distant Mountain: pthalocyanine blue, brnt. umber

Mountain: yel. ochre, aliz. crimson, gamboge, cob. blue, hookers grn. deep

Foreground: yel. ochre, sap grn., aliz. crimson
Shadows: cob. blue, aliz. crimson

Water: same as sky

Mountain: gamboge, sap grn., brnt. sienna, aliz. crimson, ultra. blue

Trees (lights): yel. ochre, sap grn., brnt. sienna
Trees (darks): hookers grn. deep, ultra. blue

Boats: cad. yel. pale, hookers grn. deep, aliz. crimson, brnt. sienna

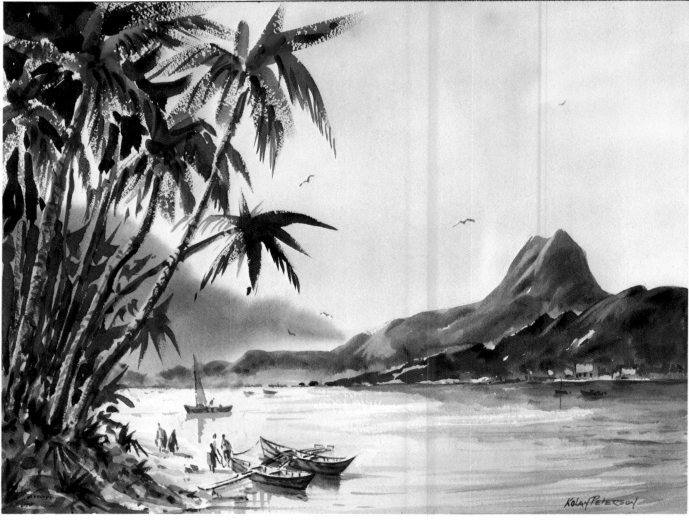

Palms And Beach — The centers of interest are the palms and the people on the left. This painting allows you to use many colors that are actually blended on the wet paper. The moun- tains to the right point to the activity on the beach. The "roundness" of the palm tree trunks are achieved with a few curved lines.

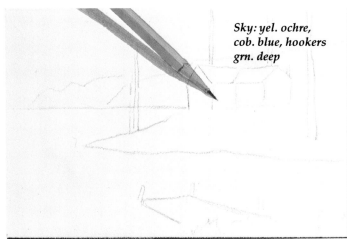

Sky: yel. ochre, cob. blue, hookers grn. deep

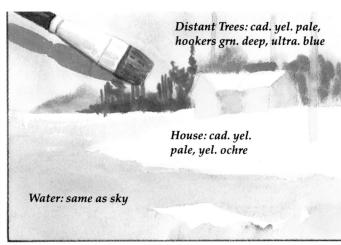

Distant Trees: cad. yel. pale, hookers grn. deep, ultra. blue

House: cad. yel. pale, yel. ochre

Water: same as sky

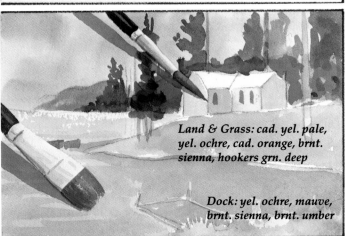

Land & Grass: cad. yel. pale, yel. ochre, cad. orange, brnt. sienna, hookers grn. deep

Dock: yel. ochre, mauve, brnt. sienna, brnt. umber

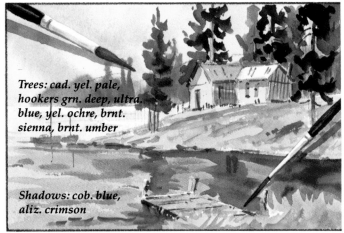

Trees: cad. yel. pale, hookers grn. deep, ultra. blue, yel. ochre, brnt. sienna, brnt. umber

Shadows: cob. blue, aliz. crimson

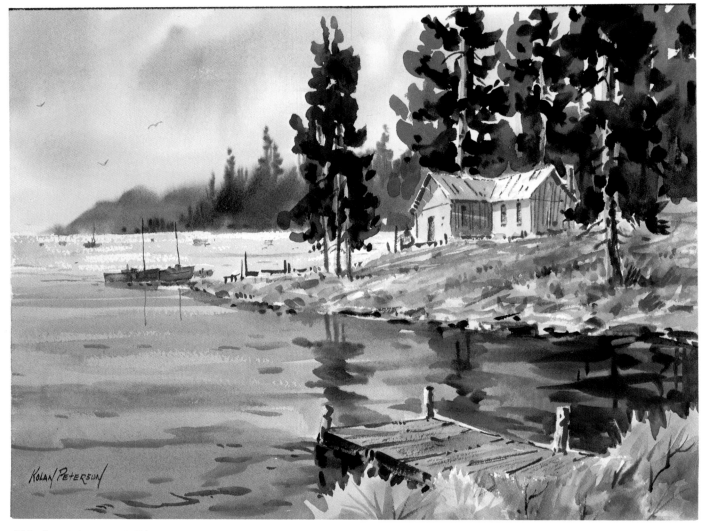

KOLAN PETERSON

Fabulous Big Bear, California — The kind people who live in this cabin purchased a sketch similar to the painting. Dry brush creates the shimmer of water against the distant shore. Apply darker colors with a 'loaded' brush to bring out reflections in the water in the foreground. The reddish-yellow dock creates contrast. Bushes overlap the dock; this effect was achieved by painting water reflections around them. Notice that the brushes around the dock soften hard lines and direct the eyes upward.

Special Effects

Table salt can be used to obtain the mottled effects you see in the green and yellow examples below. Practice this technique several times to gain confidence and to be sure of what you're doing. All you really have to do is sprinkle the salt onto the wet paint and watch it develop into an interesting pattern. The pencil sketch to the right is a separate exercise you can do on your own. It will allow you to establish back-, middle- and foreground values that you can incorporate in the finished painting, such as the one shown on the bottom of this page.

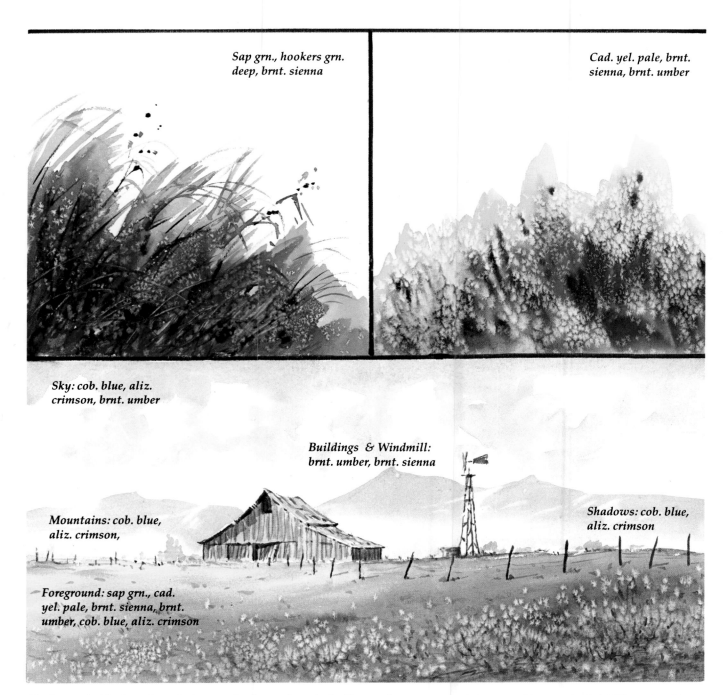

Sap grn., hookers grn. deep, brnt. sienna

Cad. yel. pale, brnt. sienna, brnt. umber

Sky: cob. blue, aliz. crimson, brnt. umber

Buildings & Windmill: brnt. umber, brnt. sienna

Mountains: cob. blue, aliz. crimson,

Shadows: cob. blue, aliz. crimson

Foreground: sap grn., cad. yel. pale, brnt. sienna, brnt. umber, cob. blue, aliz. crimson

You've probably been here before — the barn, the windmill, the distant hills, the clouds, the sky.... Does it give you a nostalgic feeling? Sure it does! The table salt technique adds a professional touch that will set you apart as a pro. After all, that's what you are striving to achieve — isn't it? The salt adds an interesting motif on which you can apply other techniques. In this case, the salt pattern is enhanced by the addition of more detail — the weeds.

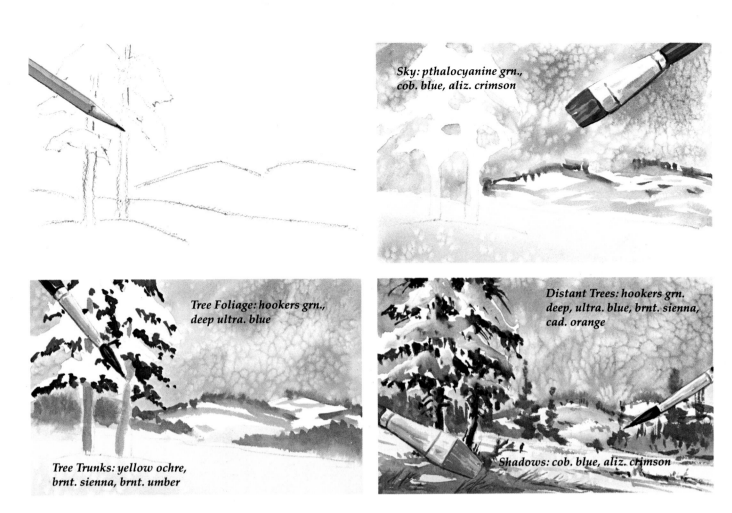

Sky: pthalocyanine grn., cob. blue, aliz. crimson

Tree Foliage: hookers grn., deep ultra. blue

Tree Trunks: yellow ochre, brnt. sienna, brnt. umber

Distant Trees: hookers grn. deep, ultra. blue, brnt. sienna, cad. orange

Shadows: cob. blue, aliz. crimson

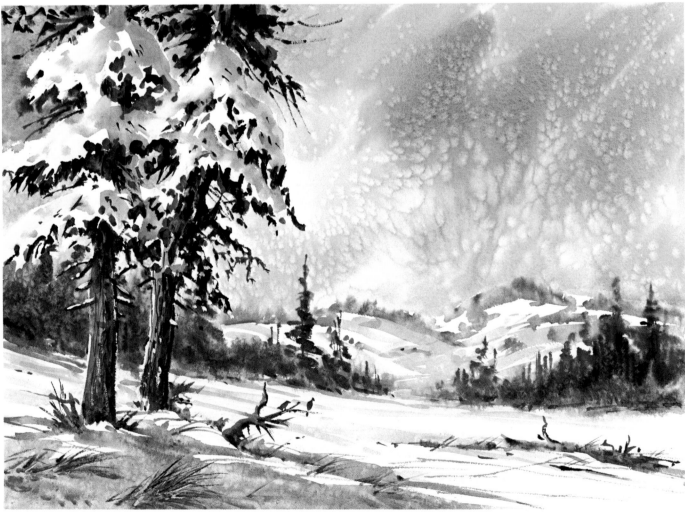

This page shows a step-by-step approach for creating a stormy effect — arriving at the final painting at the bottom of the page. If you wish, you can add birds to create a feeling of "life" in the finished picture. Before going on to the next page, notice the sky which came about through the generous use of table salt. Fetching, isn't it!?

Liquid Frisket — A Magic Medium!

Liquid frisket is used to preserve small white areas that will be developed later. In this instance, we wanted to preserve the gull and the pilings. Since the frisket is waterproof, you can paint the sky right over the masked areas. After the paint is thoroughly dry, rub off the frisket and add details. In the first example, the frisket has been left on two of the pilings. You can see how the white of the paper was preserved in the areas of the one post and bird. Now all you have to do is paint in the details and, "Voila!" — you have a watercolor like the one below.

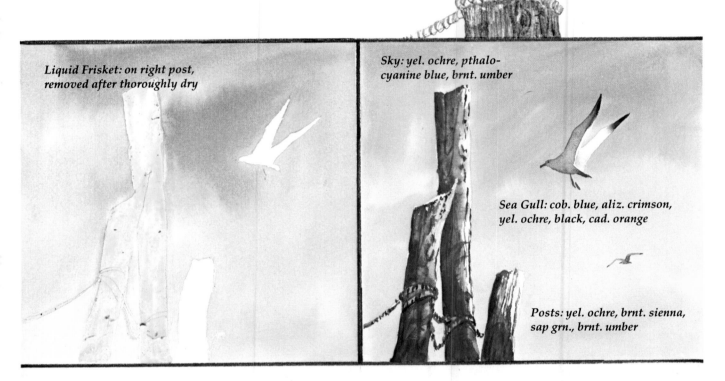

Liquid Frisket: on right post, removed after thoroughly dry

Sky: yel. ochre, pthalo-cyanine blue, brnt. umber

Sea Gull: cob. blue, aliz. crimson, yel. ochre, black, cad. orange

Posts: yel. ochre, brnt. sienna, sap grn., brnt. umber

Sky: cob. blue, yel. ochre

Distant Trees & Water: pthalo-cyanine blue, brnt. umber

Sea Gulls: cob. blue, aliz. crimson, black

Rocks: yel. ochre, sap grn., brnt. sienna, brnt. umber

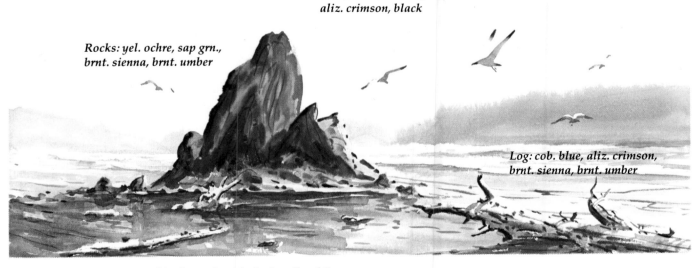

Log: cob. blue, aliz. crimson, brnt. sienna, brnt. umber

The dark lines were scraped in the rock with the handle of the brush while the paint was wet. Frisket was used to preserve the gulls and the driftwood.

It isn't always necessary to use frisket. In the example below, the trees on the left were scraped out with the bevel side of the brush (this must be done while the wash is wet). On the right, the tree trunks were sketched in and the hills and the foliage were painted around them. Obviously, you must be careful to maintain the white shapes of the larger trunks and the branches. Notice, also, that the foreground was left white. The pencil sketch on the right is a practice subject so you can try the techniques shown below. Of course, you can use your own colors.

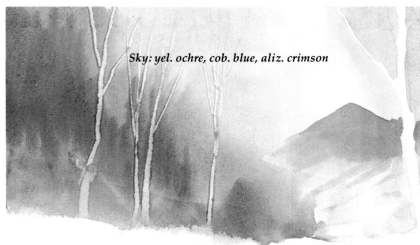

Sky: yel. ochre, cob. blue, aliz. crimson

Mountain: cob. blue, aliz. crimson

Distant Foliage: cob. blue, aliz. crimson, yel. ochre, cad. orange, hookers grn. deep

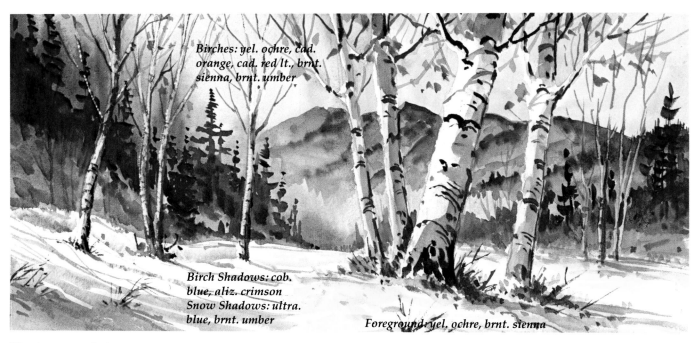

Birches: yel. ochre, cad. orange, cad. red lt., brnt. sienna, brnt. umber

Birch Shadows: cob. blue, aliz. crimson
Snow Shadows: ultra. blue, brnt. umber

Foreground: yel. ochre, brnt. sienna

The foreground shadows on the left were painted with one glaze. Ultramarine blue and burnt umber were used to show how a winter scene can be achieved. The same glaze was used on the right to bring out the shadows over the warm, autumn base colors.

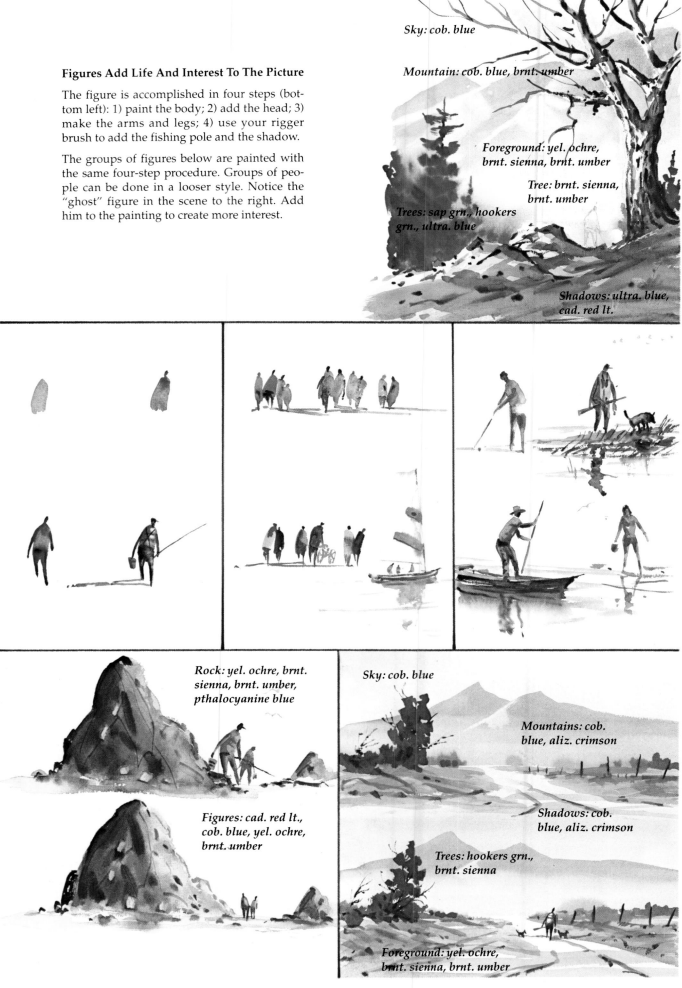

Figures Add Life And Interest To The Picture

The figure is accomplished in four steps (bottom left): 1) paint the body; 2) add the head; 3) make the arms and legs; 4) use your rigger brush to add the fishing pole and the shadow.

The groups of figures below are painted with the same four-step procedure. Groups of people can be done in a looser style. Notice the "ghost" figure in the scene to the right. Add him to the painting to create more interest.

Sky: cob. blue

Mountain: cob. blue, brnt. umber

Foreground: yel. ochre, brnt. sienna, brnt. umber

Tree: brnt. sienna, brnt. umber

Trees: sap grn., hookers grn., ultra. blue

Shadows: ultra. blue, cad. red lt.

Rock: yel. ochre, brnt. sienna, brnt. umber, pthalocyanine blue

Figures: cad. red lt., cob. blue, yel. ochre, brnt. umber

Sky: cob. blue

Mountains: cob. blue, aliz. crimson

Shadows: cob. blue, aliz. crimson

Trees: hookers grn., brnt. sienna

Foreground: yel. ochre, brnt. sienna, brnt. umber

You can make rocks look larger or smaller with figures: the smaller the figure, the larger the rock appears; the larger the figure, the smaller the rock. The two scenes on the right are identical except for the figures. Notice how the man and the dogs in the lower example establish a point of interest and add life to an otherwise static painting.

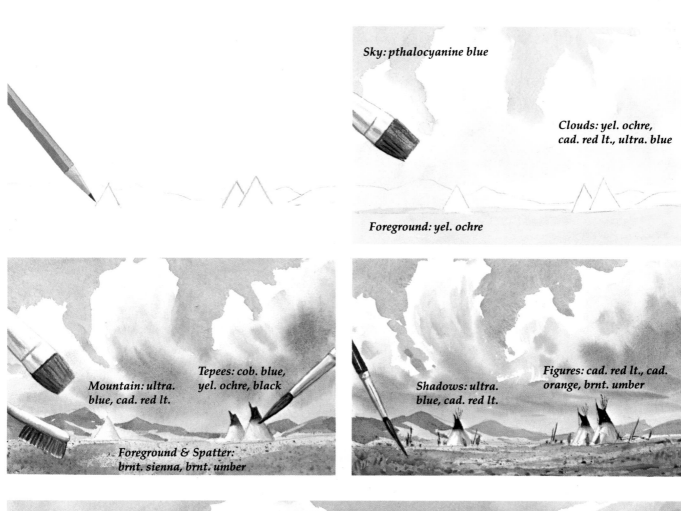

Sky: pthalocyanine blue

Clouds: yel. ochre, cad. red lt., ultra. blue

Foreground: yel. ochre

Mountain: ultra. blue, cad. red lt.

Tepees: cob. blue, yel. ochre, black

Foreground & Spatter: brnt. sienna, brnt. umber

Shadows: ultra. blue, cad. red lt.

Figures: cad. red lt., cad. orange, brnt. umber

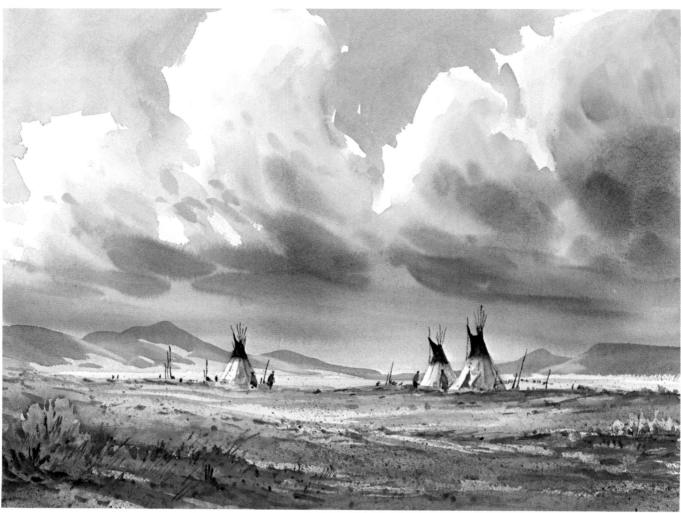

Prairie Dwellers — Keep the tepees white until you are ready to tone them. For the underpainting in the clouds, make a light wash and soften the tops of the clouds. When dry, paint the sky around the tops of the clouds. Create texture in the foreground by pointing a paint-laden toothbrush toward the area and dragging your thumb across the bristles, spattering the foreground with a spray of paint (be sure to cover the sky with paper towels before you start). Add weed texture and foreground shadows, then darken the tops of the tepees. Lastly, paint the poles, the shadow effects and the characters.

33

Tape: The Painter's Friend

You can use masking tape for many things besides sealing packages. In the first painting tape was used to establish a horizon line. After the sky was painted in, the tape was removed and the lower part of the picture was painted. (Be sure to leave a white area of water where the horizon meets the sky.) Try your hand at doing a painting of the Oregon beach scene sketched here. The values are already worked out. Use frisket for the birds.

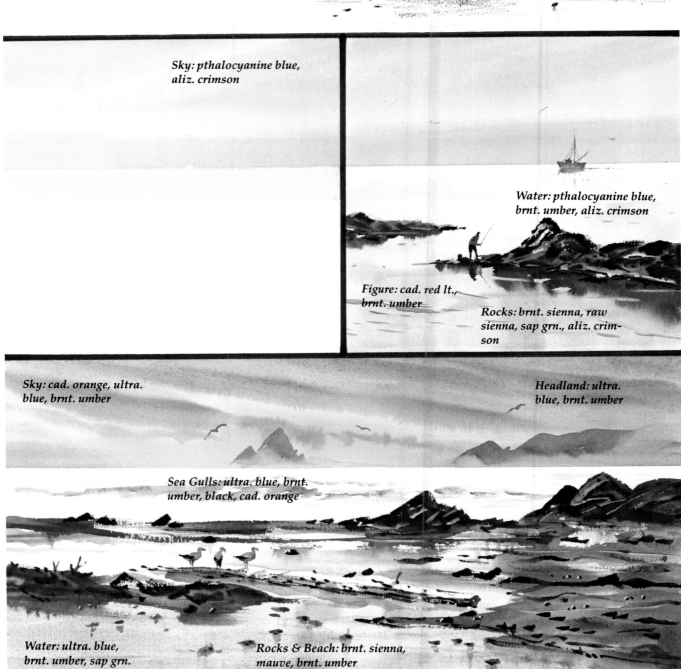

Sky: pthalocyanine blue, aliz. crimson

Water: pthalocyanine blue, brnt. umber, aliz. crimson

Figure: cad. red lt., brnt. umber

Rocks: brnt. sienna, raw sienna, sap grn., aliz. crimson

Sky: cad. orange, ultra. blue, brnt. umber

Headland: ultra. blue, brnt. umber

Sea Gulls: ultra. blue, brnt. umber, black, cad. orange

Water: ultra. blue, brnt. umber, sap grn.

Rocks & Beach: brnt. sienna, mauve, brnt. umber

This is another example of a beach scene that uses the techniques you've been practicing. The headlands are above the horizon line and the misty effect is achieved by finishing with clear water along the base of each hill. Notice how the rocks are reflected in the water. Use a knife point to pick out highlights on the rocks, the shoreline and the beach.

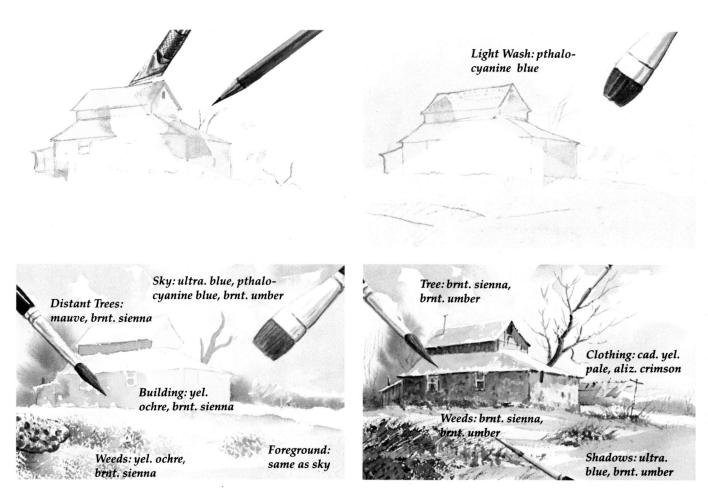

Light Wash: pthalo-cyanine blue

Distant Trees: mauve, brnt. sienna

Sky: ultra. blue, pthalo-cyanine blue, brnt. umber

Building: yel. ochre, brnt. sienna

Weeds: yel. ochre, brnt. sienna

Foreground: same as sky

Tree: brnt. sienna, brnt. umber

Clothing: cad. yel. pale, aliz. crimson

Weeds: brnt. sienna, brnt. umber

Shadows: ultra. blue, brnt. umber

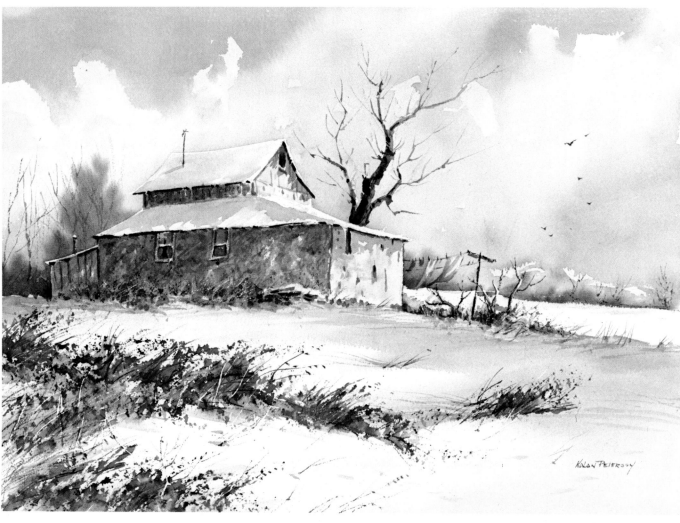

Winter Wash Day — First put tape along the edges of the house and carefully cut off any excess. Next, use liquid frisket to establish the clothing on the clothesline and a few of the weeds in the foreground. Paint in the sky and the snow. Use wet-in-wet techniques for the trees on both sides of the house. (This middle value gives the illusion of distance and ties the painting together.) Remove the tape and paint in the house as shown in step 3. Use a sponge to make the grass texture in the foreground. Paint the stark tree on the right. Rub off the frisket and paint the washes. Model the structure and the grass as in step 4, do the finishing touches and your creation is complete!

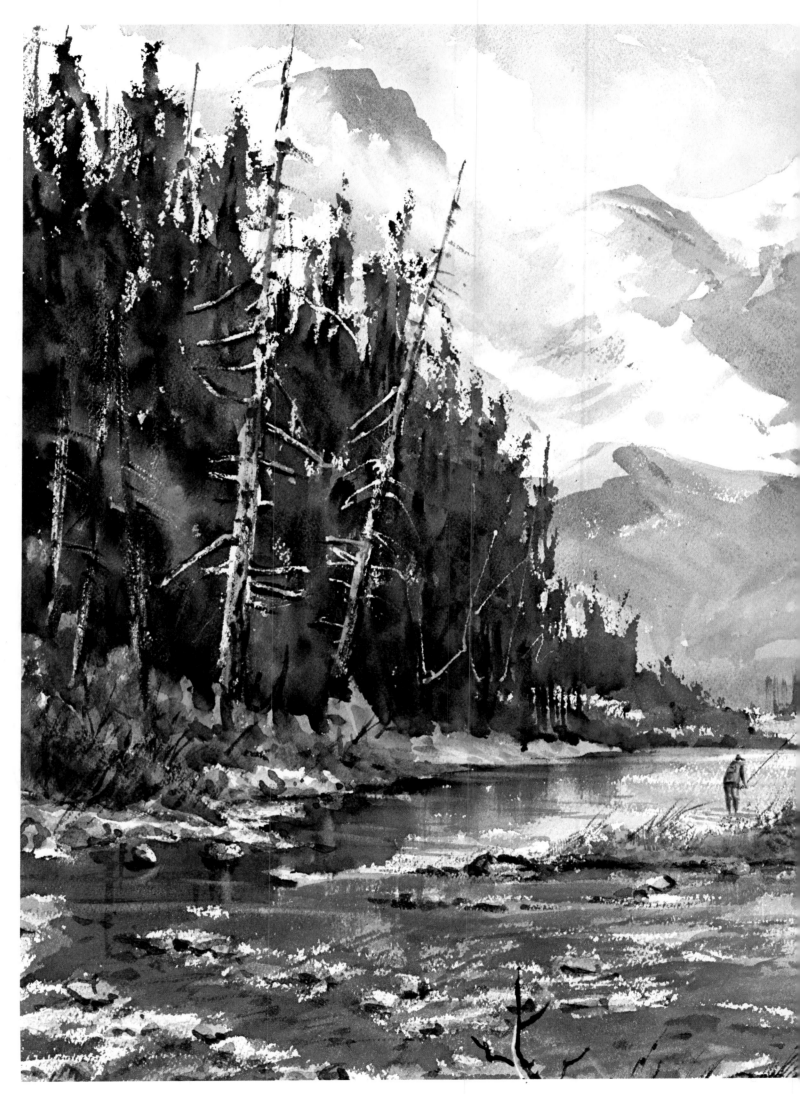

Kenai River, Alaska

Study this painting to see if you can spot some of the techniques that have been demonstrated throughout this book.

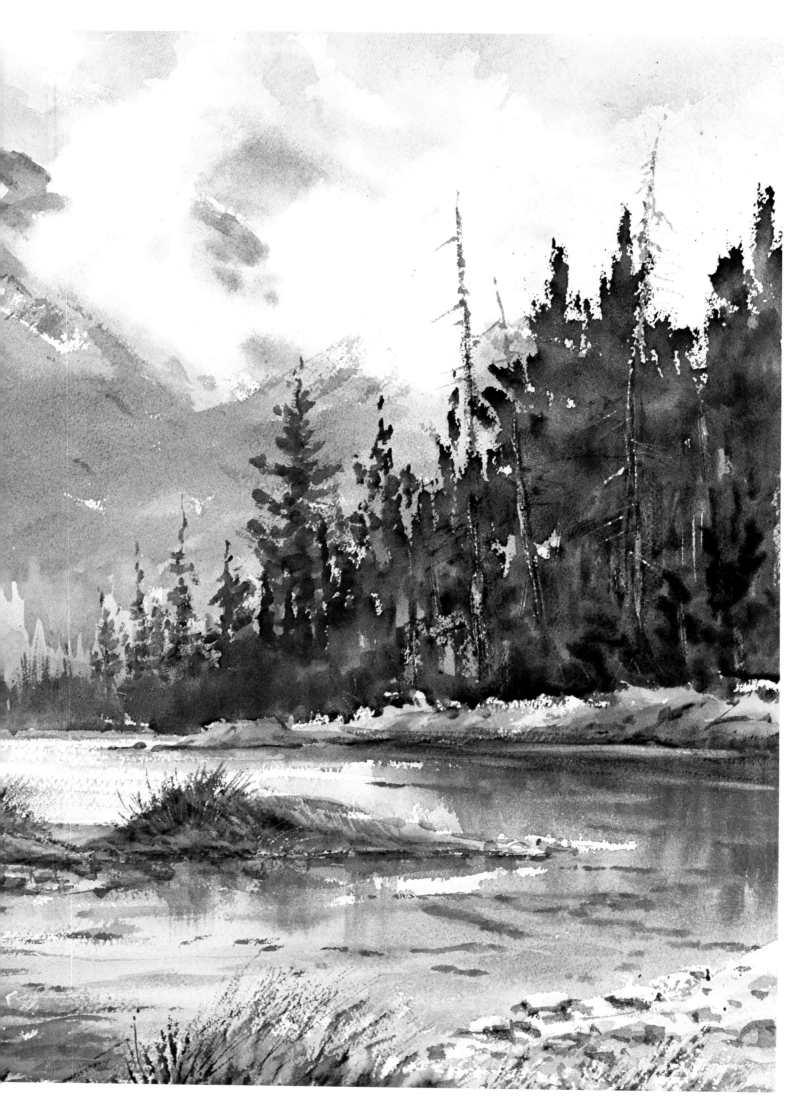

Stencils Are Beautiful

Stencils are an important part of an artist's "bag of tricks." They are used to lift out shapes from previously painted areas. Thus, you can super-impose leaves, tree trunks, rocks, logs, birds, etc., over areas of the picture that you have already painted in. How do you make a stencil? The one shown here was cut from index card stock. One could easily use plastic, old photo-graphic negatives, etc. Notice how the leaves bring drama to the cabin in the sketch on the right. If you wish, you can use this sketch as a basis for a trial watercolor. Let your imagination roam— you'll create something beautiful.

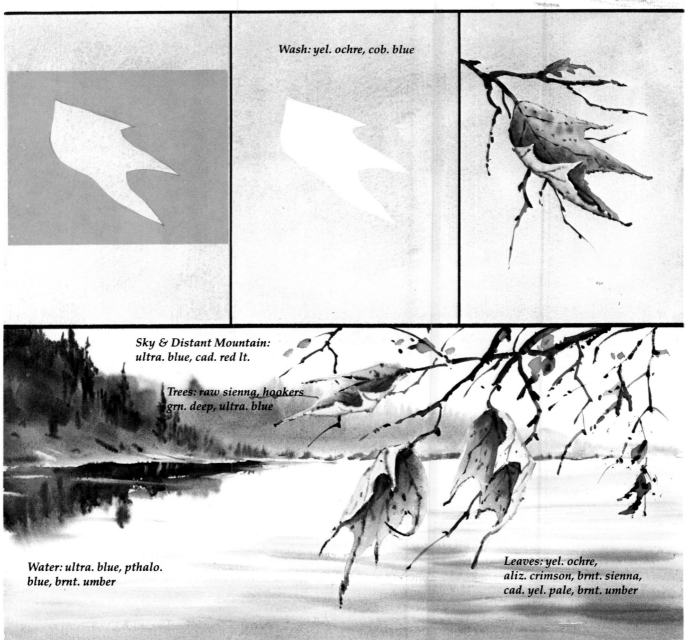

Wash: yel. ochre, cob. blue

Sky & Distant Mountain: ultra. blue, cad. red lt.

Trees: raw sienna, hookers grn. deep, ultra. blue

Water: ultra. blue, pthalo. blue, brnt. umber

Leaves: yel. ochre, aliz. crimson, brnt. sienna, cad. yel. pale, brnt. umber

Stencils produce dramatic effects. After you have cut out the image, lay it over the wash and use a damp sponge to lift out the paint. Then blot dry and paint in the leaves and branches.

Call It Special Effects — Spatter!

You can use it to produce stunning impressions — as this painting attests. Essentially, spatter does one thing — it creates a texture that can't be achieved any other way. A particularly fine example is the bucket in the painting below. This is a two-step procedure. Mask out the bucket with liquid frisket and use an old toothbrush to spatter into the wet underpainting around the bucket. (Simply load the toothbrush with color, point it at the area you wish to cover, and draw your thumb across the bristles.) Be sure to place paper towels over the areas of the painting you want to protect before you begin. Next, remove the liquid frisket and paint the details of the bucket.

See what you can do using the pencil sketch shown on the right as the centerpiece of your theme.

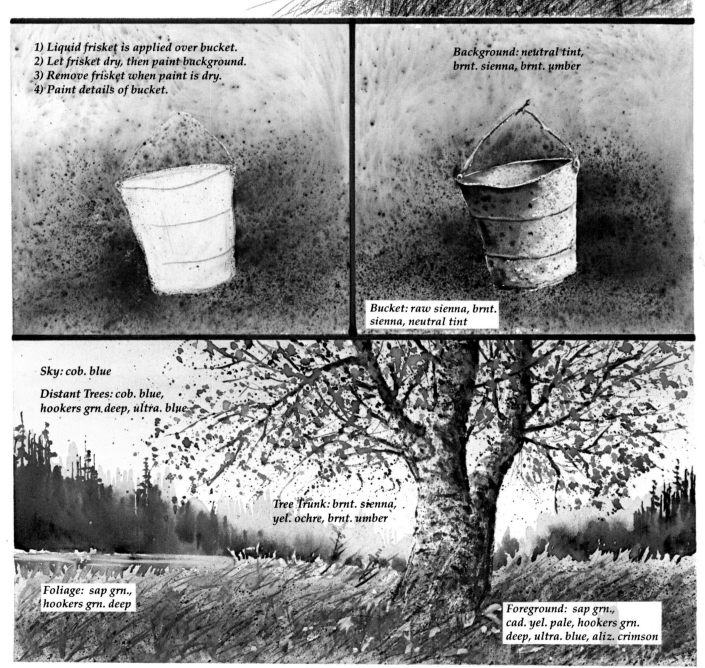

1) Liquid frisket is applied over bucket.
2) Let frisket dry, then paint background.
3) Remove frisket when paint is dry.
4) Paint details of bucket.

Background: neutral tint, brnt. sienna, brnt. umber

Bucket: raw sienna, brnt. sienna, neutral tint

Sky: cob. blue

Distant Trees: cob. blue, hookers grn. deep, ultra. blue

Tree Trunk: brnt. sienna, yel. ochre, brnt. umber

Foliage: sap grn., hookers grn. deep

Foreground: sap grn., cad. yel. pale, hookers grn. deep, ultra. blue, aliz. crimson

While we're at it, let's observe what spatter has done for the foliage and the tree trunk above. Also, notice that the red flowers painted along the horizon make the foreground greens look greener. This is a technique that uses complementary colors to achieve a harmonious effect.

The Misty, Foggy Sea

Author Joe Conrad would have felt right at home with these watercolors. He loved the sea and described in his books many scenes such as you see here.

Gray-blues and gray-greens create the mood you are seeking to establish in your finished watercolor. For step 1, lay in your blue washes then lift out light areas from around the distant headlands with a moist brush. In step 2, paint the rocks and add rich, heavy darks on foreground rock arrangement (notice how the distant outcropping is kept lighter to establish the feeling of distance). After you have brought your foreground into focus, add driftwood details. You will notice that the white areas were "painted around" in the preceding step. You may want to try a watercolor using the pencil sketch to the right.

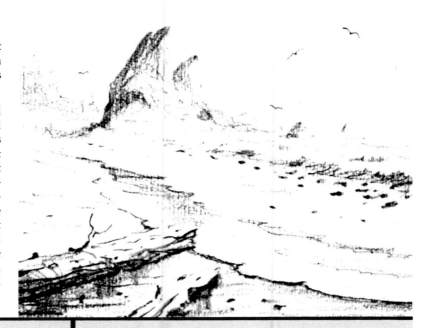

Sky & Water: pthalocyanine blue, brnt. umber

Headlands: same as sky

Paint Around the Driftwood

Distant Rock: yel. ochre, brnt. sienna, pthalocyanine blue

Rocks: yel. ochre, brnt. sienna, brnt. umber, pthalocyanine blue

Driftwood: cob. blue, brnt. sienna, brnt. umber

Sky: pthalocyanine blue, brnt. umber, cad. orange

Headland: ultra. blue, cad. orange, brnt. umber

(Frisket on Birds)

Rocks: yel. ochre, cad. orange, pthalocyanine blue, brnt. umber

Shadows & Reflections: ultra. blue, cad. red lt.

Beach: yel. ochre, sap grn., brnt. sienna, brnt. umber

Water: yel. ochre, pthalocyanine blue, brnt. umber

Here is the finished painting. Water detail has been kept simple and the gulls add needed life. You may also want to add a couple of people walking along the beach.

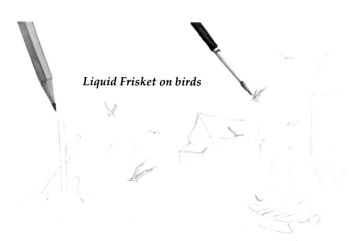

Liquid Frisket on birds

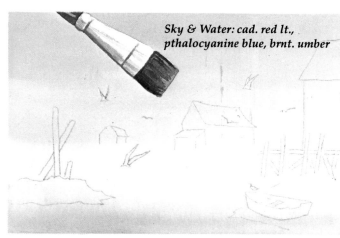

Sky & Water: cad. red lt., pthalocyanine blue, brnt. umber

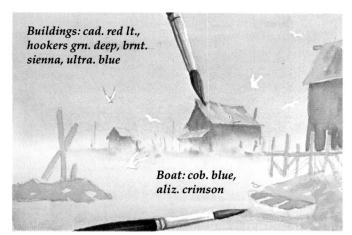

Buildings: cad. red lt., hookers grn. deep, brnt. sienna, ultra. blue

Boat: cob. blue, aliz. crimson

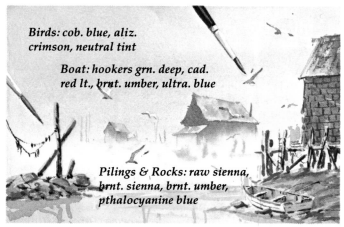

Birds: cob. blue, aliz. crimson, neutral tint

Boat: hookers grn. deep, cad. red lt., brnt. umber, ultra. blue

Pilings & Rocks: raw sienna, brnt. sienna, brnt. umber, pthalocyanine blue

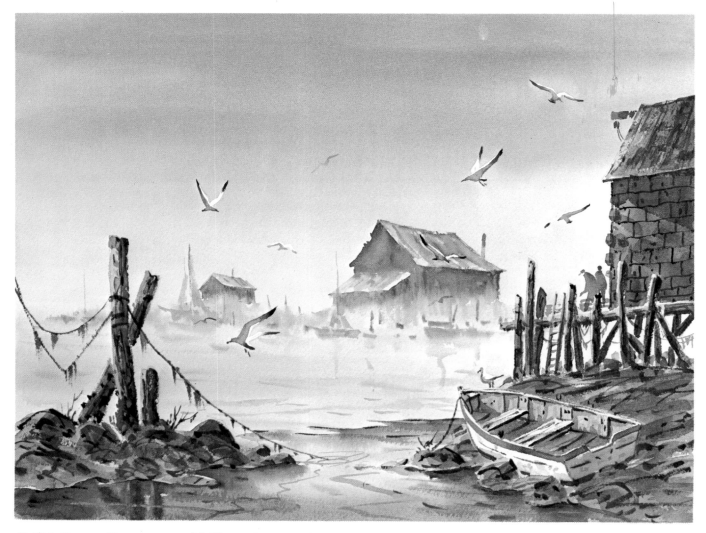

Catfish Cove — Have you ever felt like getting away from it all? Well, perhaps you can't take off right now, but you can paint yourself a dream! See if you can identify some of the techniques you have learned on the previous pages. The step-by-step process shown at the top of this page has a principal item you should notice — the mist creeping into the area around the old shacks in the middle distance.

Repeat Performance

That's what this is, another spatter technique — but with a difference. This time we use opaque white to "spatter" in the snow. It works like a charm and you'll be pleased with yourself once you've done this type of watercolor. In the first step, paint a light blue wash over the snow area before adding landscape shadows and other details. You'll notice the white spatter treatment. Try doing your latest snow adventure sketch in watercolor.

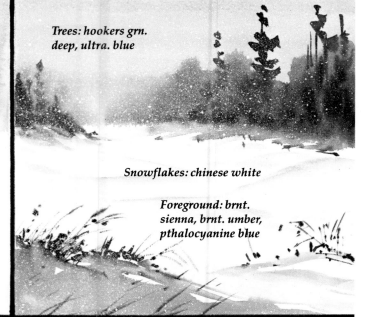

Trees: hookers grn. deep, ultra. blue

Snowflakes: chinese white

Sky & Snow: pthalocyanine blue, brnt. umber

Foreground: brnt. sienna, brnt. umber, pthalocyanine blue

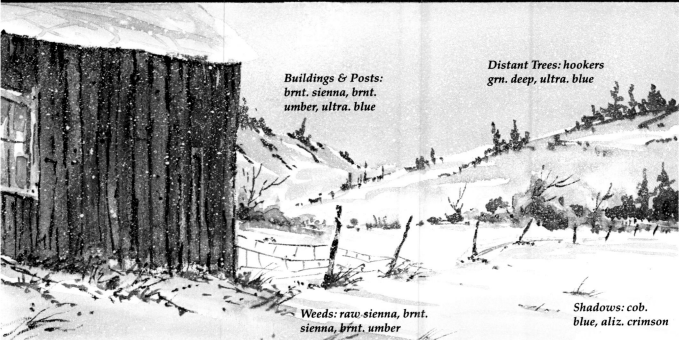

Buildings & Posts: brnt. sienna, brnt. umber, ultra. blue

Distant Trees: hookers grn. deep, ultra. blue

Weeds: raw sienna, brnt. sienna, brnt. umber

Shadows: cob. blue, aliz. crimson

The bottom painting shows an old barn-style home with a simple window treatment. Refrain from too much detail in the window area as the snowflakes will tie in all the components of your composition.

Stormy Weather

These two pages show how streaks of rain can be achieved by lifting color with a moist brush, or an etching knife or razor blade. If you wish, you can use both approaches in the same painting. You'll need to paint threatening skies since the darker areas bring out the streaking rain. Remember to let the paint dry before lifting out or etching.

The simple pencil sketch to the right, complete with cattails, will test your skills.

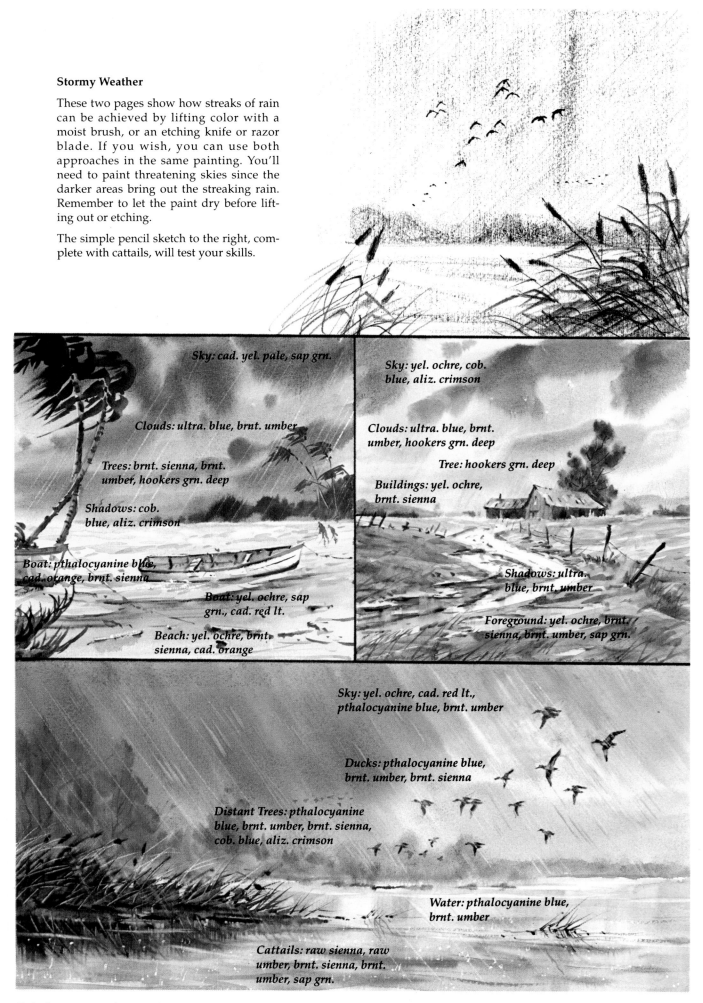

Sky: cad. yel. pale, sap grn.

Clouds: ultra. blue, brnt. umber

Trees: brnt. sienna, brnt. umber, hookers grn. deep

Shadows: cob. blue, aliz. crimson

Boat: pthalocyanine blue, cad. orange, brnt. sienna

Boat: yel. ochre, sap grn., cad. red lt.

Beach: yel. ochre, brnt. sienna, cad. orange

Sky: yel. ochre, cob. blue, aliz. crimson

Clouds: ultra. blue, brnt. umber, hookers grn. deep

Tree: hookers grn. deep

Buildings: yel. ochre, brnt. sienna

Shadows: ultra. blue, brnt. umber

Foreground: yel. ochre, brnt. sienna, brnt. umber, sap grn.

Sky: yel. ochre, cad. red lt., pthalocyanine blue, brnt. umber

Ducks: pthalocyanine blue, brnt. umber, brnt. sienna

Distant Trees: pthalocyanine blue, brnt. umber, brnt. sienna, cob. blue, aliz. crimson

Water: pthalocyanine blue, brnt. umber

Cattails: raw sienna, raw umber, brnt. sienna, brnt. umber, sap grn.

Raindrops — are done with a razor blade after the painting is dry. Notice that the sky is graded from light to dark (an interesting effect) and the ducks do not fear the dark sky; they draw your eyes right into the weather.

WATERCOLOR
Workshop by Rose Edin

ABOUT THE AUTHOR

Rose Edin is an accomplished painter; she is a signature member of the Midwest Watercolor Society and a popular workshop instructor throughout the United States and abroad.

Rose began her art education in high school by taking a correspondence course through Art Instruction Schools. She earned her B.A. from North Park College in Chicago and has continued her studies at the Minneapolis College of Art and at Colorado State University. A grand prize winner in Art Instruction School's national competition, Rose continues to win top awards in competitions throughout the United States.

Rose has studied with such teachers as Olex Bulavitsky, Zoltan Szabo, Robert E. Wood, Tony van Hasset, Charles Reid and Dong Kingman. She teaches and paints with technical perfection and abundant energy.

Rose's compositions are complex, yet flowing. The involved use of darks and lights contributes to a dynamic display of color. Attention to detail and the use of numerous glazes give her paintings a unique quality of freshness and life.

SECTION 3

Alfama

Alfama is an old area in Lisbon, Portugal where the streets are so narrow that the direct sun only reaches them for about an hour each day. I took many photographs of this interesting place. For this painting I combined several elements and moved them around to create a more pleasing composition. The entire painting is done in complementary colors, as shown in the color bar. Some areas have 4 or 5 thin glazes to create the existing colors.

When deciding where to place objects of interest in some paintings, draw them on a separate piece of paper, then cut them out and move them around on the sheet to find a comfortable location. You may have to redraw them in a different size to make them work. When working with photographs, don't feel "locked in" to what you see. Change the elements to please your eye and to enhance the composition. For example, the rooster and the chicken in this painting were originally around the corner from this spot.

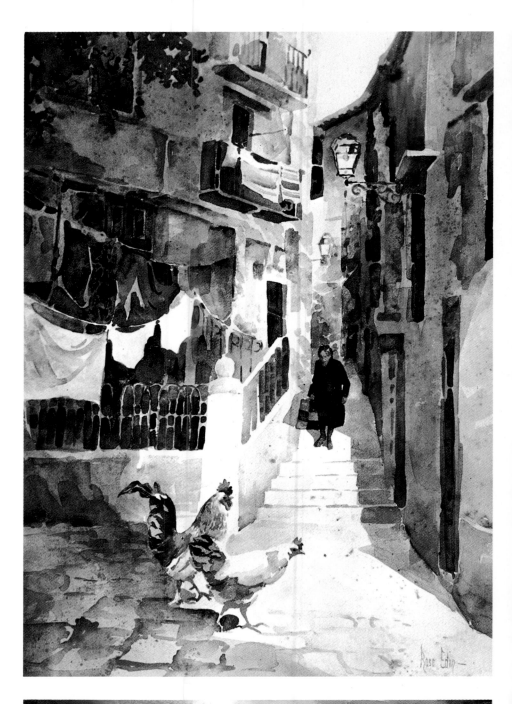

Pthalo. Blue | French Ultramarine | Cerulean Blue | New Gamboge | Raw Sienna | Cadmium Orange | Scarlett Lake | Alizarin Crimson | Bu Si

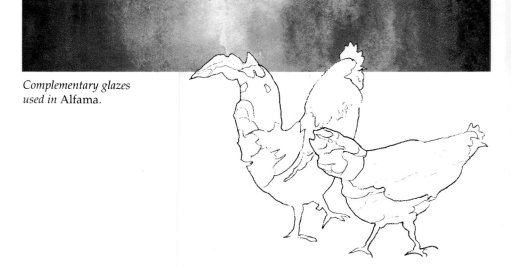

Complementary glazes used in Alfama.

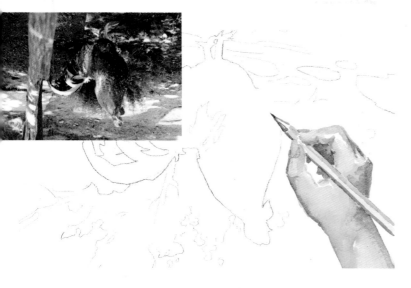

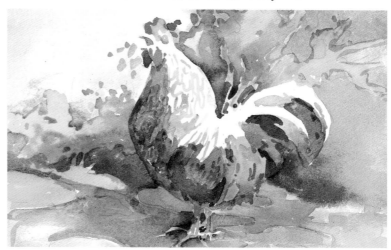

Three Blues: French Ultramarine, Cerulean, Pthalocyanine.

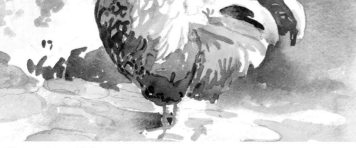

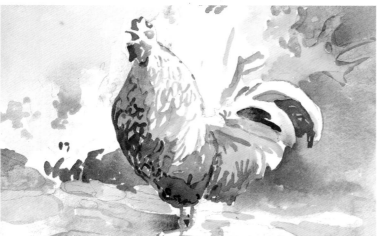

Warm colors added.

Green harmonies added. Glazes of the opposite color applied.

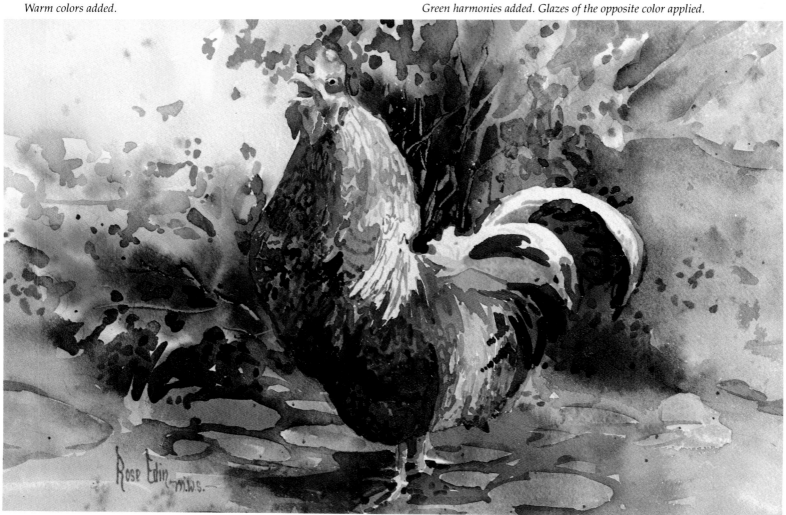

Rose Edin m.w.s.

When drawing a complicated subject from a photograph, try working upside down, as shown in this illustration. This will enable you to see the relationship of shapes much better — which is exactly what drawing really is! *King of the Hill* was done in a workshop setting using the steps recorded here. The darks were applied last.

Color Harmonies

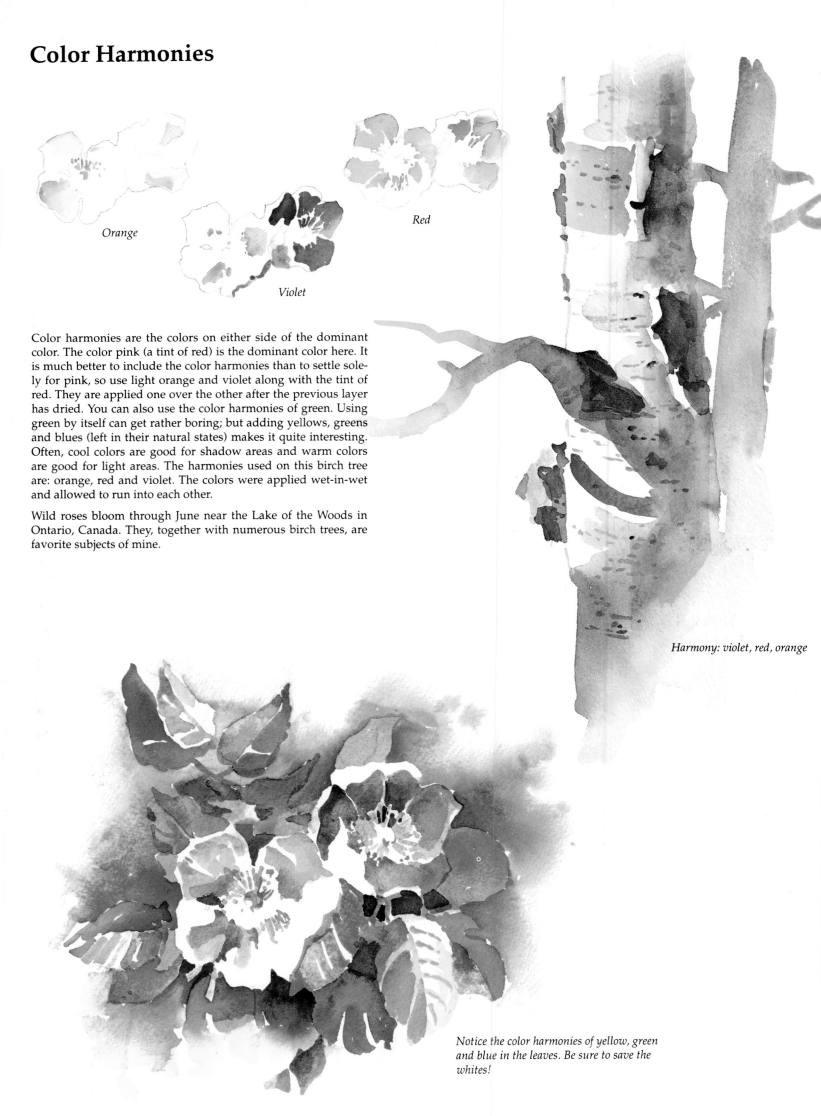

Orange

Violet

Red

Color harmonies are the colors on either side of the dominant color. The color pink (a tint of red) is the dominant color here. It is much better to include the color harmonies than to settle solely for pink, so use light orange and violet along with the tint of red. They are applied one over the other after the previous layer has dried. You can also use the color harmonies of green. Using green by itself can get rather boring; but adding yellows, greens and blues (left in their natural states) makes it quite interesting. Often, cool colors are good for shadow areas and warm colors are good for light areas. The harmonies used on this birch tree are: orange, red and violet. The colors were applied wet-in-wet and allowed to run into each other.

Wild roses bloom through June near the Lake of the Woods in Ontario, Canada. They, together with numerous birch trees, are favorite subjects of mine.

Harmony: violet, red, orange

Notice the color harmonies of yellow, green and blue in the leaves. Be sure to save the whites!

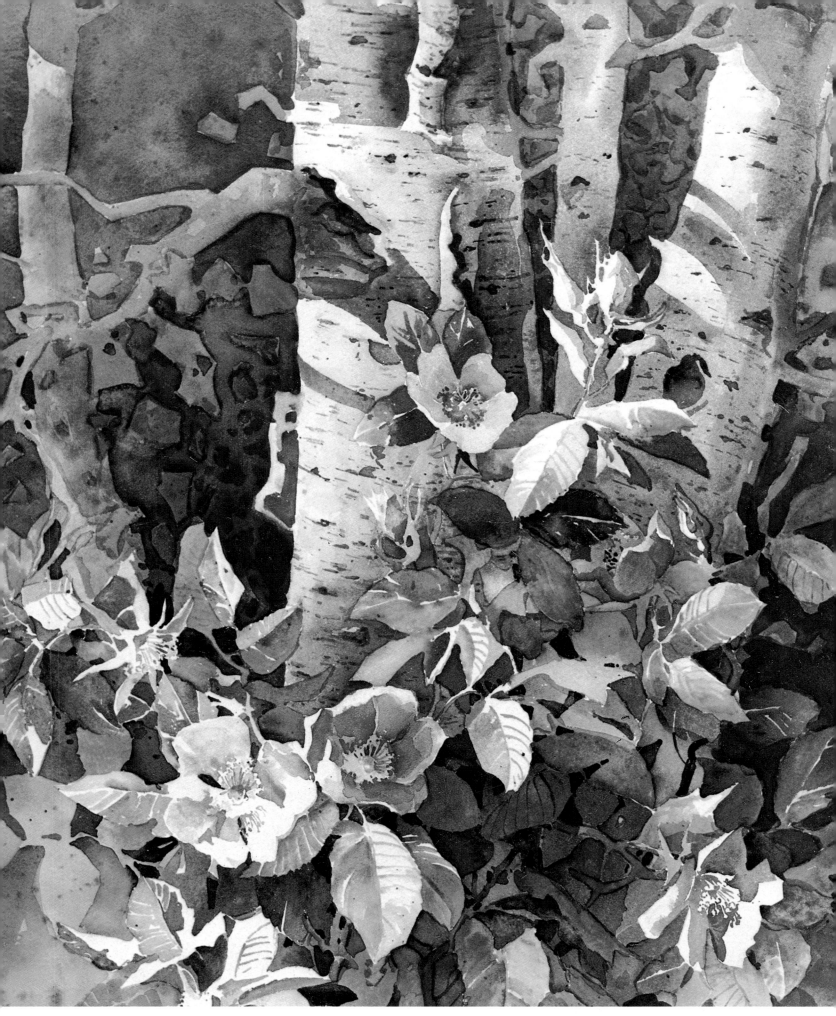

Assignment — Choose a flower you would like to paint. Use the harmonies of the dominant color to create more exciting color values. Think about cool colors in the shadows and warm colors where light hits. It is best to occasionally overlap these colors. Use the same technique for the green leaves. Small studies like this can make very interesting paintings. Use mostly water with very little pigment, as shown in the illustration.

Wet-In-Wet Background

There are many approaches to the same subject. *Poinsettia* was created in a workshop setting using a live subject and the techniques demonstrated here. The results are terrific!

After completing the drawing, wet the paper thoroughly. While the paper is still wet, float color into the areas where it should occur, creating soft edges. After the first application dries, apply the color harmonies for the reds, greens and whites. Finally, paint the dark background by carefully applying water all the way to the edges to create softness. Any visible pencil lines can be erased when the painting is completely dry.

Drawing first: wet-in-wet background.

Notice the color harmonies in these particular areas.

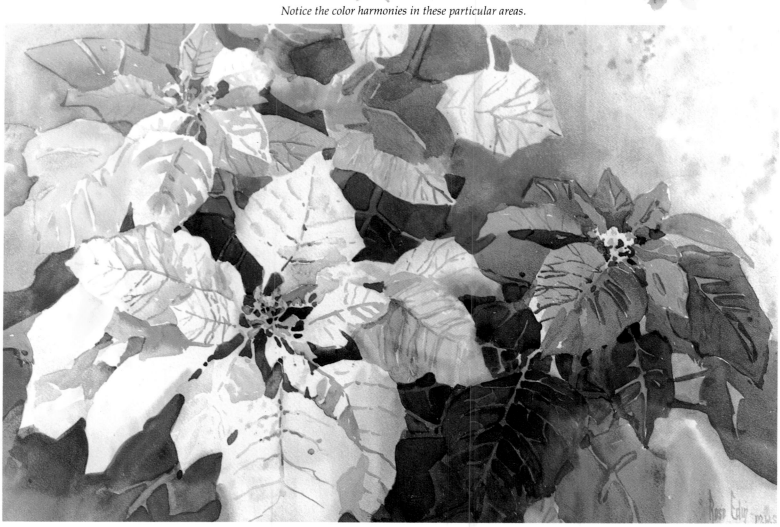

Assignment — Use the same subject as in the assignment on page 49, but this time wet the entire page before you apply the underpainting. Proceed as you did the first time. Which result do you prefer?

Complementary Colors

Red and Green *Yellow and Violet* *Blue and Orange*

Colors directly across from each other on the color wheel are called COMPLE-MENTARY COLORS (or "opposite" colors). Complementary colors create the greatest contrasts possible. To bring out a certain color, use a touch of its complement next to it. To tone down a color, cover it with a transparent glaze of its complement after the color has dried. Some beautiful color values are created this way. Be sure to memorize the three complementary sets: red and green, blue and orange, yellow and violet.

Two very different results can occur when using complementary colors, depending on whether the two colors are mixed on the palette or if the first color is allowed to dry before its complement is applied over it. In the first illustration the colors have been applied wet-in-wet, allowing the opposite colors to "float" together as they are applied into the wet background. In the lower illustration the first colors have been allowed to dry before their complements were applied.

Both wet-in-wet and glazing techniques were used for *Tolten's Place*. The colors were mixed on the palette for the background trees, while the rocks, the water and the cabin have several glazes. An area can sometimes be glazed as many as four times, but be sure to use plenty of water with the pigment. By mixing colors on the palette a grayer color in the background is created. Sparkle is achieved in the foreground rocks by letting each color dry before the next is applied.

Tolten's Place

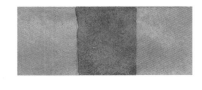
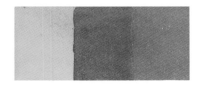

Here, the first colors were allowed to dry before applying their complements.

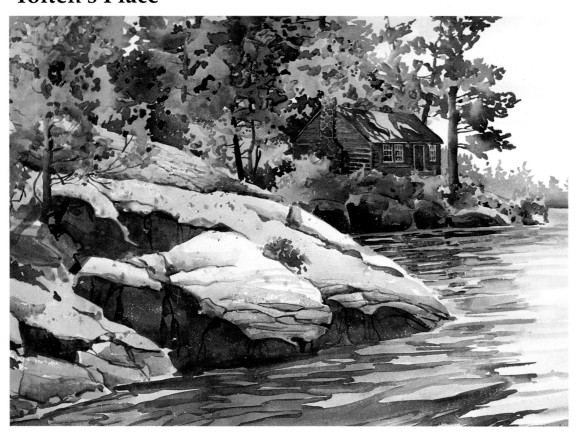

Assignment — Choose a photograph which has complementary colors in it. Try doing your drawing upside down. Start the painting by applying all cool colors which you can interpret, then apply the warm glazes. Finish with the dark values.

Sugar And Spice

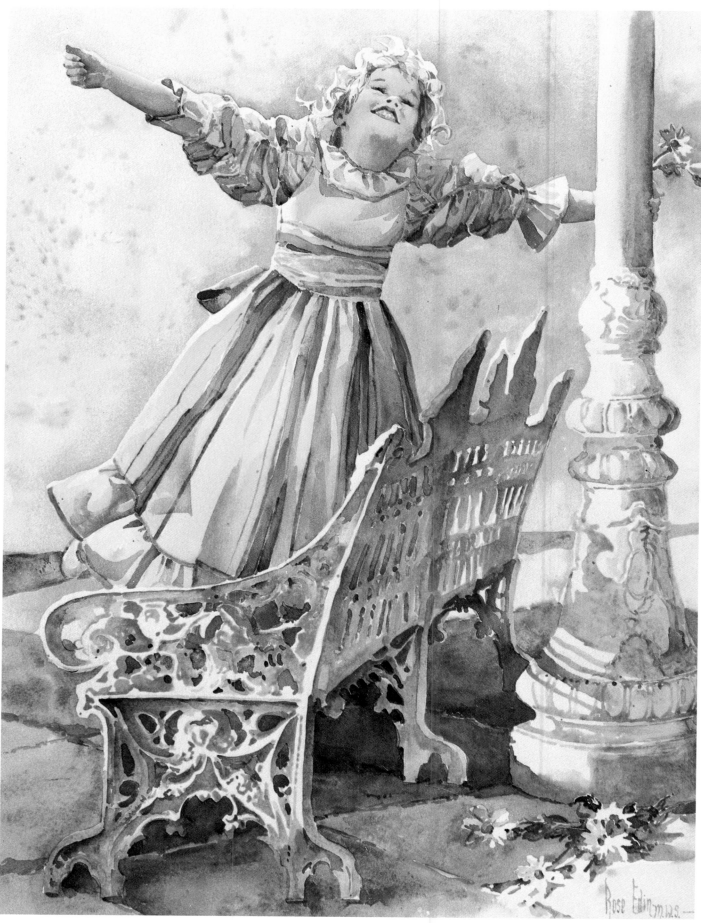

This is an example of the use of complementary colors where the first color was allowed to dry before applying the opposite color. The post, the bench, and the shadows were all painted with cerulean blue. After the blue dried, its complement, yellow (raw sienna), along with oranges and reds, were applied in various areas.

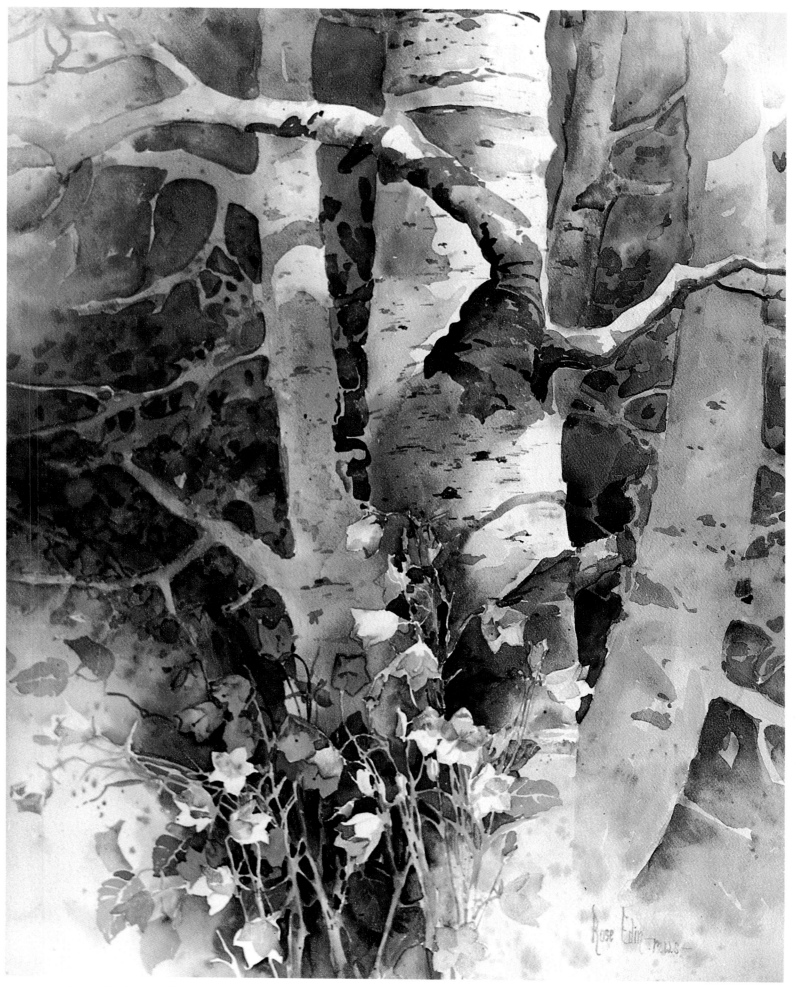

A vignette is created when the corners and some areas of the painting are gradually shaded off into white. *Bluebells* is an example of this technique. These lovely little flowers bloom through the entire summer in Ontario, Canada.

October

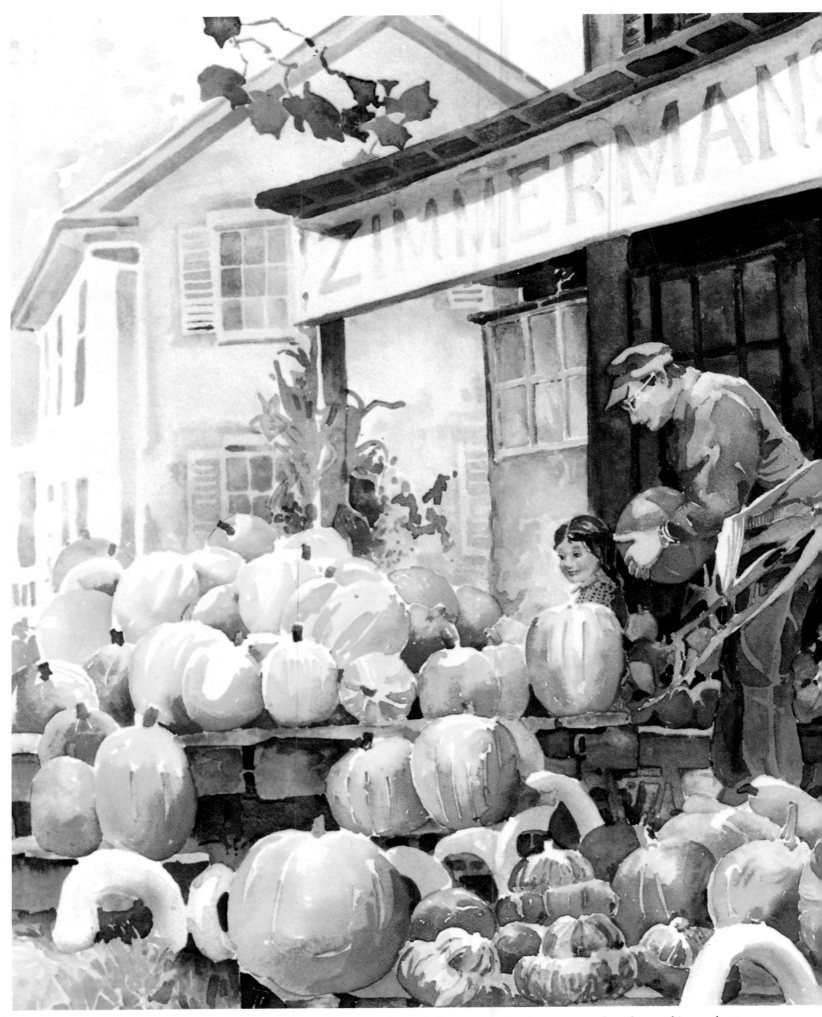

This was an overcast day in Lancaster County, Pennsylvania. What a day brightener to see the hundreds of pumpkins outside of Zimmerman's store! A combination of color harmonies (red, orange, and yellow) was used on the pumkins, and complementary colors were used in the background.

Several photographs were used to compose this painting. The drawing and placement of shapes took longer than the actual painting. Don't be afraid to draw accurately before you begin the painting — one needs to plan ahead with watercolor!

Town Talk

This painting was done from a photograph taken while my family was vacationing in the coastal town of Bahia, Brazil. These ladies were so intent on their story they didn't even notice when I took their picture. This painting is a commentary on the congeniality found between the various races in this beautiful country.

Contour Drawing

Cadmium Orange

Scarlet Lake

Alizarin Crimson

New Gamboge

Raw Sienna

Cerulean Blue

French Ultramarine Blue

Pthalocyanine Blue

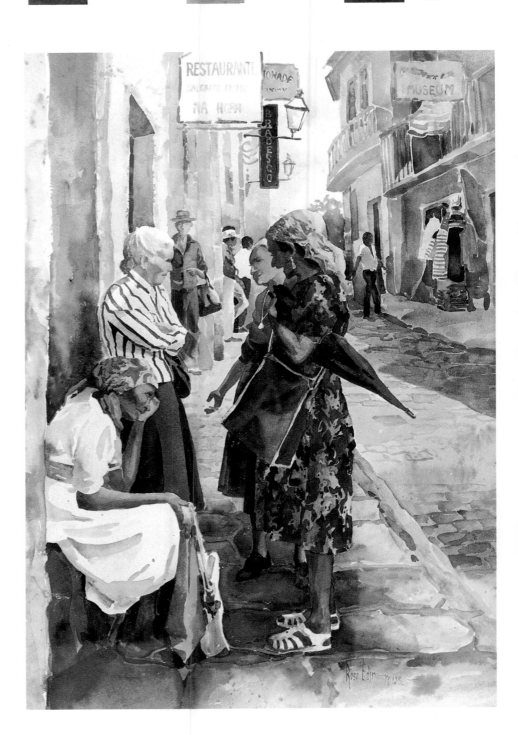

In this painting, pure reds, blues and yellows have been used in the interest area. The background is made up of complementary glazes.

When drawing figures, draw a contour (continuous) line along the outer edge of the figures. Making this painting upside down (as shown on page 47) may be helpful. Try grouping several figures together — be conscious of the shapes behind and between the figures. Spend time on your drawing. If the proportions are correct you can be very free with your painting.

Assignment — For inspiration, find a photograph that has several figures in it and try drawing the figures upside down, concentrating on the outer edges. Apply some of the colors in their full intensities in the interest area. Use complementary glazes in the background.

Special Effects: Negative Areas

Quite interesting effects can be achieved by leaving negative shapes in a painting. The eye is not able to take in too much detail; therefore, the artist can simplify the problem by painting around the background shapes as was done in *Columbine*, *Wild Iris*, and *Fall Floral*.

Notice that overlapping and painting off the edge of the paper creates an interesting composition. Going off the edge of the paper with your composition offers the viewer a visual path into the painting.

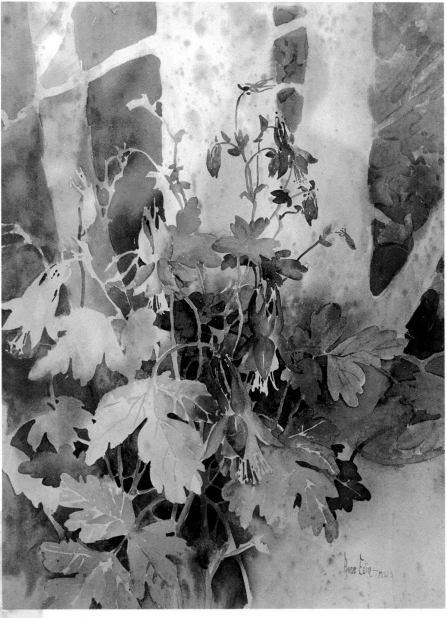

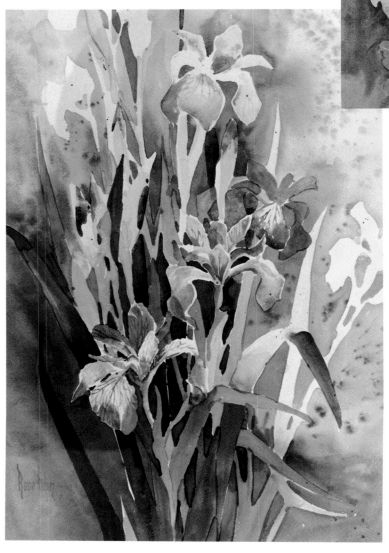

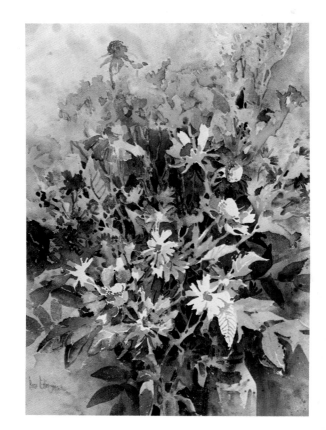

High Key Painting: Mostly Whites

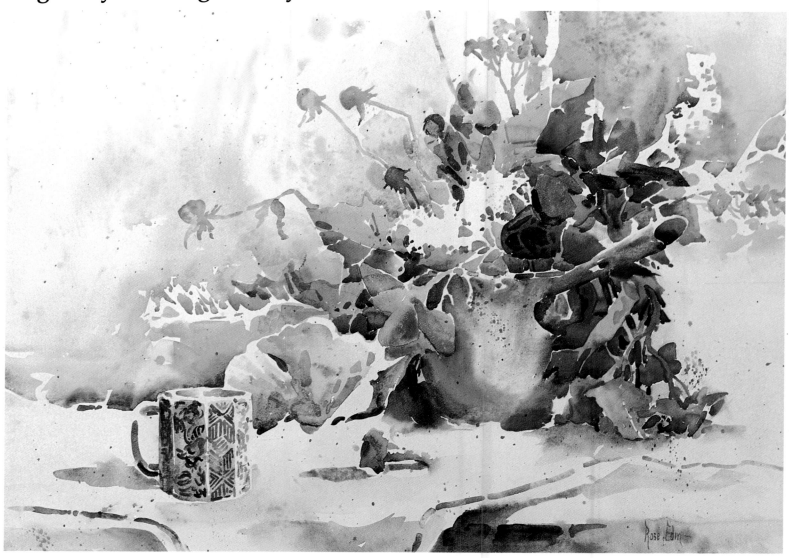

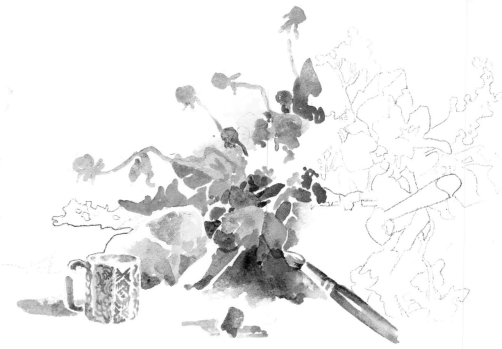

A HIGH KEY painting is one in which many whites are used. This is probably the most common type of watercolor painting. The painting above was created primarily in one application with very little glazing. The subject matter was painted before the light background was washed in. The painting was done very rapidly in a workshop setting with a live setup.

Assignment — Choose a still life in which you wish to leave the background white (or very light, as in this subject). Some of the areas within the painting should also be very light to relate it to the background. Wet the entire background before applying a small amount of pigment.

Low Key Painting: Mostly Darks

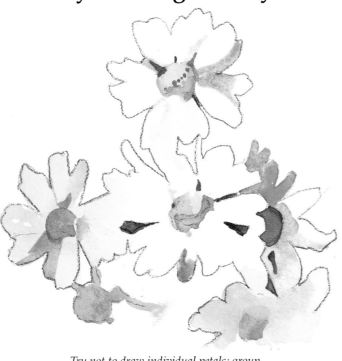

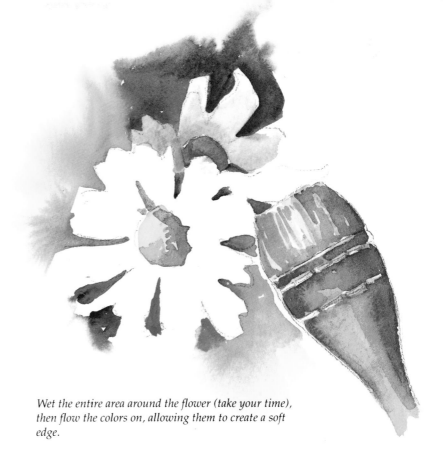

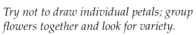

Try not to draw individual petals; group flowers together and look for variety.

Wet the entire area around the flower (take your time), then flow the colors on, allowing them to create a soft edge.

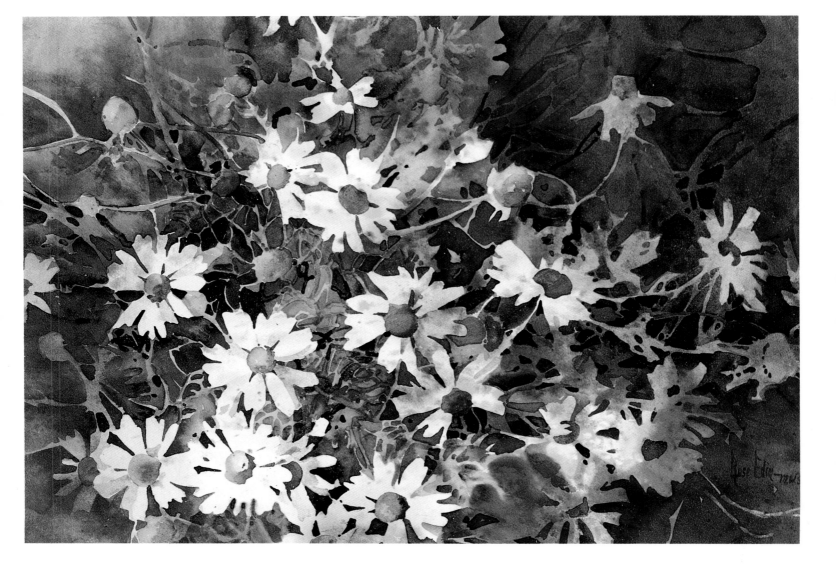

Assignment — Choose a subject with a dark background. You may want to use the same subject you chose for the assignment on page 58 and see how different it looks with a dark background. Be sure to leave the whites!

How To Create An Interest Area

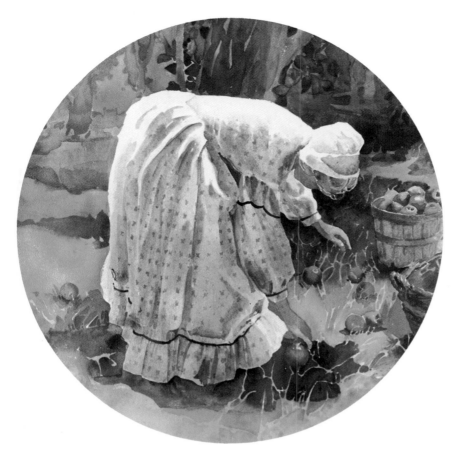

Harvest: Light Against Dark

Most paintings tend to draw your attention to a certain area. This is called the "center of interest." There are many ways to create this area; the most obvious is through the drawing and composition of the painting. However, color and value (light and dark) also have a great influence in guiding the eye to certain areas. The paintings on these two pages show what color and value can do. (Note — not every painting will use all these principles.)

Harvest is a good example of how a light color will automatically attract the eye. If your subject matter doesn't have much white, interpret the lights as whites and leave the paper free of color in those areas.

Friends attracts attention by using pure colors without graying them. The warm colors and lights on the fruit lead your eye to the figures above them.

Marketplace makes use of small shapes and detail. The eye is attracted to the most detailed area of the foreground — the women, the fruit and the umbrellas.

Tethered is a dark subject against a light stone wall. In this painting, the darkest areas attract attention. Note that even in the darkest subjects the light creates a lot of contrast.

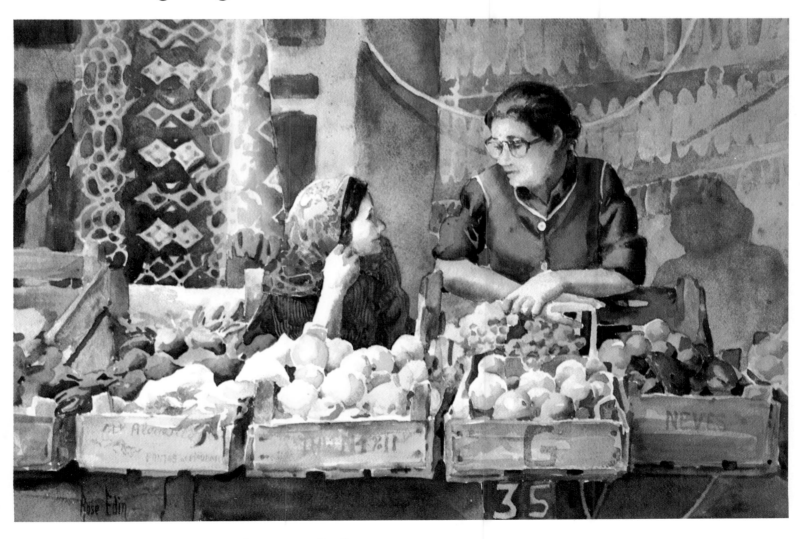

Friends: Warm And Pure Colors

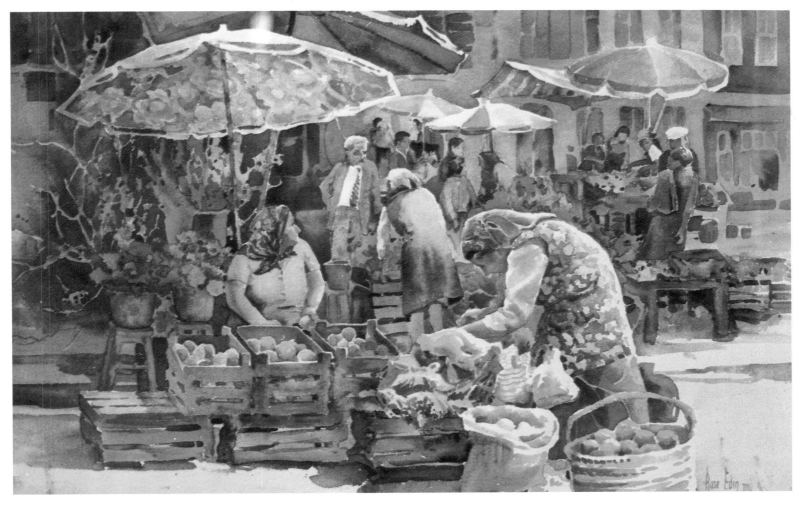

Marketplace: Smaller Color Shapes

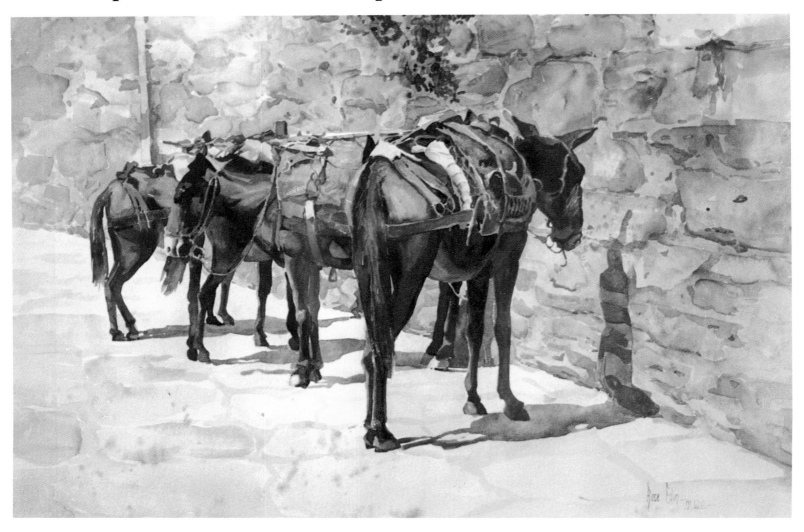

Tethered: Dark Objects Against A Lighter Background

Special Effects: Salt

When your watercolor is just beginning to lose its shine as it dries, sprinkle some salt on the painting. Various colors will react differently to the salt. Note that the effect of the salt is more apparent in *Wild Rose* than in *Sea Gulls*.

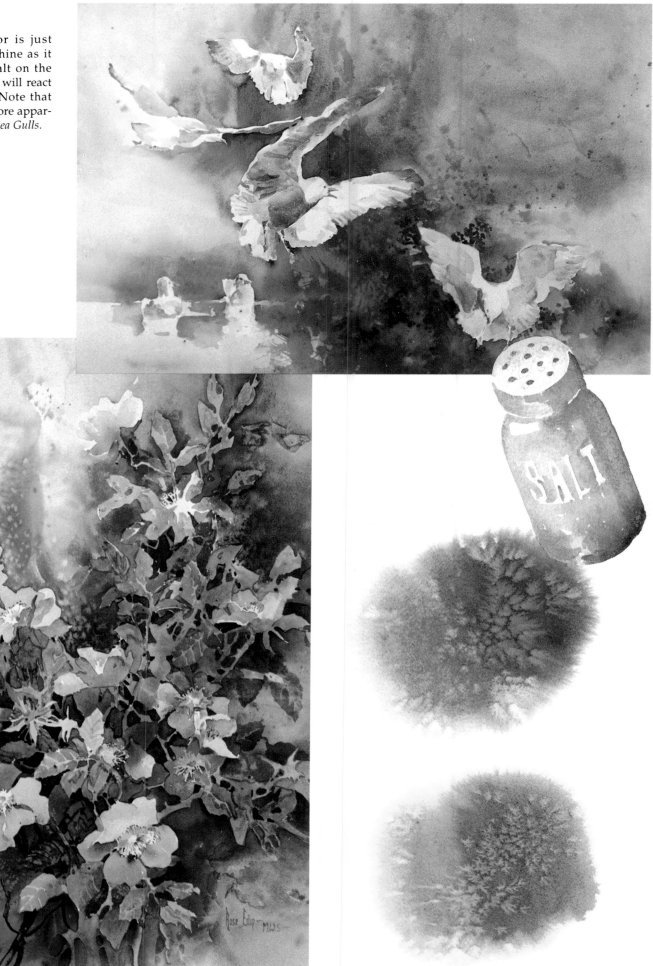

Assignment — Experiment by painting a background with plenty of pigment in your water. Sprinkle some salt onto it and observe the results. Try this with different color combinations and during different stages of the drying process.

Monday

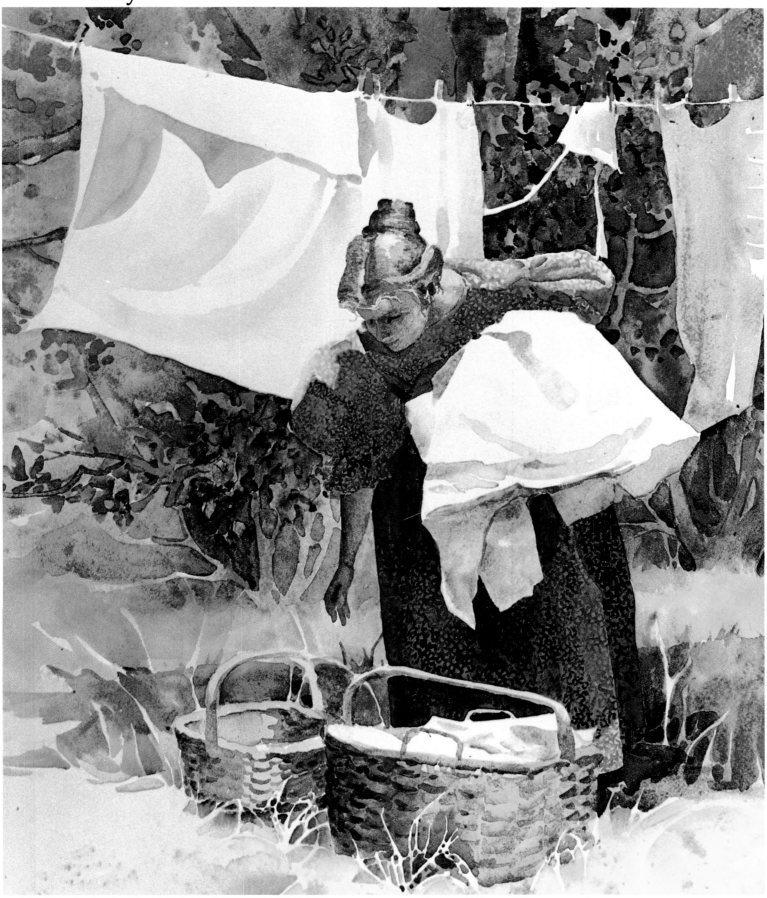

No white paint is used in a transparent watercolor painting; any white you see is the paper. The light colors are mostly water with just a slight amount of pigment. Dark colors are obtained with more pigment and less water. Dark colors can also be achieved by applying several layers of paint over one another after the previous layer has dried. Transparent watercolorists always try to maintain a "sparkle" in their work by using transparent watercolor throughout.

Monday was created from a photograph taken in Sturbridge Village, Massachusetts where wash day is reenacted every Monday morning. This lovely young lady was irresistible to the camera as well as to the paint brush. Notice the use of whites!

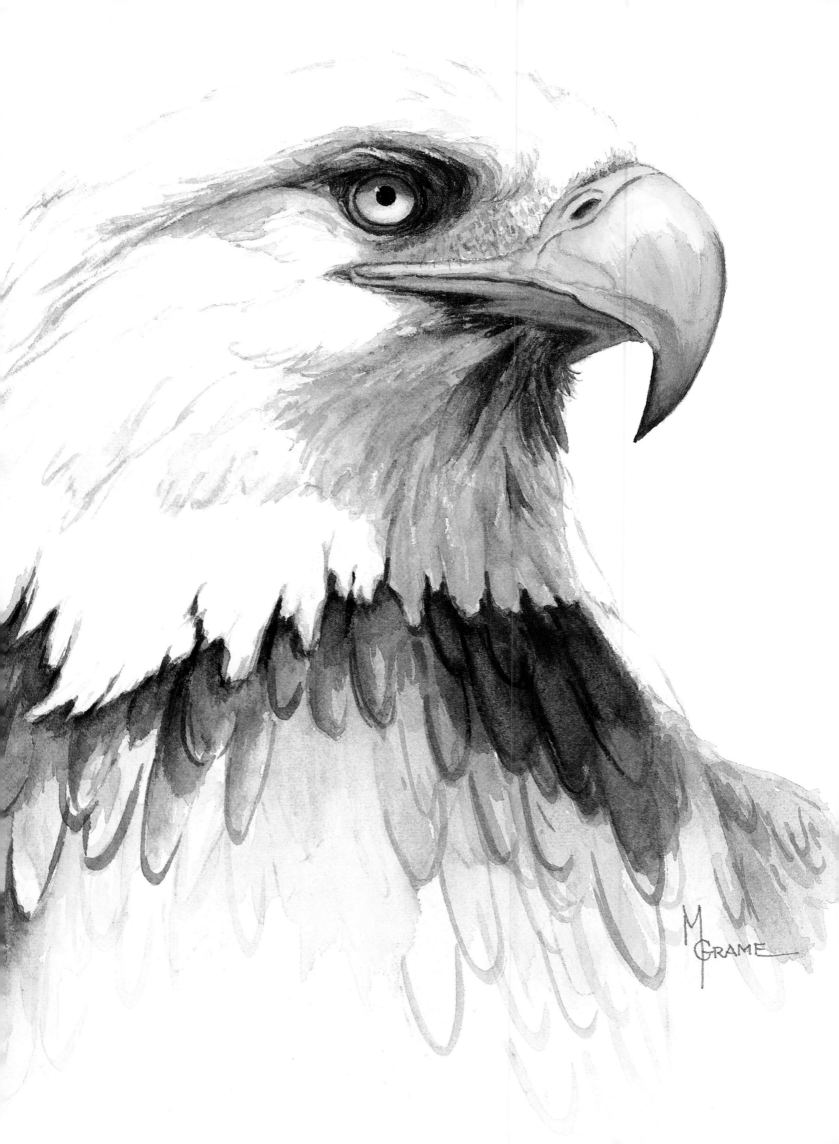

Animals by Marilyn Grame
IN WATERCOLOR

ABOUT THE AUTHOR

Marilyn Grame, a San Diego, California native, was exposed to art at an early age as her mother, father and uncle were all artistically talented. She refined her natural gift by studying with several west coast professionals.

A former gallery owner, Marilyn has been represented by various galleries in the San Diego area. She has had solo shows in San Diego and Kansas, and has received numerous awards at local, state and national levels. Two of her works hang in the permanent collection of the San Bernardino County Museum. Her paintings are included in private collections throughout the United States, Germany, Holland and Scotland.

Marilyn has been an art instructor for over 20 years. She also gives painting demonstrations for art associations and women's clubs in San Diego area; teaching and painting in a wide range of media and subject matter. She belongs to the National League of American Pen Women; Foothills Art Association, La Mesa; Fine Arts Association, San Diego; and the San Diego Watercolor Society.

Marilyn's control of watercolor allows her to create highly detailed renderings without portraying stiffness. Attention to minute details in areas such as eyes, shadows, etc., results in subjects that have feeling and seem alive.

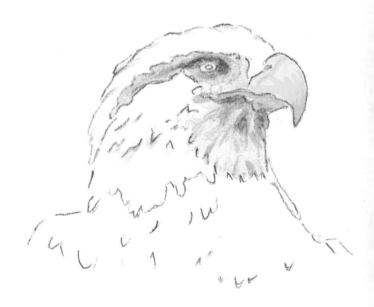

SECTION 4

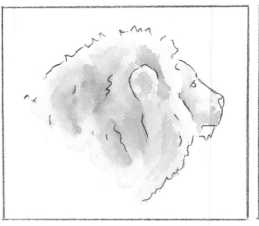

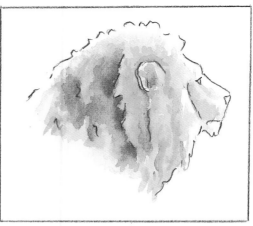

This lion drawing is based on a circle and a square. Note — always use the largest brush you can for any given area; this will keep your painting from becoming too "picky." A good #10 round sable-type brush that comes to a good point can be an invaluable tool.

Use a brush to carefully wet the entire head area with clean water. Then drop in color #1 (be sure to leave light areas white). Continue by adding #2 for the next darker areas.

The middle or "transition" color (also referred to as "local color"), #3, is always the strongest and purest of the five values. A brush loaded with clean water was used to soften some of the edges.

Five-Value Approach

#1 #2 #3 #4 #5

#1 — Yellow Ochre + Burnt Sienna
#2 — Add more Burnt Sienna to #1
#3 — Pure Burnt Sienna
#4 — Add Ultramarine Blue to #3
#5 — Add more Ultramarine to #4

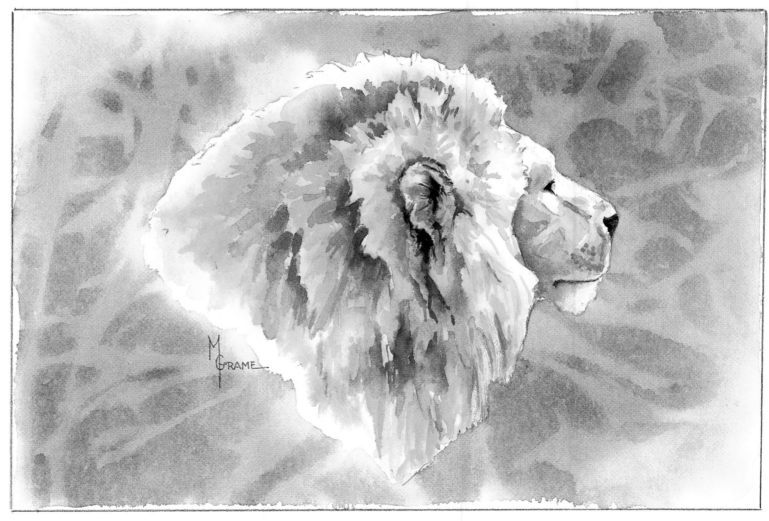

Keep graduating the values to darker (#4) and darkest (#5). The eye and the nose are done with #5. When the head is dry, wet the background with clean water, cutting around the edges of the lion. A bit of white left in the background won't hurt — in fact, it may be helpful to avoid bleeding. Then drop sap green into the wet wash. A more heavily pigmented application here and there will create a mottled look. To create more texture, press a piece of crumpled, cheap plastic wrap onto the wet surface and leave it in place until the paint is dry. (Good quality plastic wrap doesn't work because it won't stay crumpled.) It is always a surprise to see the results!

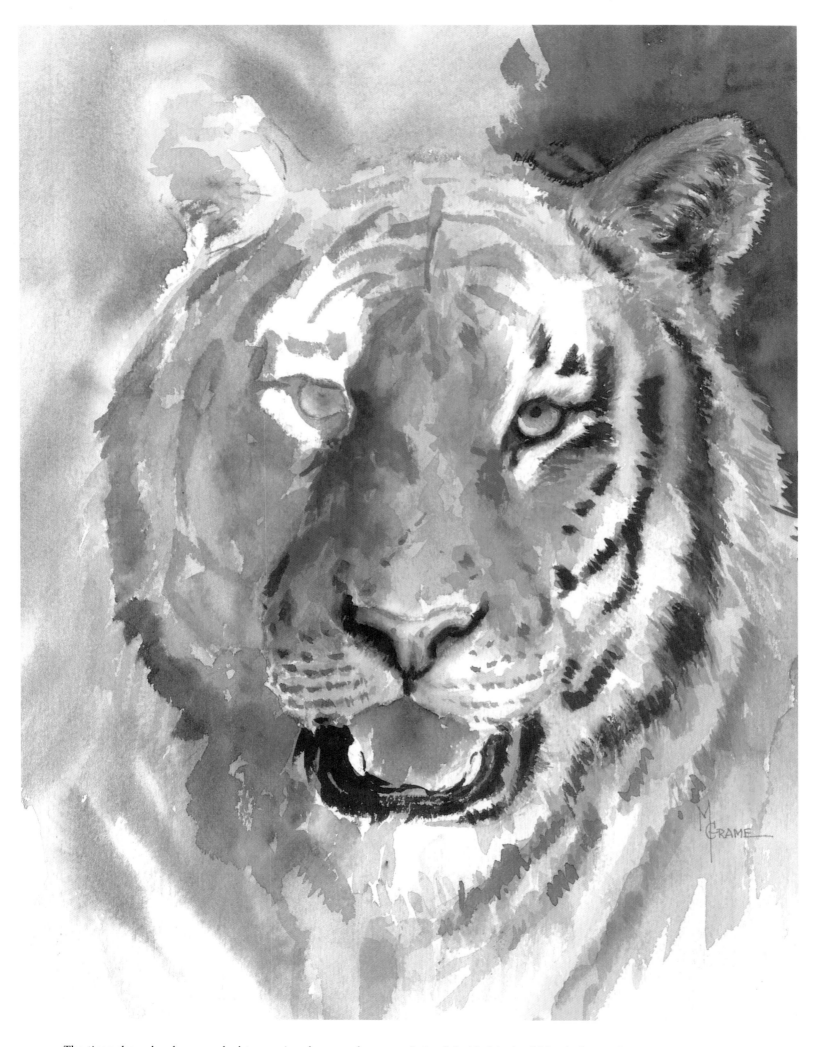

The tiger above has been worked to varying degrees of completion. This should give you an idea of the steps involved in making a finished watercolor painting. The background was washed in first.

Later, I decided it should be darker, so I increased the ratio of pigment to water and got the deep value at the right. This was painted on rough paper to enhance the texture.

This cute koala was painted from a snapshot taken at the San Diego Zoo. The rendering is quite refined, with close attention to light and shadow patterns. The lights are the white of the paper. The tree branches are detailed in some areas, and faded out in others. Notice the cast shadow patterns from the koala. In my paintings I always consider cause and effect. A warm reflected light from the branch is seen on the left side of the animal. The character of the paper helped to enhance the texture of the dense fur. Interestingly, koalas have two thumbs.

When drawing, I tend to look for angles, then curves. After the angles are established, the connections between them can be modified into curves.

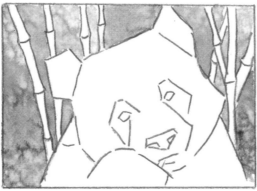

Wet the background area first, cutting around the bamboo and the panda. (Note — do each small area in turn.) While the paper is still wet, drop in some hookers green deep, using slightly heavier pigment in some areas. Before the paint dries, sprinkle on some salt. Proceed to each new area, being careful to blow off excess salt in the area you are wetting. Let the entire background dry completely, then brush off the salt.

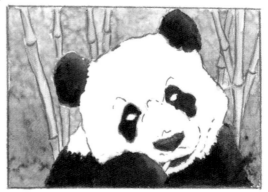

The bamboo is yellow ochre with a slight variety of values. The black areas on the panda are a mixture of ultramarine blue and burnt sienna. The pigment for the panda is heavier than usual and varies from warm to cool.

More detail can now be added to the bamboo. The cast shadows are added when the details are dry. Shadows on the white fur are a very light value of the black mixture with some yellow ochre added separately here and there. The eyes are brown (burnt sienna and ultramarine blue). Let dry, then paint in the shadow, softening the bottom edge. Let dry again, then position the pupil, saving the highlight (if you can).

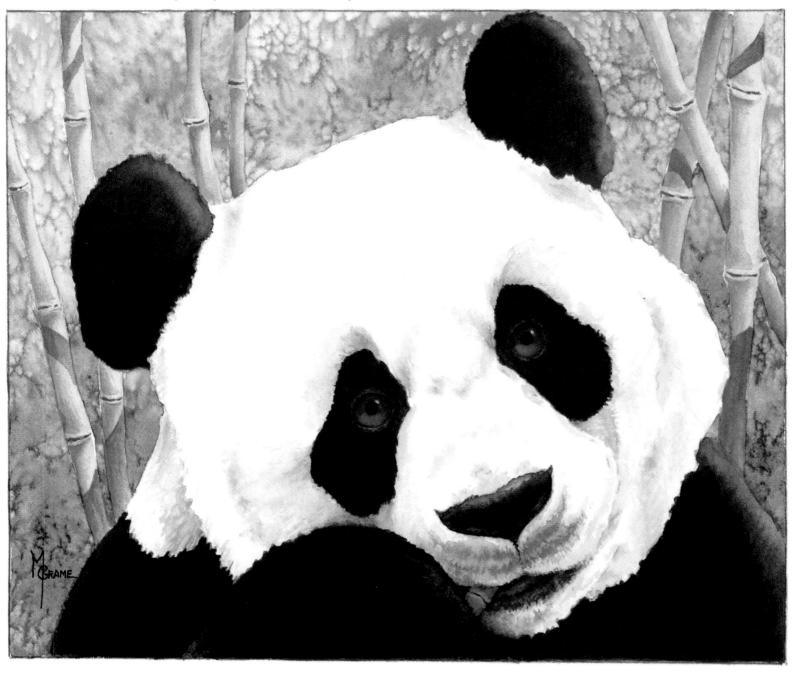

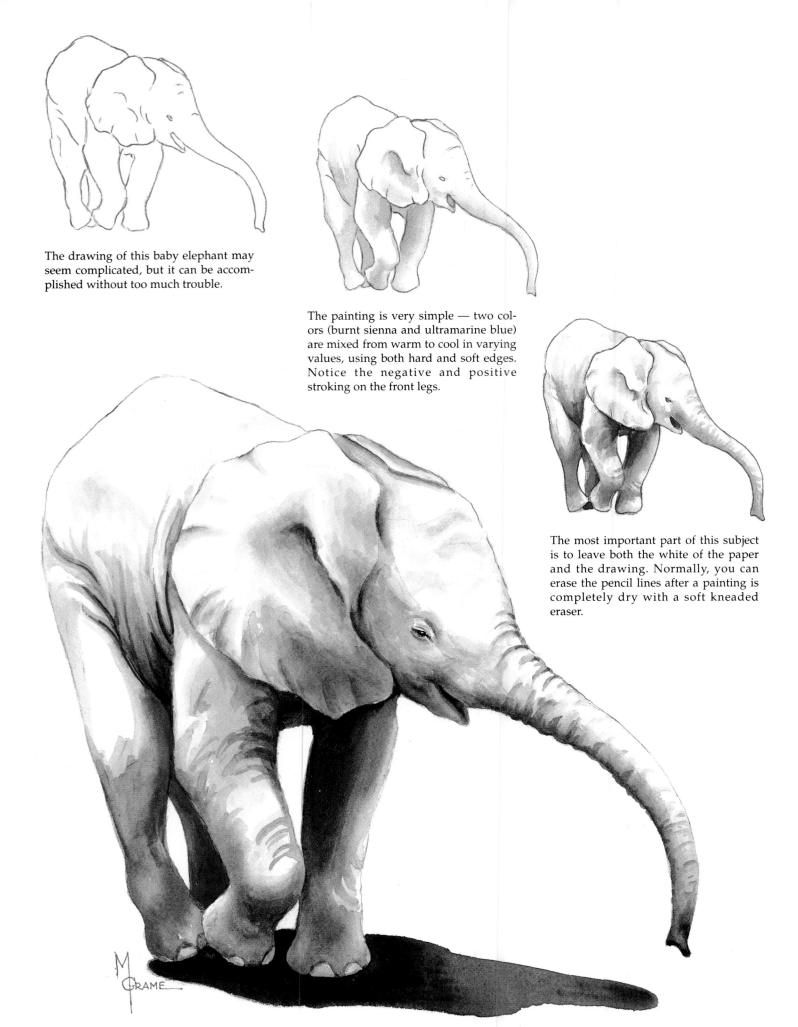

The drawing of this baby elephant may seem complicated, but it can be accomplished without too much trouble.

The painting is very simple — two colors (burnt sienna and ultramarine blue) are mixed from warm to cool in varying values, using both hard and soft edges. Notice the negative and positive stroking on the front legs.

The most important part of this subject is to leave both the white of the paper and the drawing. Normally, you can erase the pencil lines after a painting is completely dry with a soft kneaded eraser.

To paint the cast shadow, wet the area then drop in heavy pigment, from warm to cool. A cast shadow is darker nearer the subject, then it begins to pick up reflected light from the surroundings. Leave a little dot in the elephant's eye for a highlight. If you forget, it can be scratched out with the point of a razor blade or you can use a little dot of white acrylic or goauche (opaque watercolor).

This camel has overhead lighting just like the elephant on page 70. The lighting throws the bone structure of this comical looking fellow into relief. This also has wonderful reflected lighting from underneath.

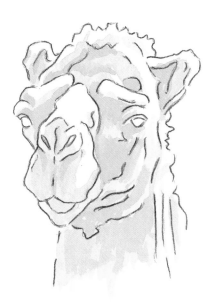

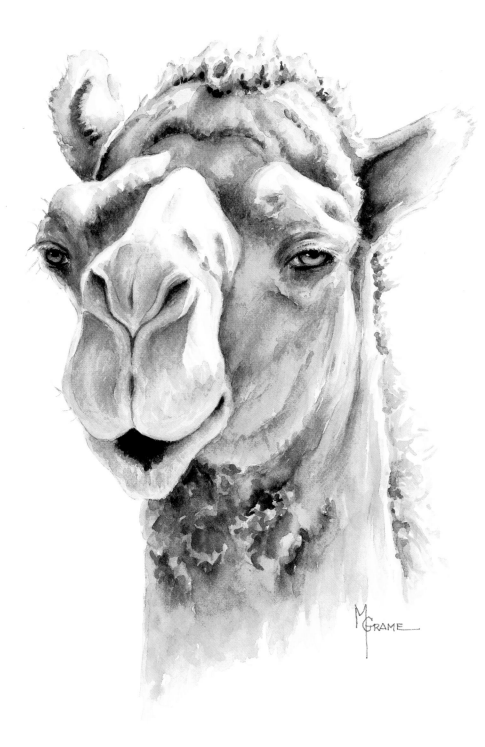

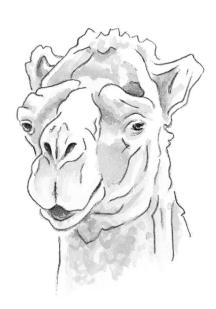

The steps are progressive washes in yellow ochre, burnt sienna, and ultramarine blue. Leave some edges hard and soften others with a brush and clean water. A hair dryer can come in handy between applications of paint to keep the colors crisp.

Note — before using a hair dryer between applications, give the paint time to sink into the paper. Forced drying tends to weaken the color.

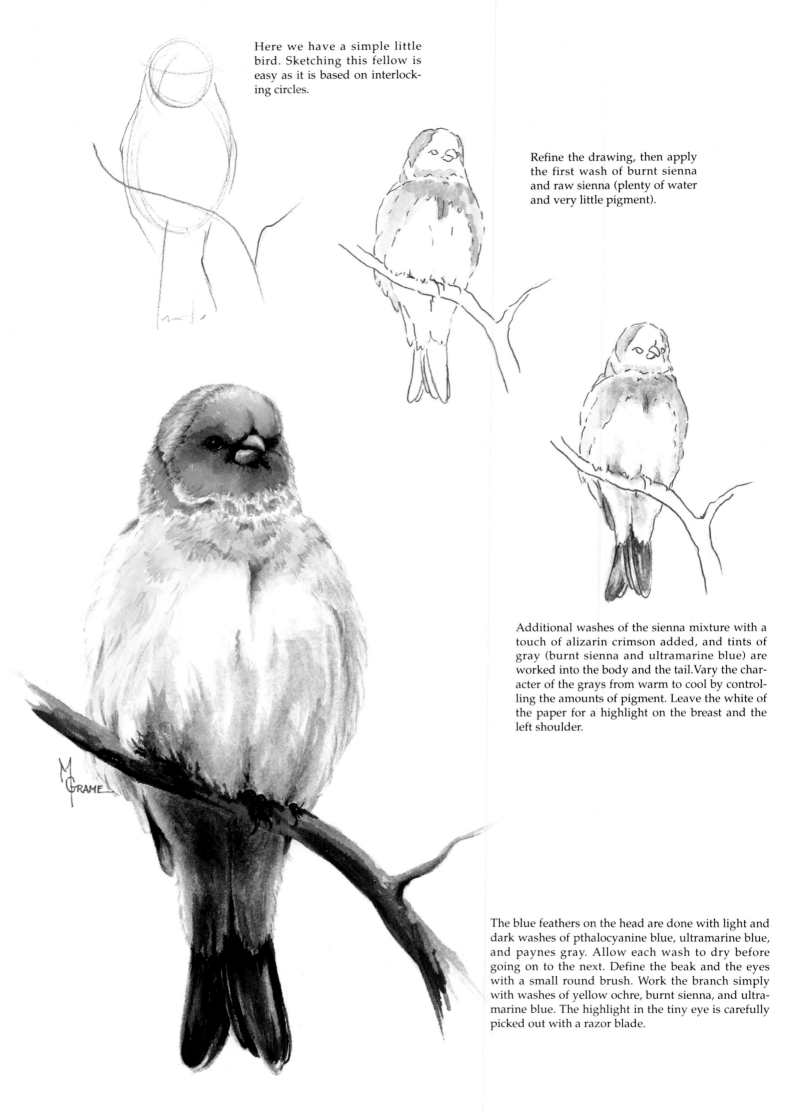

Here we have a simple little bird. Sketching this fellow is easy as it is based on interlocking circles.

Refine the drawing, then apply the first wash of burnt sienna and raw sienna (plenty of water and very little pigment).

Additional washes of the sienna mixture with a touch of alizarin crimson added, and tints of gray (burnt sienna and ultramarine blue) are worked into the body and the tail. Vary the character of the grays from warm to cool by controlling the amounts of pigment. Leave the white of the paper for a highlight on the breast and the left shoulder.

The blue feathers on the head are done with light and dark washes of pthalocyanine blue, ultramarine blue, and paynes gray. Allow each wash to dry before going on to the next. Define the beak and the eyes with a small round brush. Work the branch simply with washes of yellow ochre, burnt sienna, and ultramarine blue. The highlight in the tiny eye is carefully picked out with a razor blade.

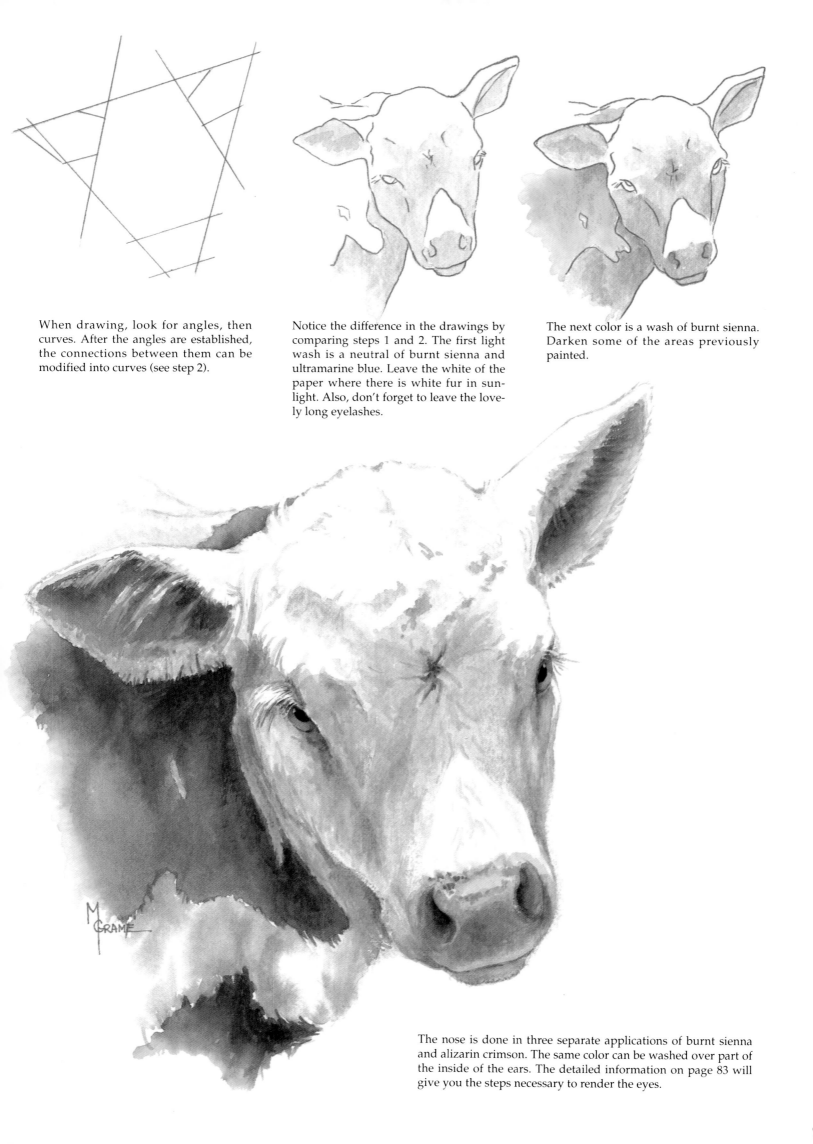

When drawing, look for angles, then curves. After the angles are established, the connections between them can be modified into curves (see step 2).

Notice the difference in the drawings by comparing steps 1 and 2. The first light wash is a neutral of burnt sienna and ultramarine blue. Leave the white of the paper where there is white fur in sunlight. Also, don't forget to leave the lovely long eyelashes.

The next color is a wash of burnt sienna. Darken some of the areas previously painted.

The nose is done in three separate applications of burnt sienna and alizarin crimson. The same color can be washed over part of the inside of the ears. The detailed information on page 83 will give you the steps necessary to render the eyes.

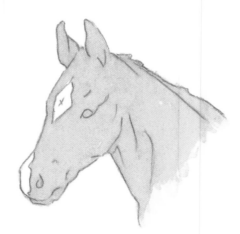

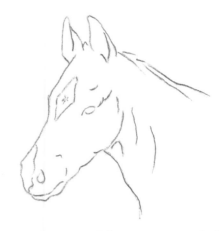

Apply a wash of burnt sienna over the dry yellow ochre. Leave some of the underpainting for the highlights, then soften the edges with a damp brush (this takes some practice).

To make this lovely chestnut color, start with a wash of yellow ochre. Reserve the white of the paper for the blaze on the forehead and the snip on the nose.

This colt is one of the many young foals we have had on our ranch from time to time.

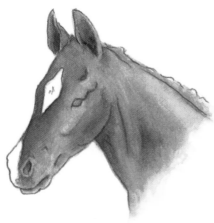

Burnt sienna and ultramarine blue are the basis for the darks. Successive applications of an identical color and value will create a darker appearance.

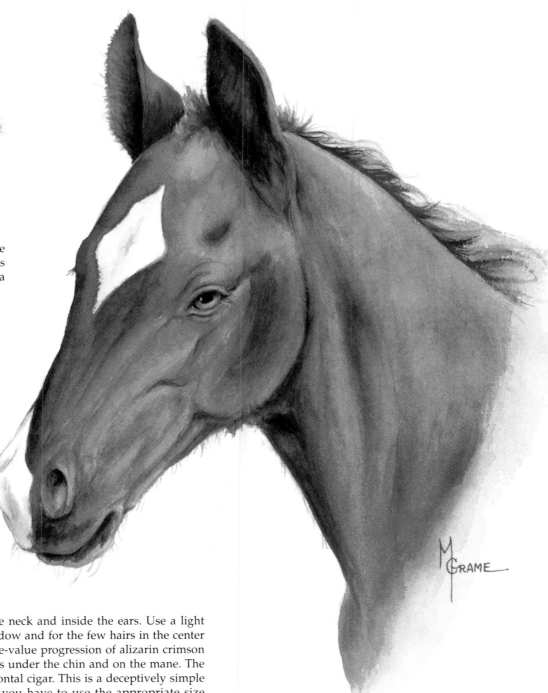

Cast a darker shadow on the front of the neck and inside the ears. Use a light gray wash where the nose turns into shadow and for the few hairs in the center cowlick of the blaze. The nostril is a three-value progression of alizarin crimson and burnt sienna. Apply a few stray hairs under the chin and on the mane. The pupil of a horse is elongated like a horizontal cigar. This is a deceptively simple painting. To do something this smooth you have to use the appropriate size brush for each area and keep the paint flowing so there are no hard edges where you don't want them. Don't be discouraged with your first attempt — try again!

In this Great Palm Cockatoo I am taking "artistic license" with the color.

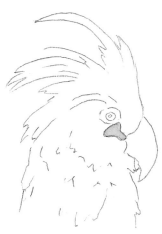

Use alizarin crimson for the red cheek. Apply it lightly at first, then as it dries create a darker, subtle value by adding paynes gray to the alizarin. When dry, a touch of cadmium red light washed over the cheek will enliven the color.

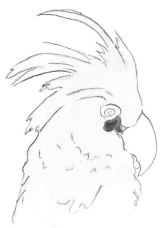

Underpaint the feathers with a light application of pthalocyanine blue. As it dries, drop in more blue, denoting the darker areas. Temporarily leave white around the eye. Later, put in a few gray wrinkles. Be careful with pthalocyanine blue as it is a very strong, staining color.

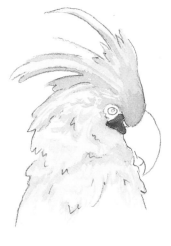

After the underpainting has dried, paint in the darker feathers with pthalocyanine blue, paynes gray, and a touch of alizarin crimson. The feathers are rendered by painting the shadows underneath, then blending away, leaving a hard edge which forms the adjacent feather edge.

The beak is paynes gray with just a touch of blue and alizarin. This makes the color livelier than paynes gray alone and ties it in to the red cheek. The eye is values of the bird mixture. Wait until the eye is dry before painting the pupil.

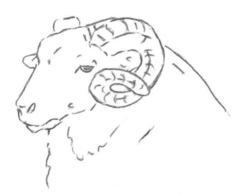

This white ram has a great horn design. Notice how it twists to show first one side and then the other.

A very light wash of yellow ochre can be applied to the horn. When dry, a slightly darker value is used to show the ridges.

Wash in the shadows on the white fur with burnt sienna and ultramarine blue — lightly at first, then tucking in the darks. These progressive washes can be applied into previously damp areas. When dry, add a warm reflected light to the right side of the face and neck.

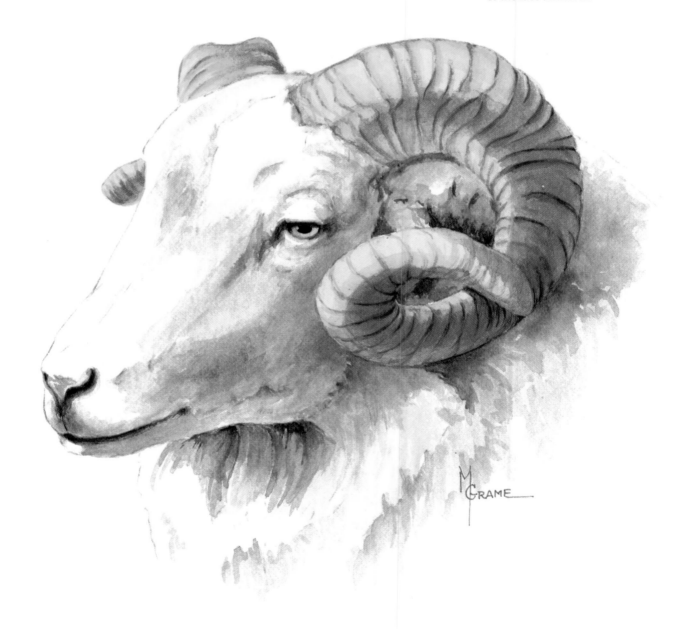

Add more detail to the horns with a darker mixture (yellow ochre, burnt sienna, and ultramarine blue). The eye is yellow ochre; be sure to let it dry before painting the pupil. The nostril is worked in warm gray values. When the horns are dry, a shadow can be carefully applied. Put this shadow on quickly — don't massage it or you will disturb the ridges.

The lilac crowned amazon is very colorful. This makes it a bit of a challenge to do in watercolor. Each color must be done separately and allowed to dry before proceeding to the next. The use of salt will create the texture of feathers without a lot of intricate painting. When working with salt it is best to work in smaller areas so the paint doesn't dry before you can drop in the salt. The divisions for the separate salt applications are indicated in red.

The green is cadmium yellow pale and hookers green deep. Wet the area then apply the color. While it is still wet, drop in some darker values by adding some paynes gray to the green. As it dries, a bit more detailing can be added. **Or**, before the shine disappears, shake on some margarita salt. Be sure to leave it on until the paint is **completely dry**, then brush it off. Don't force-dry! The salt needs time to absorb the paint.

Next, put a bit of lilac (pthalocyanine red and cobalt blue) on the top of the head, around the eye, and at the nape. Various values and detailing can be done as previously stated, but you might want to let the salt do the work. Table salt or the new "lite" salt (used here) will leave a smaller design.

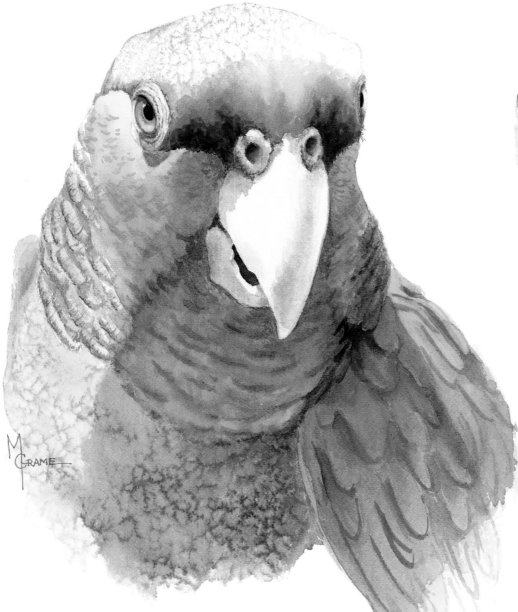

The frontal plane is pthalocyanine red. It is darkened gradually through cadmium red light, alizarin crimson, and paynes gray.

NOTE — it is always interesting to see the patterns salt leaves. At times it can be very successful; other times it doesn't quite work, as you can see above. Practice before trying it on a finished piece until you know the **right moment** to add the salt. Darker applications show it off to greater effect, but staining colors do not work as well. Be sure the paint is **ABSOLUTELY DRY** before you brush off the salt. Nothing could be more frustrating than to brush a streak of color across your paper with a damp piece of salt!

Work the eyes with cadmium orange and a touch of cadmium red light and burnt sienna. The base coat on the beak is a peachy color. Add alizarin crimson to the eye mixture. Apply this with varying values by using more water for the lights and more pigment for the darker spots. When dry, apply a glaze of lavender to create the form. The mouth is alizarin crimson, ultramarine blue, and burnt sienna. The nostril repeats these colors with a bit of orange added.

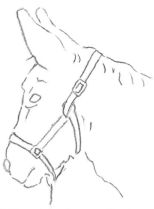

This is our burro, Gayla, who served well as a lawnmower. A burro's head is shaped similar to a horse's, but it is broader, stockier and, of course, they have much larger ears!

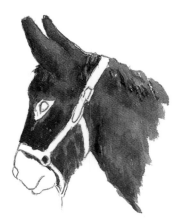

The fur is quite dark. To keep it from looking too dull, start with burnt sienna, then gradually go darker with more burnt sienna and ultramarine blue. Keep the whites of the muzzle and the area around the eye. For now, cut carefully around the halter.

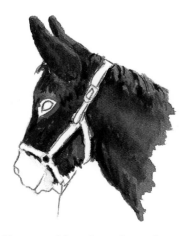

Keep working the values, the accents, and the cast shadows from the halter. The paint should be fairly heavily pigmented. Try to maintain the shaggy look, especially under the jaw. When the paint is dry, some light hairs can be picked out with a damp brush and blotted with a tissue. Shadows on the muzzle are done with a gray mixture of ultramarine blue and burnt sienna.

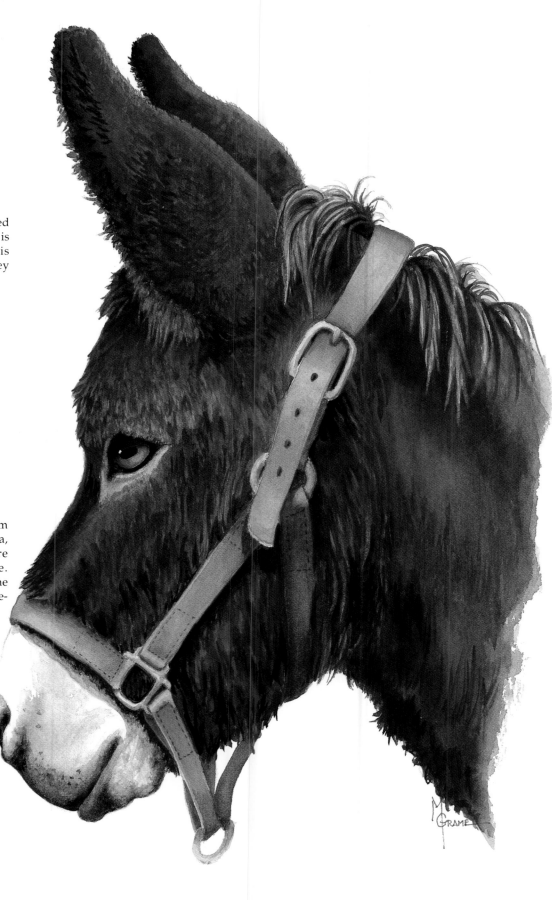

Go darker in the nostril and here and there around the muzzle. Use a light tone around the eye (let dry before working the eye). The eye is done in values of the fur color. The detailing of the halter is important. In order to show that the burro is wearing it, you must pay close attention to how the light affects it. The light creates the contour as it recedes *around* the animal, grading through values of cadmium red light, alizarin crimson, and paynes gray. The metal can be "gold" or "silver."

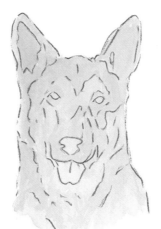

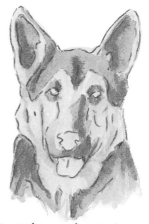

This was my dear friend and companion, Baron Von Rin Tin Tin (grandson of the famous movie star, Rin Tin Tin).

The initial wash is pale burnt sienna. Modulate values here, leaving the lightest areas above the eyes, down the left side of the face, and under the chin. When dry, add a wash of raw sienna.

Next, apply pure burnt sienna, softening some edges and leaving others hard. This is the base coat for the darks.

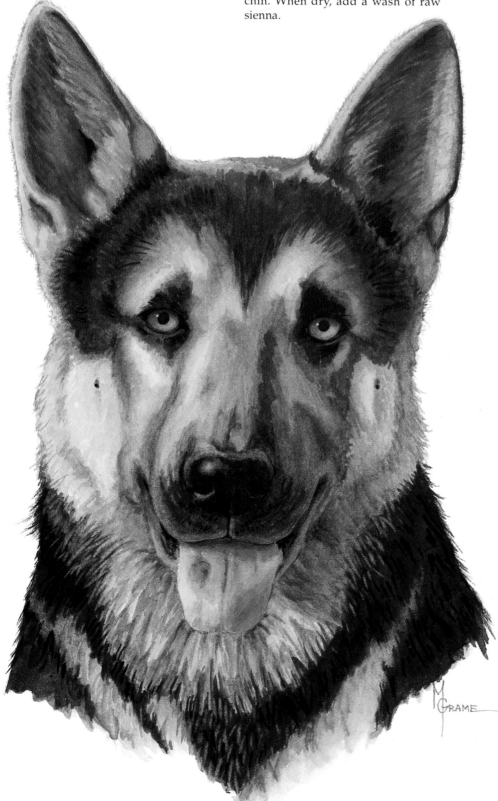

Begin applying dark values (ultramarine blue and burnt sienna) in varying degrees of warm and cool. Add more raw sienna here and there to spice up the lights and put some cadmium red light in the ears. The eyes are yellow ochre worked into burnt sienna and ultramarine blue. Try to leave some lighter areas on the nose. The tongue is three values of yellow ochre, alizarin crimson and cadmium red light, with a bit of burnt sienna and ultramarine blue to darken. You can pick out some light hairs within the darks as with the burro on page 78.

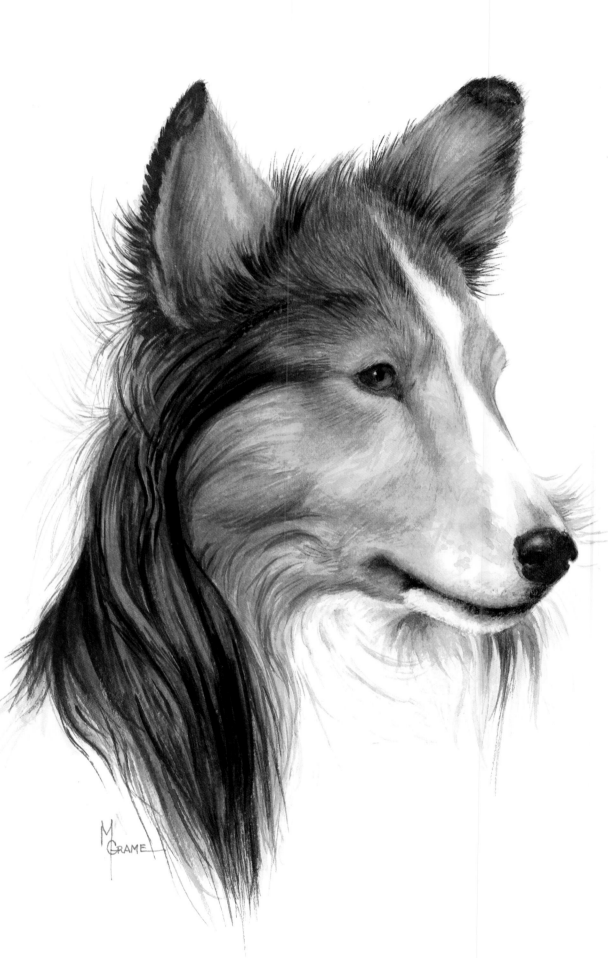

M GRAMEL

This sheltie's name is Doyle (registered name: Capri's Gold Touch O' Windrose).

The color is a bit on the red side. The mixture is yellow ochre, alizarin crimson, and burnt sienna. Be sure to leave the whites — you can't get them back!

Next, add a darker, more heavily pigmented value of the same color with some ultramarine blue added.

The extreme darks will be painted in the negative — that is, you are creating the positive hair strands by painting the dark behind them. The whites can delicately be touched with a gray mixture to create shadows. Refine the nose and the eye; try to leave the white highlights. Pull out the fine hairs with a small round brush.

Take this opportunity to create a different effect by applying some opaque Chinese white to this cute little squirrel.

The underpainting is a very light value of raw sienna. This will give an underlying warmth to the fur. Allow to dry.

Now apply burnt sienna and ultramarine blue mixed on the cool side to indicate shadow masses. Soften some of the edges so you can later pick back and forth between the value areas.

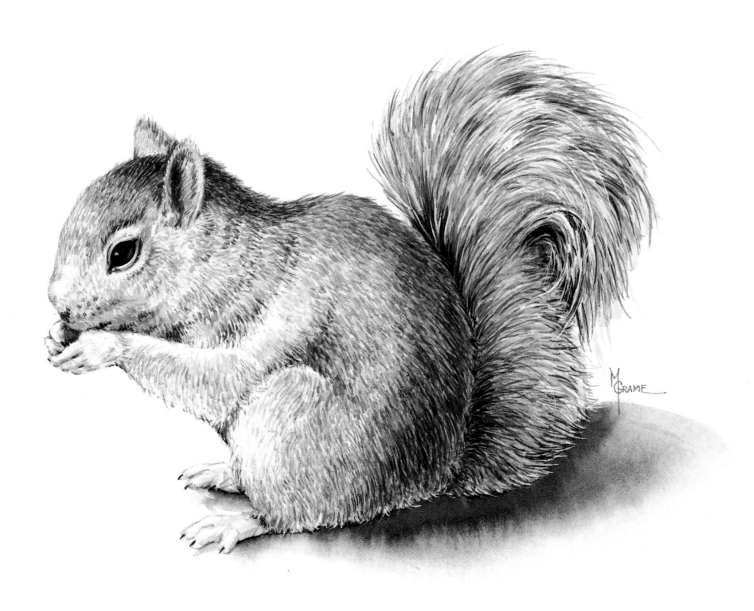

Occasionally change from cool to warm with your mixture. Using a small round sable, continue to work the fur, paying close attention to the direction in which it grows. Note that a stroke becomes finer as you raise the brush — you want this taper to be at the ends of the fur. Now use Chinese white to indicate some of the light hairs. If some of the strokes look too blunt, soften the area growing out of the depth of the fur with some gray. The cast shadow anchors him to the ground.

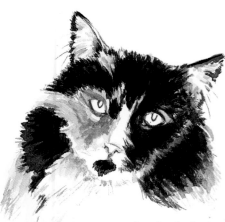

The basis of this drawing is a triangle. Notice the numerous angles that are apparent here. In this case, do not "round out" between them. As "Bandit" is so furry, guidelines are all that are needed.

Here, as in the amazon on page 77, we apply the distinct colors separately. The warms are burnt sienna and yellow ochre in varying degrees of light and dark. For brighter color, apply some orange and cadmium red light mixed together.

After the warms are dry, the darks can be started with a cool ultramarine blue and burnt sienna mixture. Occasionally work some heavily pigmented warm darks into the blacks. If necessary, paynes gray may be added for more extreme darks.

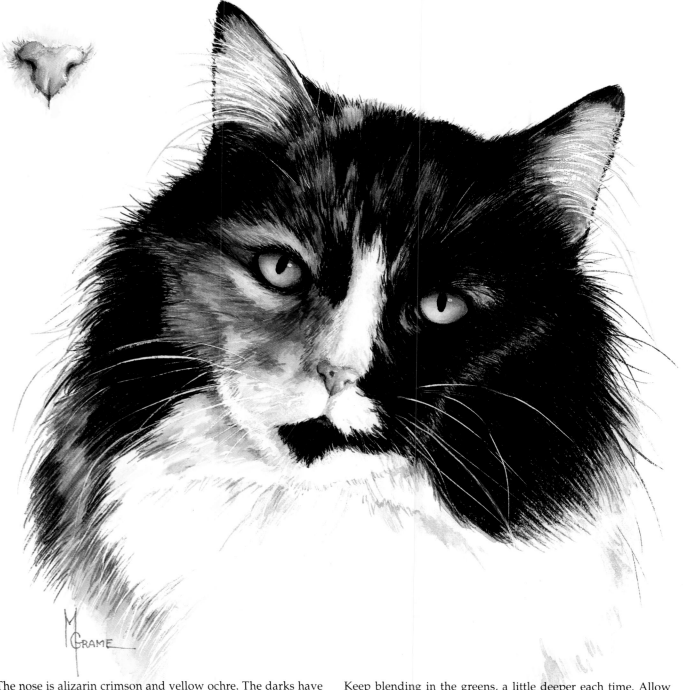

The nose is alizarin crimson and yellow ochre. The darks have burnt sienna added. Bandit has a little freckle on her nose. Notice the detail of the nose to the left. It is also based on a tri- angle. The lovely green eyes are started with cadmium yellow pale and medium, adding a touch of viridian and sap greens.

Keep blending in the greens, a little deeper each time. Allow the paint to dry between each application. Add a bit of paynes gray in the shadows. A cat's pupils are elongated vertically. The ear tufts and whiskers are added with Chinese white.

The eye of this leopard is so outstanding that I made it a lesson in itself.

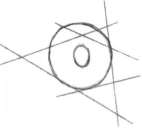

Always remember that the eyeball is an orb, so you must indicate the entire circle in your preliminary sketch. The lids are drawn over the orb, with careful attention to angles, which can then be refined into curves. The pupil should be centered within the entire orb, not just within the visible opening.

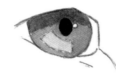

This diagram is to show only the positions of the various values. DO NOT leave the hard edges you see here.

The lid will cast a shadow on the eyeball. The shadow will be the deepest value. A glow is indicated in an arc which is illuminated as the light passes through the clear part of the eye. A highlight will be positioned opposite the glow, in the direction of the light source. Do not be influenced by your photographic source. Keep the simplicity of one highlight.

When blending, try to maintain three values in the eye (shadow, local color, and glow). The highlight should not be located over the pupil, but where the shadow and the local color meet.

The eye will never truly show its impact until it is positioned in its environment. The subtle colors and values surrounding the eye are an important part of the whole. The contrast of soft and hard edges will let the eye become a part of its surroundings.

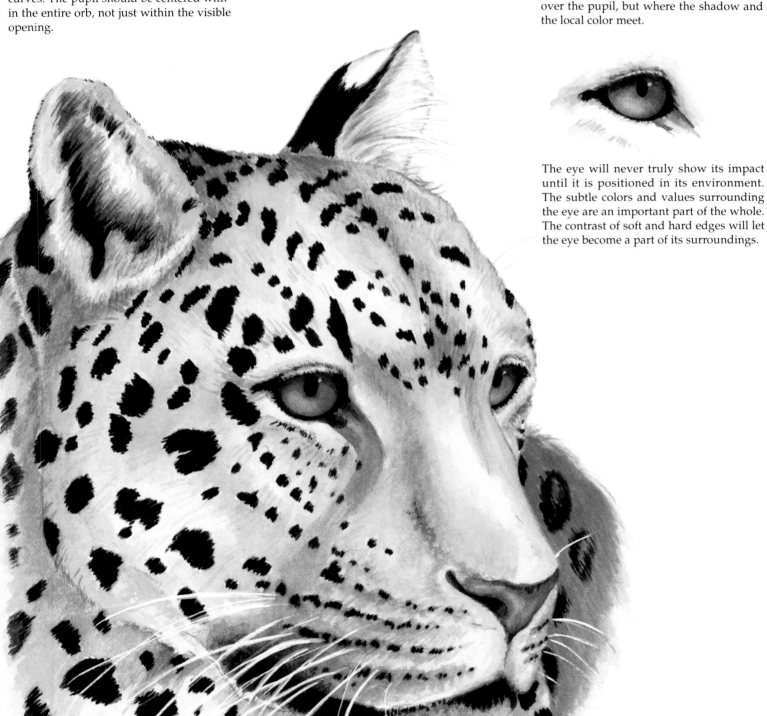

When painting the spots, apply a heavy underpainting of burnt sienna before applying the darks. This will give extra life to the dark fur.

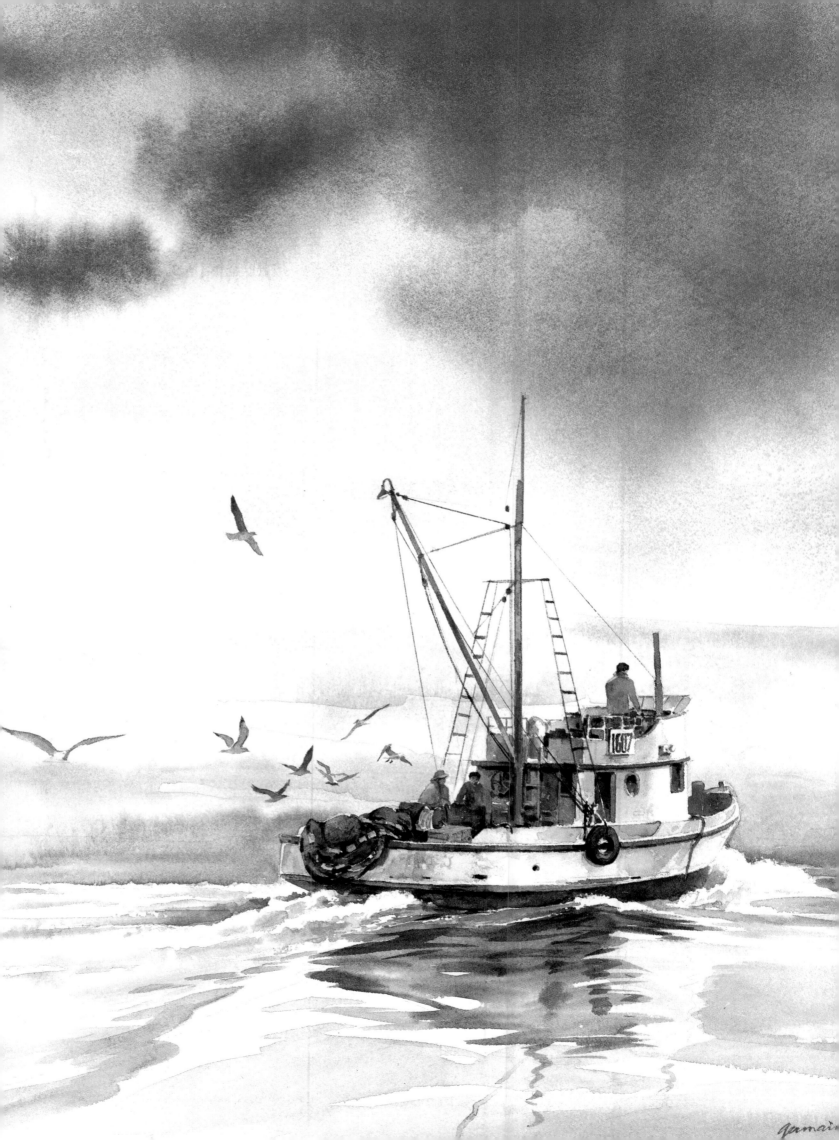

Seascapes by Frank Germain
IN WATERCOLOR

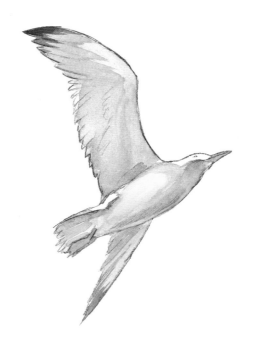

ABOUT THE AUTHOR

Frank Germain is a California native. He attended Los Angeles City College, the Art Center School of Design, and the Chouinard Art Institute.

Frank has been a commercial and fine artist for over 35 years. He is a member of the Society of Illustrators and he once served as art chairman for the Air Force Art Documentary Program.

Frank's paintings are prized in many public and private collections throughout the United States, as well as England, the Netherlands, Germany, South Africa, Japan and Saudi Arabia.

Frank's paintings are clean, accurate, crisp presentations of subjects. This presentation is a result of subtle, yet thorough, concentration on color selection and details such as texture, tone, light and shadow effects. His control of the medium in painting water is of the highest quality. Depth, color reflections, and surface effects such as waves and water movement are painted in a realistic, yet artistic manner. The dramatic use of value changes as in *"Sausalito"* reflects the ease with which Frank handles watercolors.

SECTION 5

Wave Action

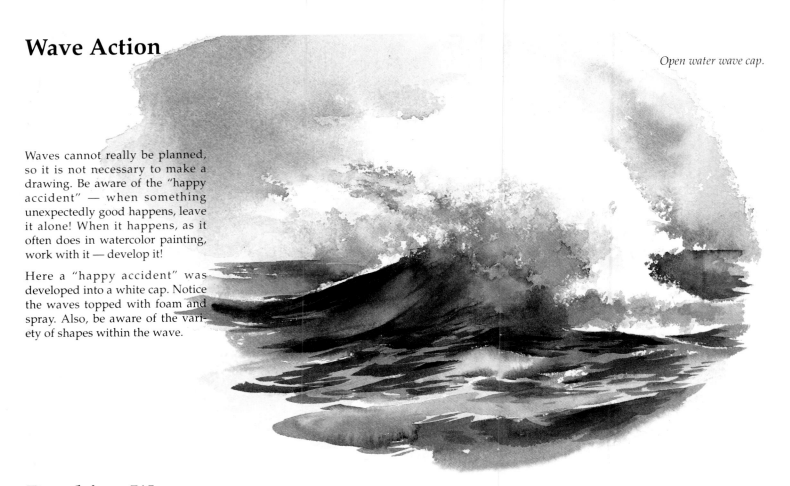

Waves cannot really be planned, so it is not necessary to make a drawing. Be aware of the "happy accident" — when something unexpectedly good happens, leave it alone! When it happens, as it often does in watercolor painting, work with it — develop it!

Here a "happy accident" was developed into a white cap. Notice the waves topped with foam and spray. Also, be aware of the variety of shapes within the wave.

Breaking Waves

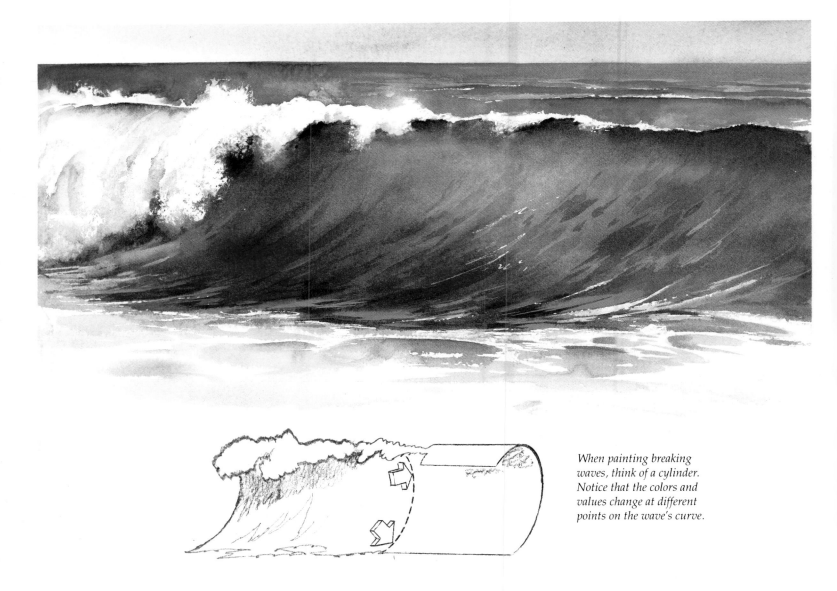

When painting breaking waves, think of a cylinder. Notice that the colors and values change at different points on the wave's curve.

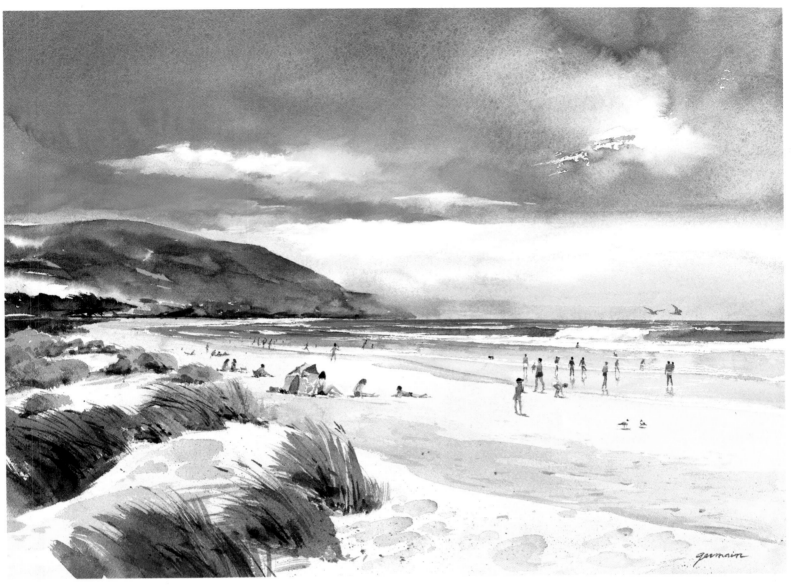

Stinson Beach **Watercolor 18" x 24"**

Paint the sky wet-in-wet with cobalt and cerulean blues.

Use a straight edge for the water. Cobalt waves, then cobalt and ultramarine.

The figures are added last, mostly in silhouette.

The grasses are cadmium yellow, and cobalt and cerulean blues painted wet-in-wet. The shadows are mauve.

Stroke in the sand with raw umber and burnt umber, as shown on pages 91 and 104.

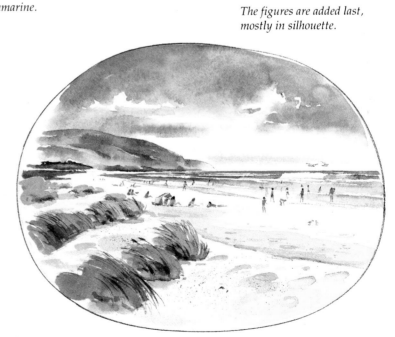

Detail grasses (see page 92).

Add darker colors on the hills and grasses. Add shadows. Spatter for sand detail and add footprints.

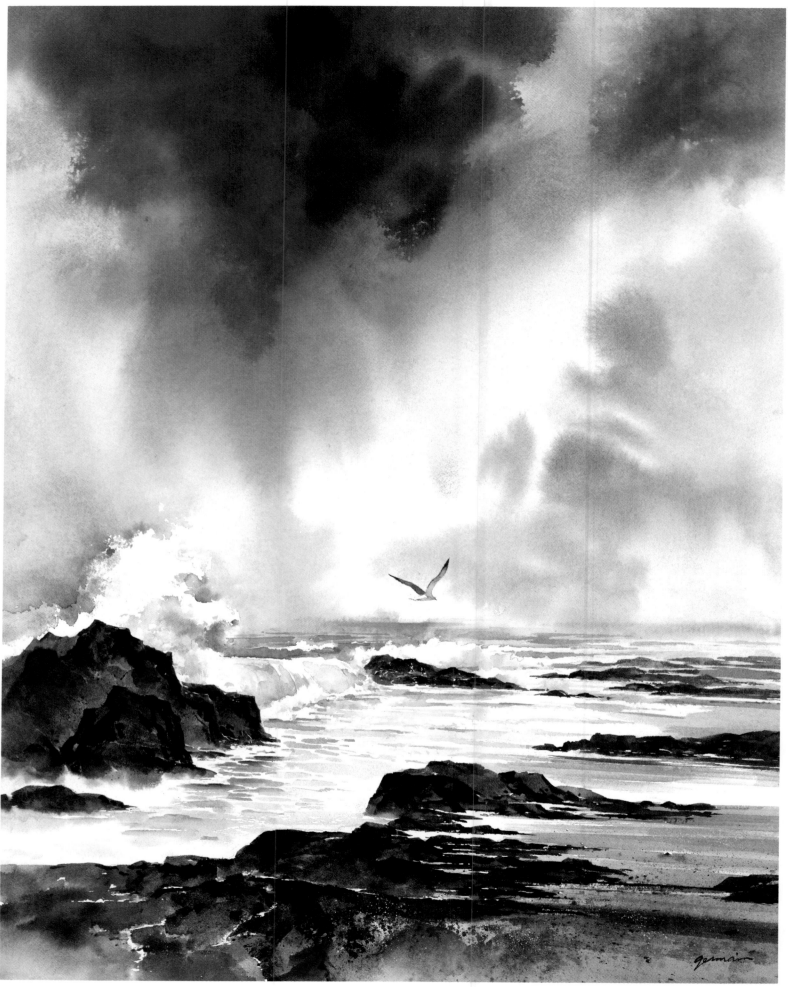

White Water Watercolor 18" x 25"

This is a typical California coastline with rocks, tide pools, spray, pounding surf, and an overcast sky. These elements create a moody atmosphere full of contrasts that is well-suited to the use of transparent watercolor (where the whites are the paper). The light colors are mostly water with very little pigment. The darks have less water and more pigment.

Painting The Sky

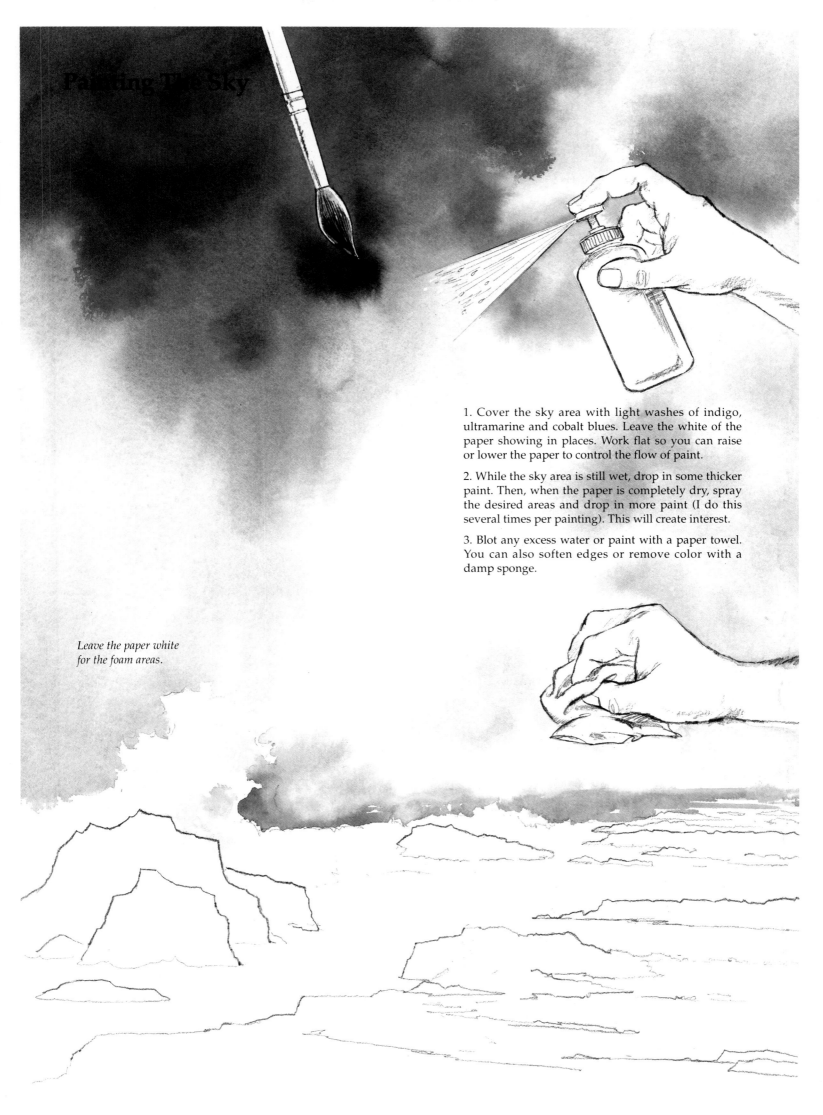

1. Cover the sky area with light washes of indigo, ultramarine and cobalt blues. Leave the white of the paper showing in places. Work flat so you can raise or lower the paper to control the flow of paint.

2. While the sky area is still wet, drop in some thicker paint. Then, when the paper is completely dry, spray the desired areas and drop in more paint (I do this several times per painting). This will create interest.

3. Blot any excess water or paint with a paper towel. You can also soften edges or remove color with a damp sponge.

Leave the paper white for the foam areas.

Painting Rocks

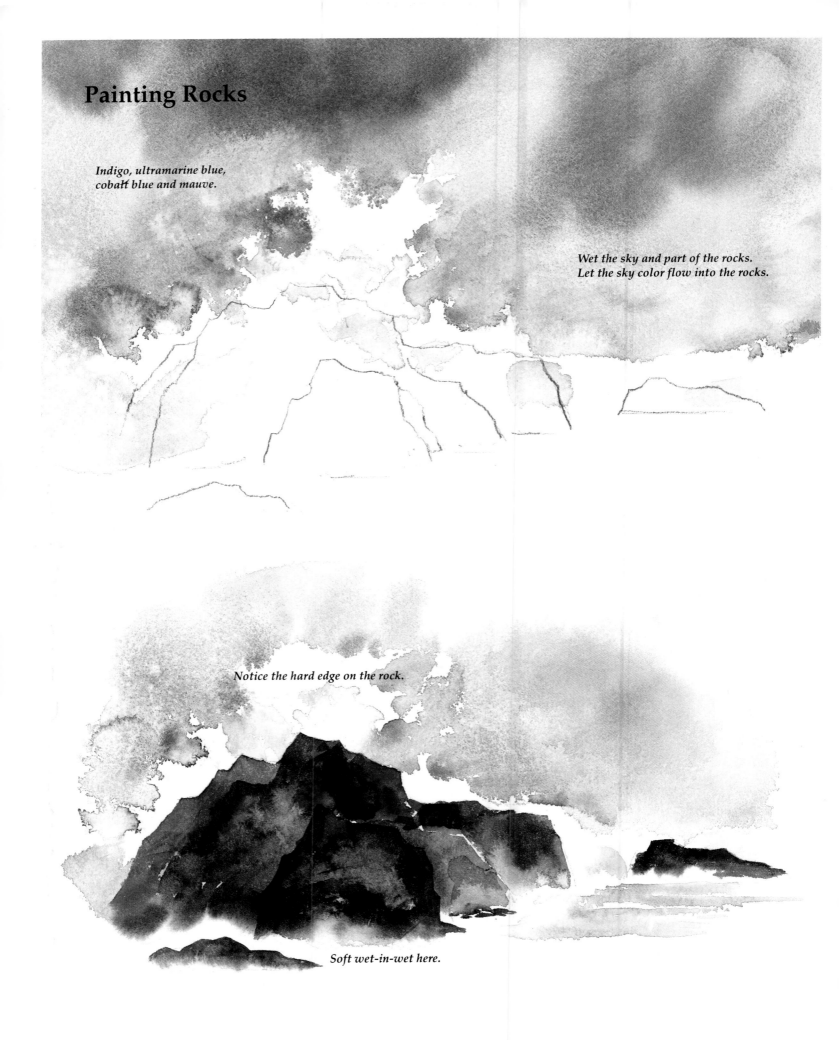

*Indigo, ultramarine blue,
cobalt blue and mauve.*

*Wet the sky and part of the rocks.
Let the sky color flow into the rocks.*

Notice the hard edge on the rock.

Soft wet-in-wet here.

Paint the basic shape of the rock, varying the colors and the lights and darks. Consider the nature of the rocks — they are hard with sharp edges (not "doughy"); they have a variety of shapes within the total shape, they have texture, and they have contrasts of light and dark (especially when wet).

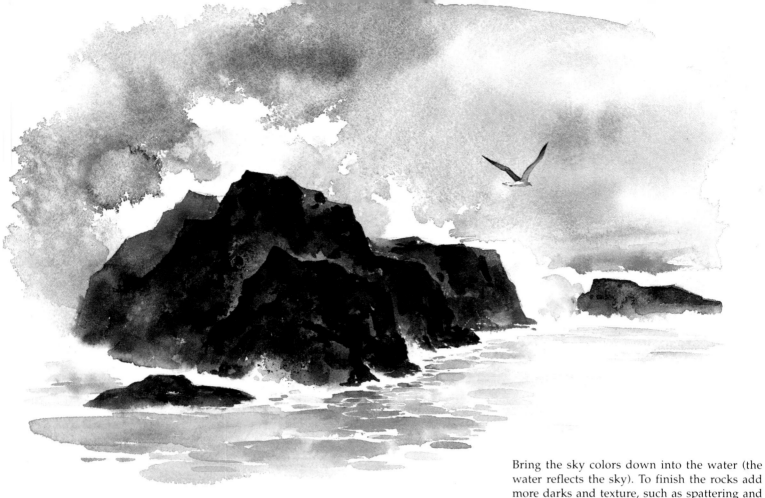

Bring the sky colors down into the water (the water reflects the sky). To finish the rocks add more darks and texture, such as spattering and blotting.

Finally, draw the sea gull on tracing paper and move it around the painting until it looks right. Transfer it to the board and paint it.

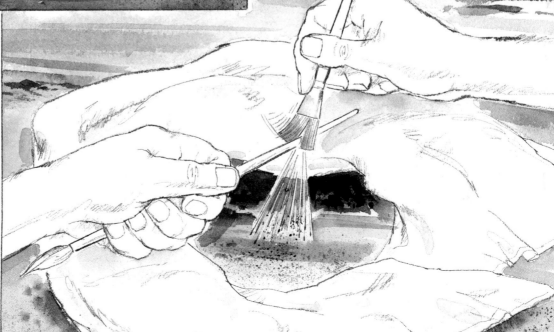

Painting Sand

Painting wet-in-wet, use raw umber, burnt umber, mauve, and ultramarine blue to build up the sand and the shadows. While still wet, stroke horizontally with a totally clean, dry brush until the sand looks flat. Note — the dry brush should move pigment around, it should not add or take pigment away. Lastly, spatter in the sand texture, as shown (cover the rest of the painting with a cloth to protect it).

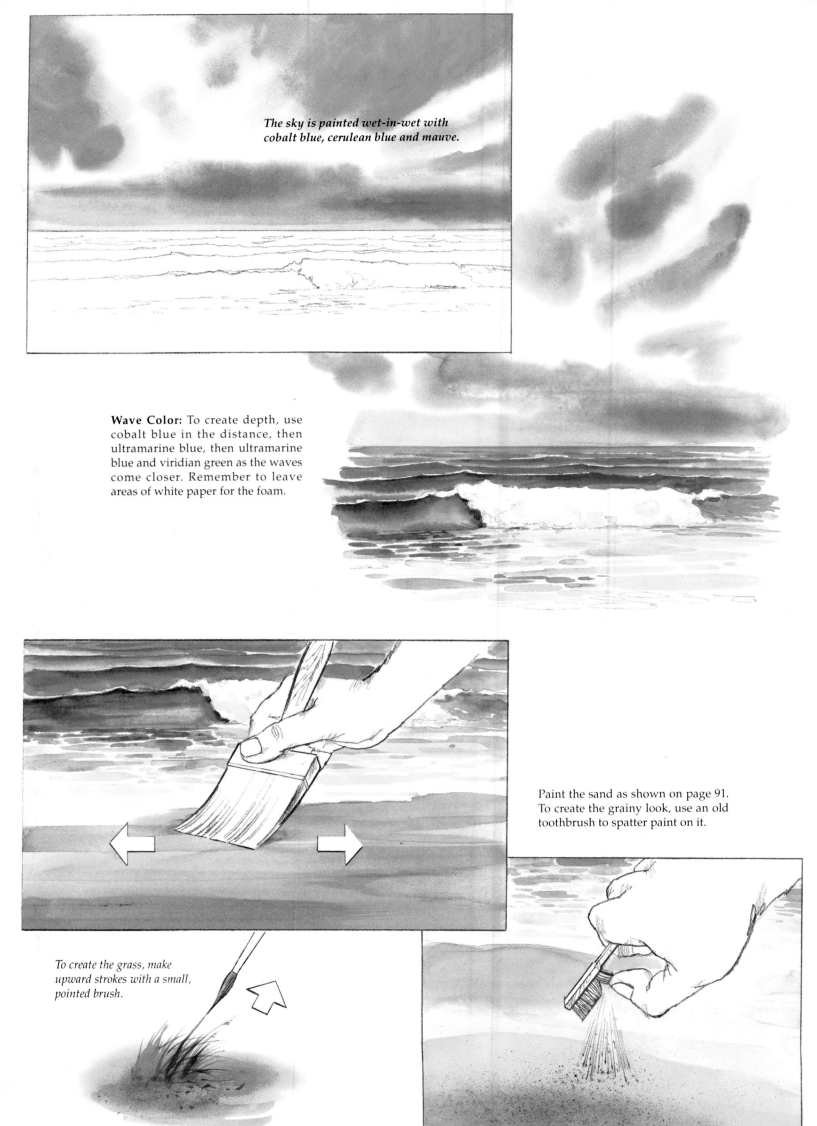

The sky is painted wet-in-wet with cobalt blue, cerulean blue and mauve.

Wave Color: To create depth, use cobalt blue in the distance, then ultramarine blue, then ultramarine blue and viridian green as the waves come closer. Remember to leave areas of white paper for the foam.

Paint the sand as shown on page 91. To create the grainy look, use an old toothbrush to spatter paint on it.

To create the grass, make upward strokes with a small, pointed brush.

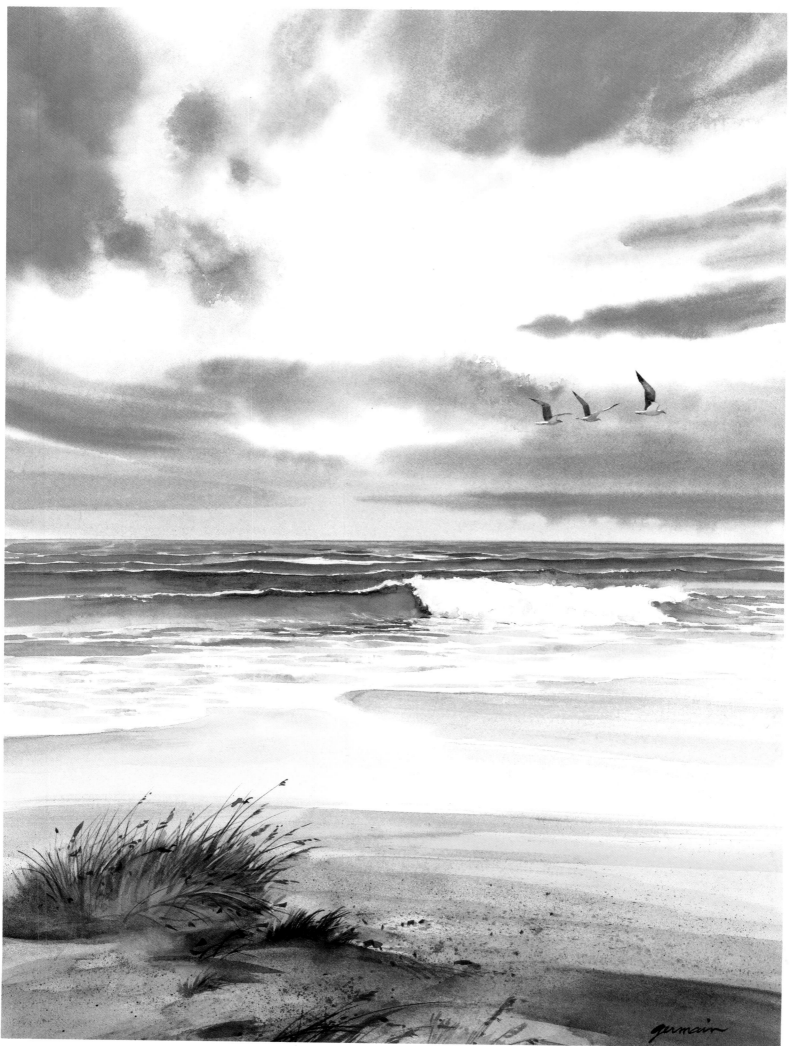

Rolling Surf Watercolor 18" x 25"

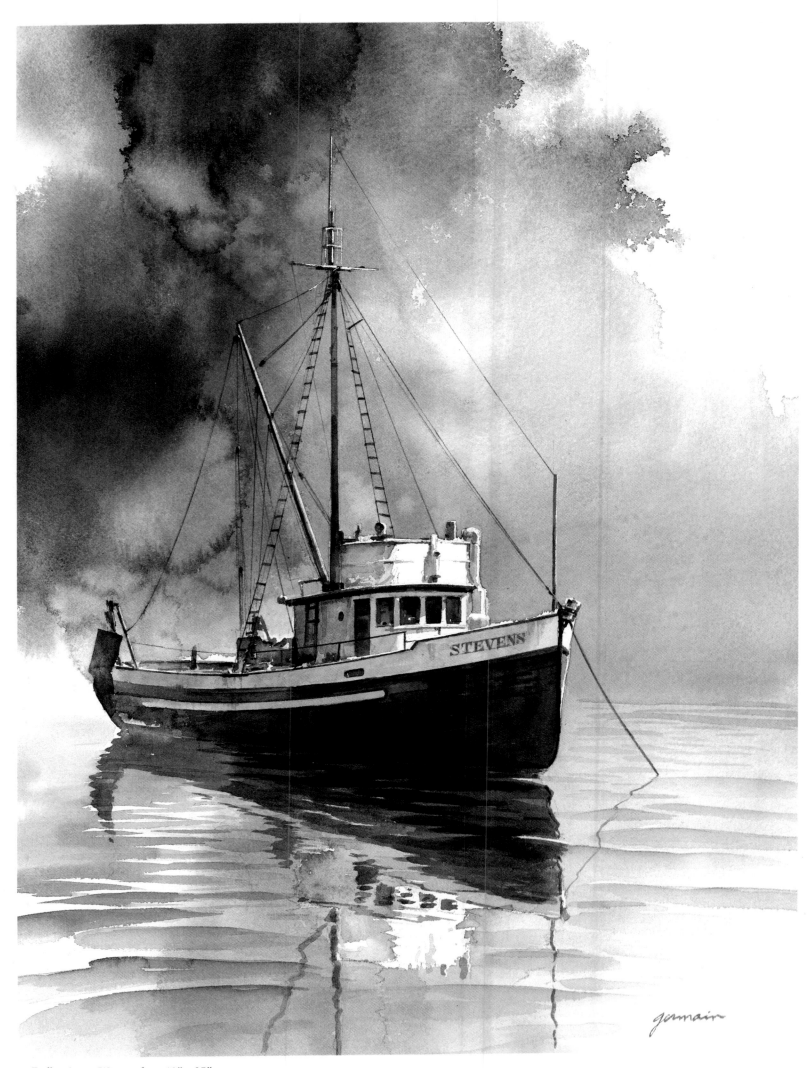

Reflections Watercolor 18" x 25"

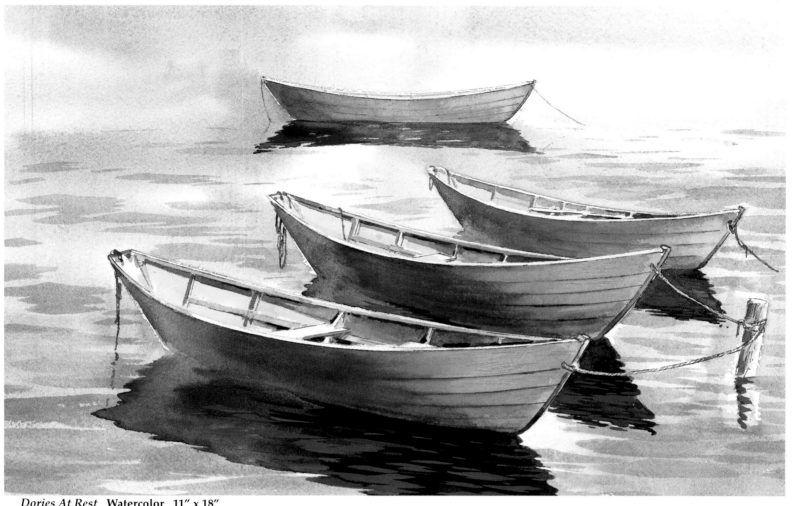

Dories At Rest Watercolor 11" x 18"

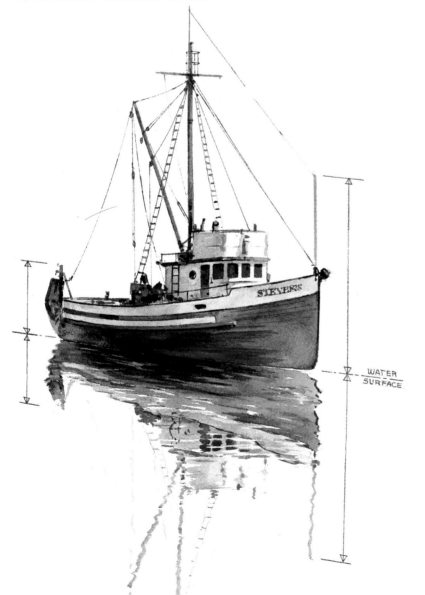

Reflections

Objects reflect straight down from the water surface (or plane) the same distance as the object is above the water surface.

Water is like a mirror. The reflection has the same vanishing point as the object. Water also reflects the sky color when the water surface is calm or glassy. Wave action causes the reflections to lengthen because of the tilt of the surface. Choppy, rough water shows little or no reflection.

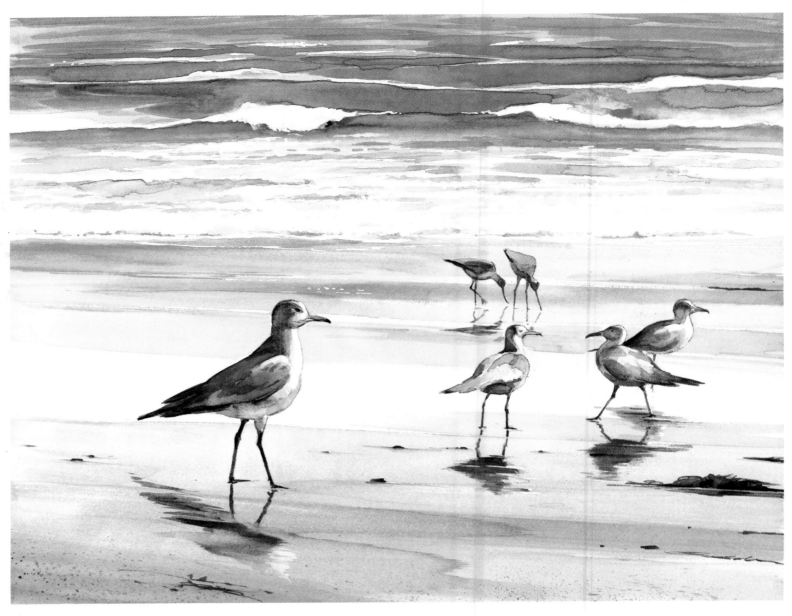

Beach Buddies **Watercolor 11" x 14"**

Study the water reflections of these sea birds in wet sand. Even a film of water on the sand reflects. Consider the surface plane as a mirror, but water streaks on the sand will affect the reflections, as shown here.

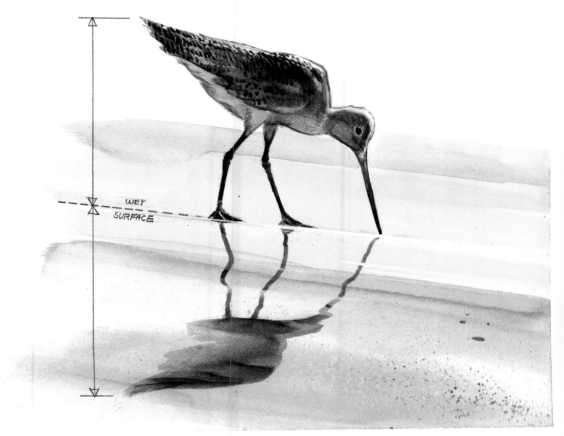

WET
SURFACE

Any part of the bird above the water surface is reflected the same distance in a straight line below the water surface (or plane). Note — birds in flight reflect the same way: from the bird in the air to the surface plane and down the same distance below the plane.

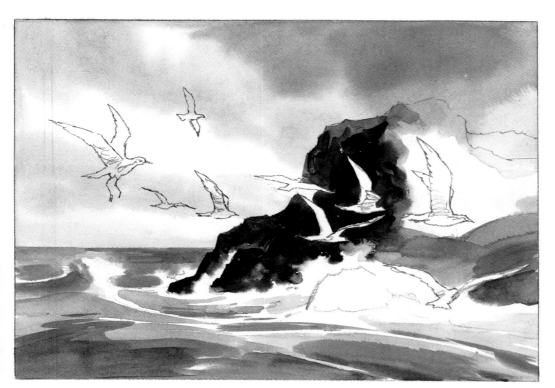

Painting Birds

You can paint the background around the birds or you can mask them out with liquid or paper frisket first. Both methods are shown here.

Use more than one color on the birds. To create interest, paint light against dark and vice versa, as shown here. This painting was done on compressed illustration board.

The sky is painted wet-in-wet with cobalt and indigo. Some edges are hard; others are soft. The rocks are mostly indigo. Use blotting and spattering techniques to create texture. The water is cobalt, ultramarine, viridian and a touch of indigo.

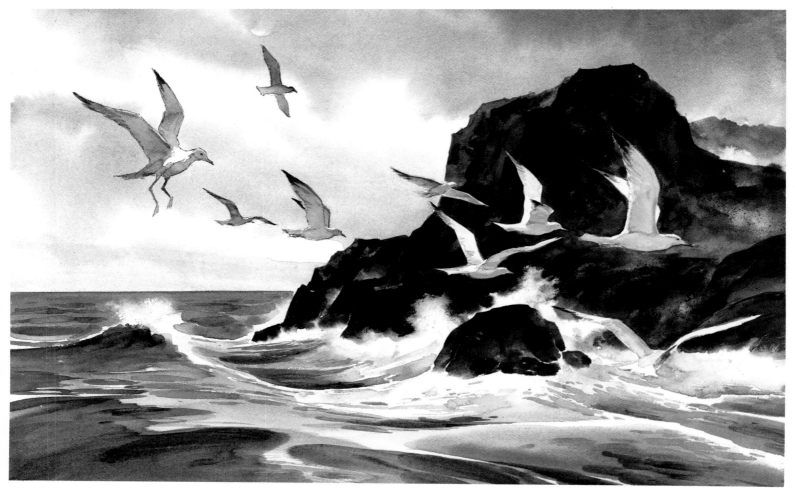

Birds In Flight Watercolor 10" x 14"

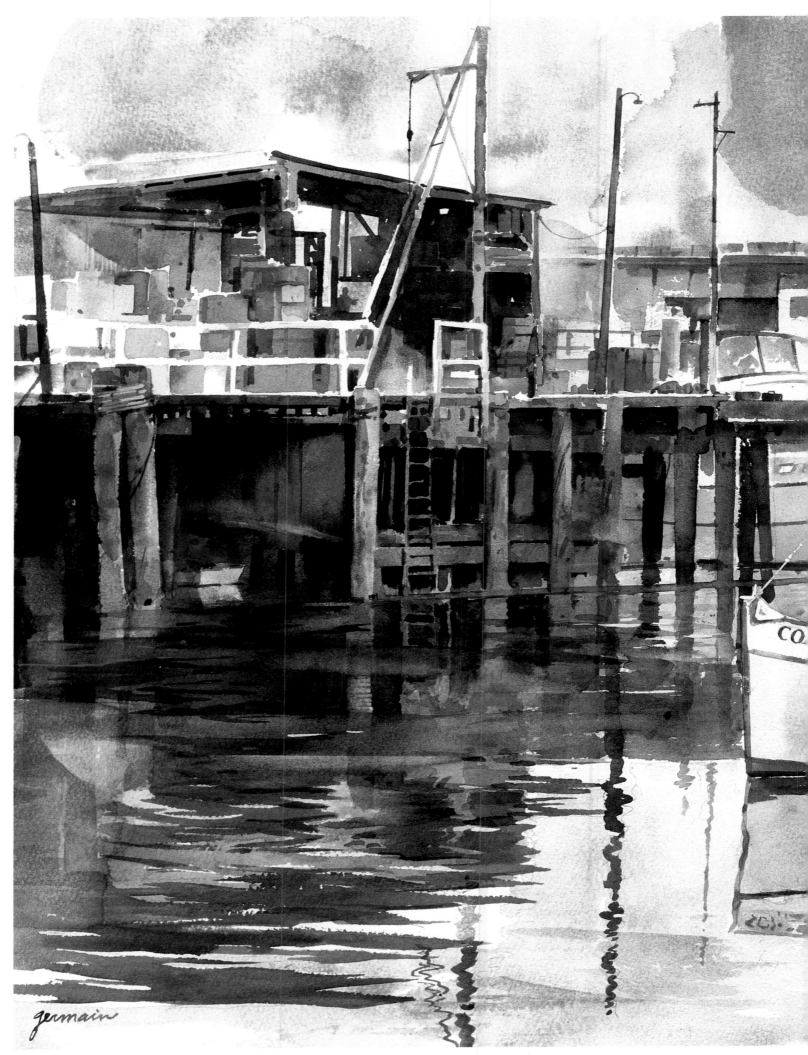

Sausalito Watercolor 17" x 21"

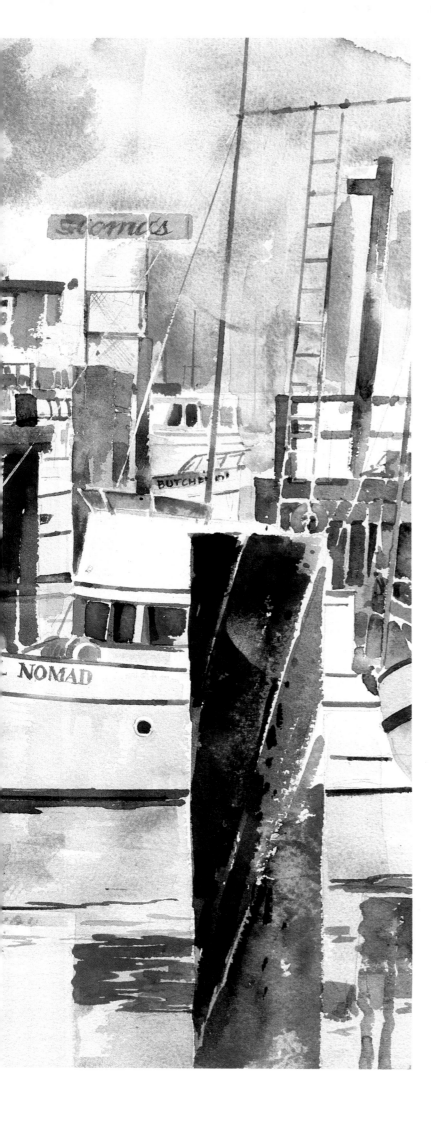

The Sausalito Harbor scene demonstrates much of what we have learned about reflections. I have tried to create the impression of a colorful and crowded harbor. It may appear complicated, but I have broken it down into a series of basic shapes below.

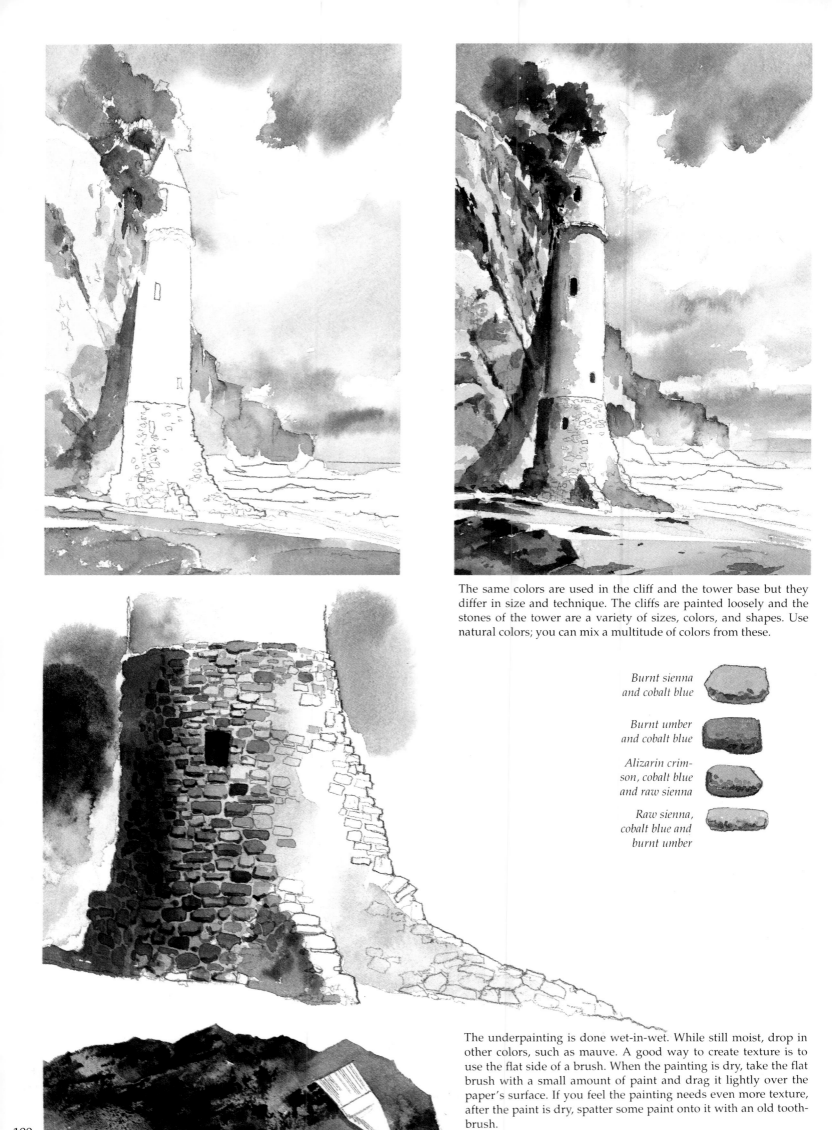

The same colors are used in the cliff and the tower base but they differ in size and technique. The cliffs are painted loosely and the stones of the tower are a variety of sizes, colors, and shapes. Use natural colors; you can mix a multitude of colors from these.

Burnt sienna and cobalt blue

Burnt umber and cobalt blue

Alizarin crimson, cobalt blue and raw sienna

Raw sienna, cobalt blue and burnt umber

The underpainting is done wet-in-wet. While still moist, drop in other colors, such as mauve. A good way to create texture is to use the flat side of a brush. When the painting is dry, take the flat brush with a small amount of paint and drag it lightly over the paper's surface. If you feel the painting needs even more texture, after the paint is dry, spatter some paint onto it with an old tooth-brush.

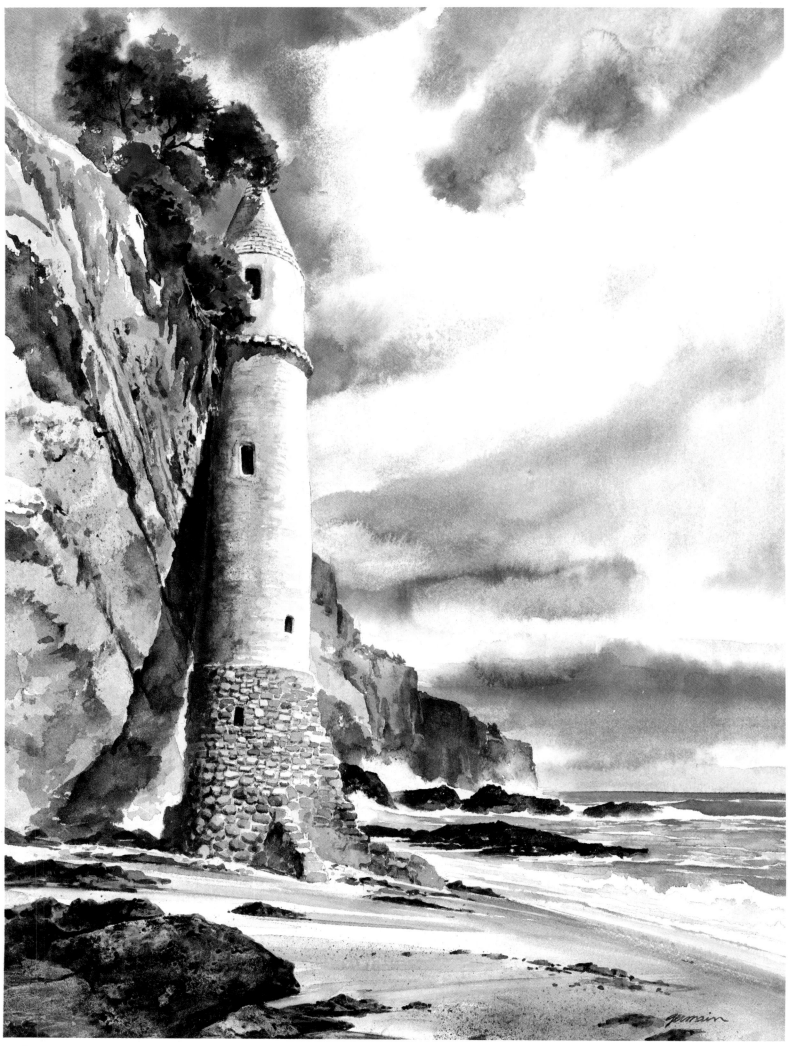

Victoria Beach Staircase **Watercolor** 18" x 25"

Windswept Trees

Notice the angle of the lean of the trees — they all lean the same way. Change colors as you go and make various sizes of limbs. Make thin and broad strokes. To create texture in the trees and the road use blotting and spattering techniques.

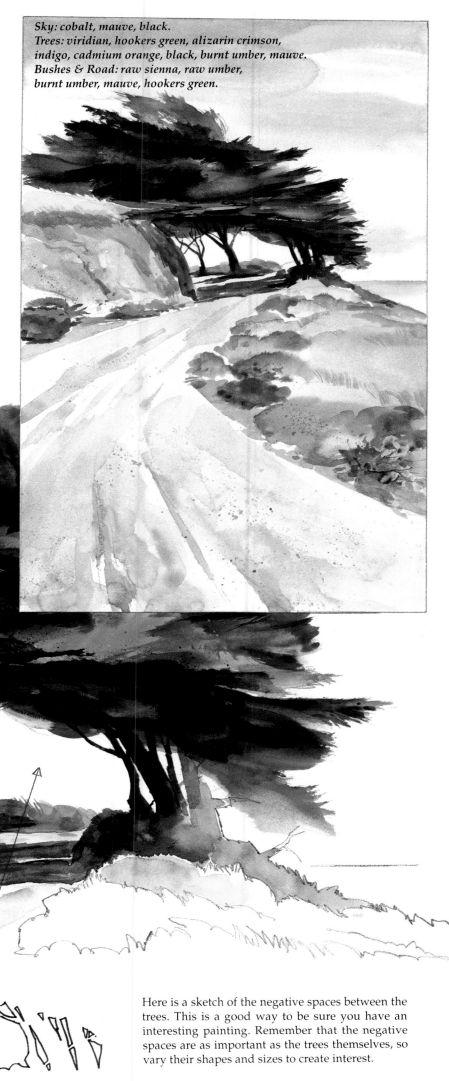

Sky: cobalt, mauve, black.
Trees: viridian, hookers green, alizarin crimson,
indigo, cadmium orange, black, burnt umber, mauve.
Bushes & Road: raw sienna, raw umber,
burnt umber, mauve, hookers green.

Here is a sketch of the negative spaces between the trees. This is a good way to be sure you have an interesting painting. Remember that the negative spaces are as important as the trees themselves, so vary their shapes and sizes to create interest.

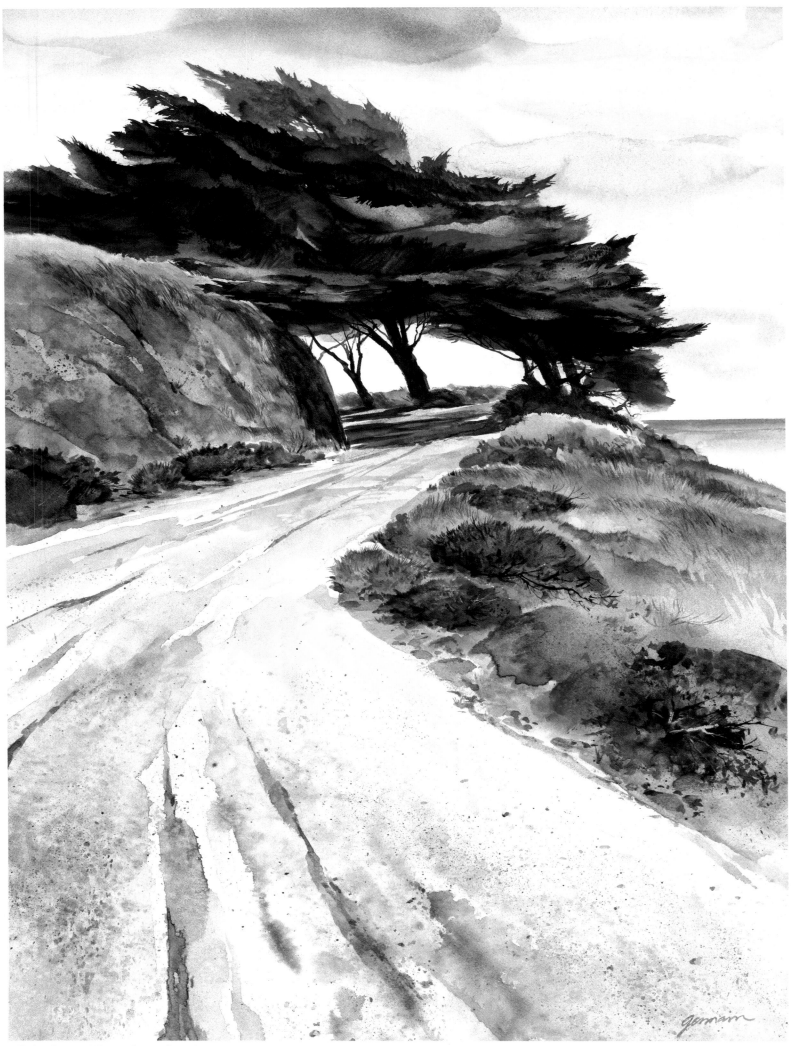

Point Reyes Watercolor 18" x 25"

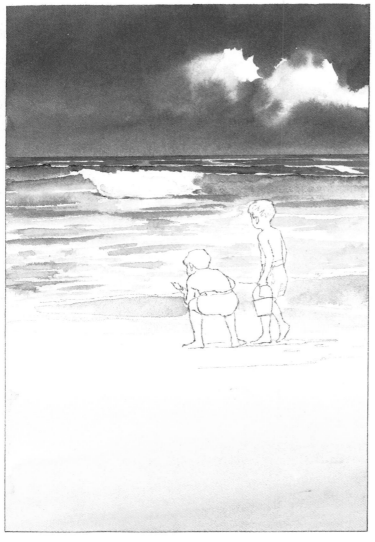

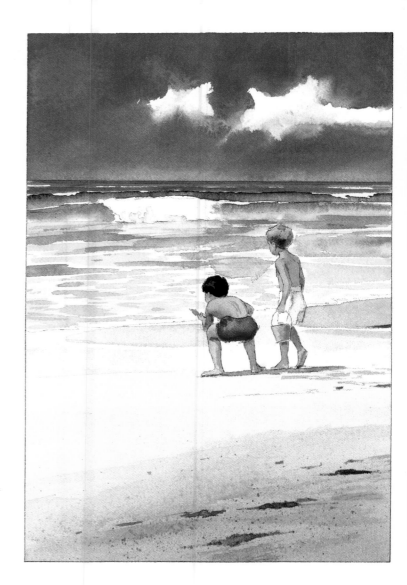

A scene with a warm, bright sun like this will have cool shadows (the figures are a good example). To create depth, the colors range from cool and pale in the distance to warm and dark in the foreground. Notice that the foreground has the only texturing. The footprints and seaweed create contrast and interest.

Figures: The skin tones are yellow-ochre, alizarin crimson, cadmium red and cobalt. The shadows are mauve and raw umber.

Paint the sand with horizontal strokes. Begin with thin paint, then make it darker as you come forward. To create texture: spatter, flick, blot with wax paper, foil or paper towel, scrape, erase, etc. — the possibilities are almost endless. For this example, I used tracing paper to blot (this is exceptionally effective on smooth paper).

Blot

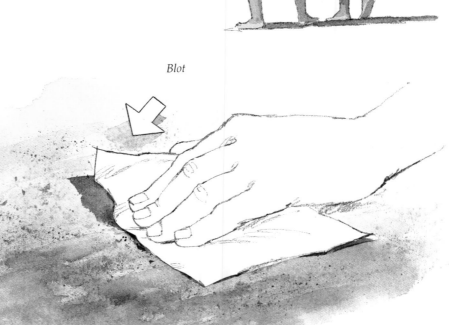

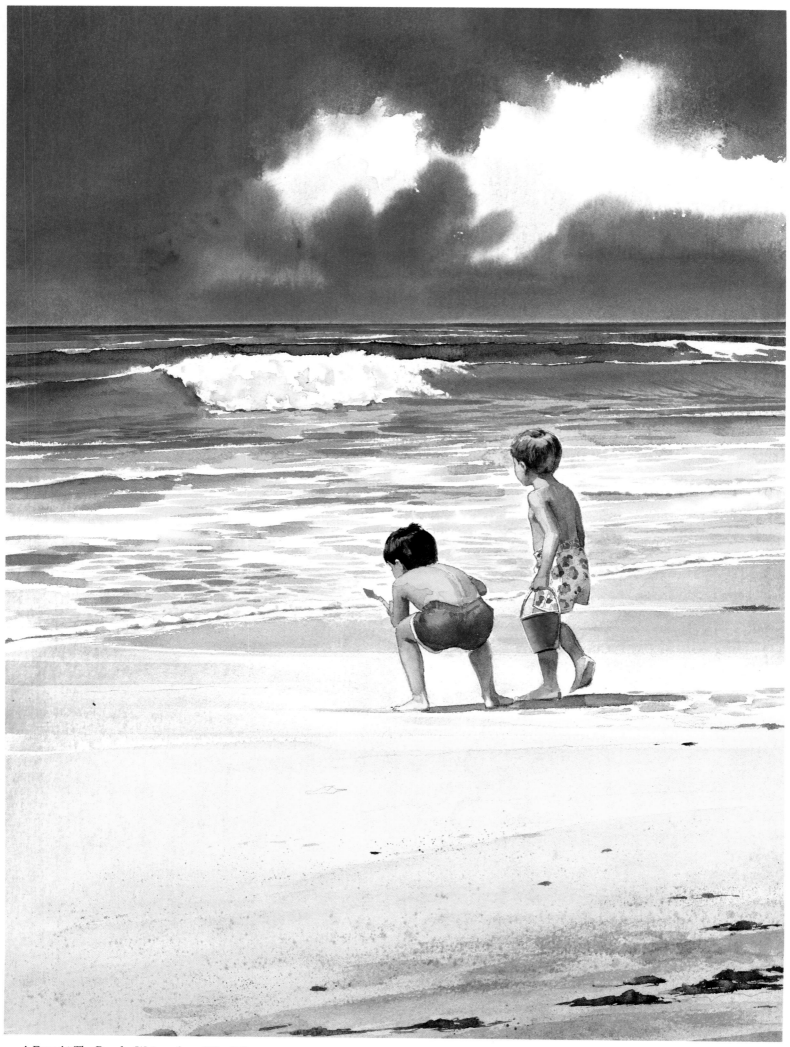

A Day At The Beach Watercolor 18" x 25"

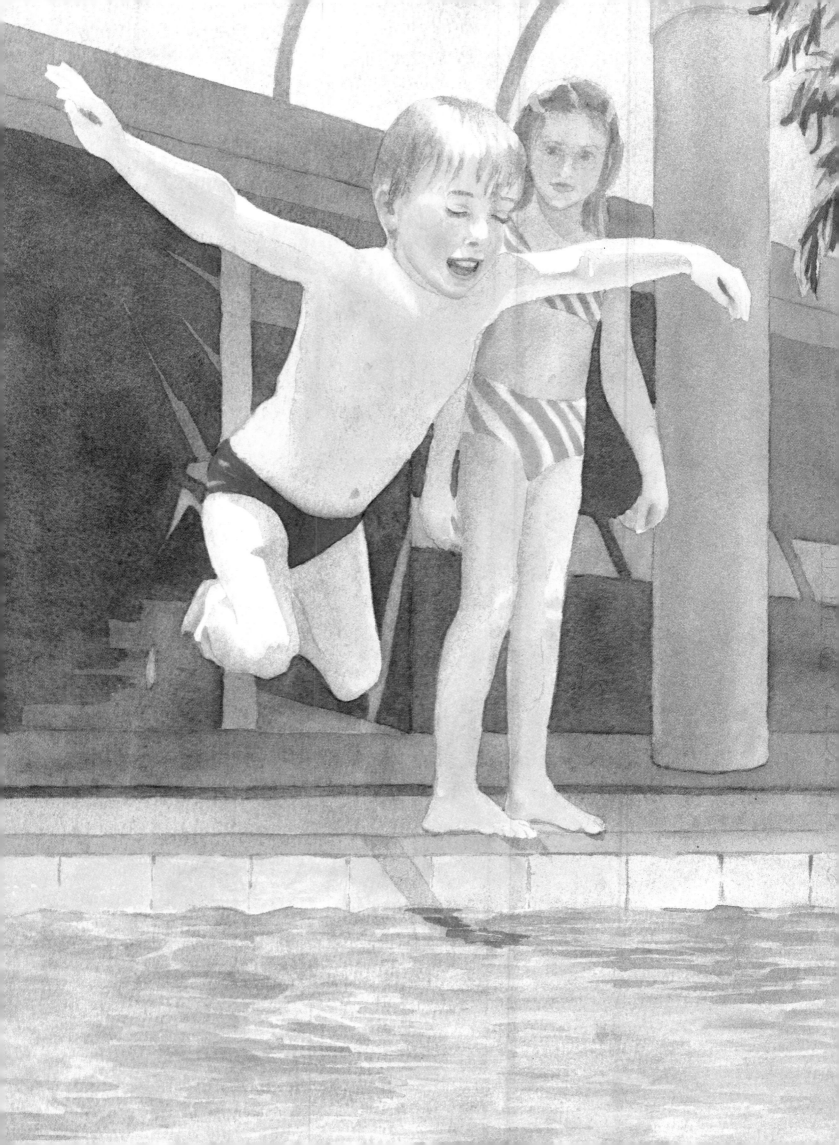

Children by Lori Quarton
IN WATERCOLOR

ABOUT THE AUTHOR

Lori Quarton was born is Seattle, Washington and attended college at Oregon State University. She has studied art under Robert E. Wood, Rex Brandt, Gerald Brommer and Betty Weis, but is mostly self-taught.

Lori is a nationally recognized artist having won awards in national competition as well as being published by the New York Graphic Society. Her work has been exhibited throughout the United States and can also be found in many private and corporate art collections.

Lori's home and studio are located in the rural community of Orange Park Acres in Southern California, where she lives with her husband, son, daughter and a menagerie of animals, including two horses, three dogs and two cats. Her love of nature, animals and children is reflected in her work.

Lori's watercolor paintings are of a soft, pastel nature. The delicate range of values used with a perspicacious selection of colors results in paintings that make a delicate, soft, thoughtful statement—a perfect result for the subject.

SECTION 6

First, wet the wall area with clear water (turn the painting upside down to control the water more easily), then apply a wash of cobalt blue and burnt sienna. Next, wet the area inside the window and add cerulean blue in the sky area and aurora yellow in the lower area. Let the paint dry.

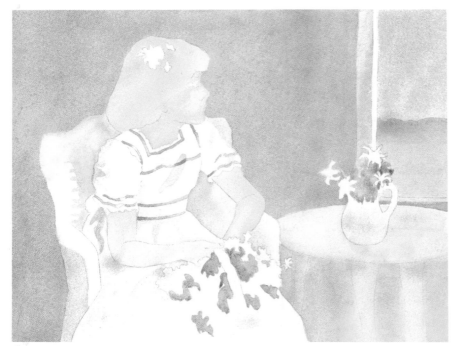

Wet the wall area again, then go back in with some pthalocyanine crimson, burnt umber, and yellow ochre (do not paint the window frame). Pull some of this color into the girl's face, neck and arms, and into the chair. Work some aurora yellow into the hair. Float some of the background color into the tablecloth. (Remember to frequently blot the outside edges of the painting with a paper towel or a dry brush to prevent "run-back.") While the paper is still shiny, run some cooler color down the sides of the tablecloth to indicate soft folds.

Add some cerulean blue, aurora yellow and yellow ochre to the daisy leaves. Rather than premixing your paints, wet the area, then drop in the color, letting it mix on the paper.

Lightly draw the flower pattern on the wallpaper, then use a damp brush to cover the flowers with liquid frisket. After the frisket has dried completely, wet the entire area with clear water and paint it with pthalocyanine crimson and a little yellow ochre, adding a touch of cobalt blue behind the girl's head. Pull a small amount of these colors into the girl's head, face, hair and arms to alleviate the hard-edged, "cutout" feeling. Paint the shadows on the dress with ultramarine blue and permanent red; use a touch of sepia to vary the mixtures. Allow the paint to dry, then remove the frisket with a rubber cement pick-up.

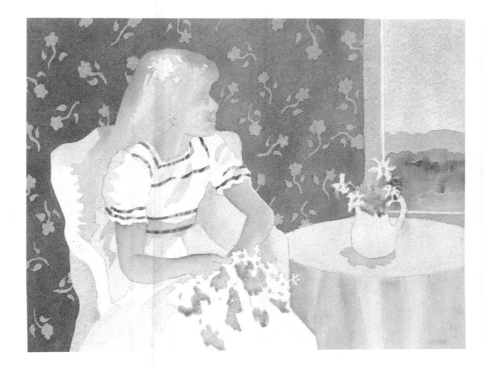

When painting the ribbon (or any fabric with folds), paint the entire area with a light value, then paint the folds with a value two or three shades darker, depending on the light conditions.

Work more color into the girl's hair with raw sienna, sepia, and a touch of pthalocyanine crimson. Add form to the features with the same colors plus a touch of cerulean blue and yellow ochre in the eye. Paint the flowers in the hair and add form to the ribbons and the basket in her lap. Finally, add a few more suggestions of texture in her hair.

When possible, paint a particular area all at once. For example, do not try to paint each individual leaf — paint the whole group of leaves, then go back in and suggest the details. Always think "shapes" — not "things."

Little Flower Girl

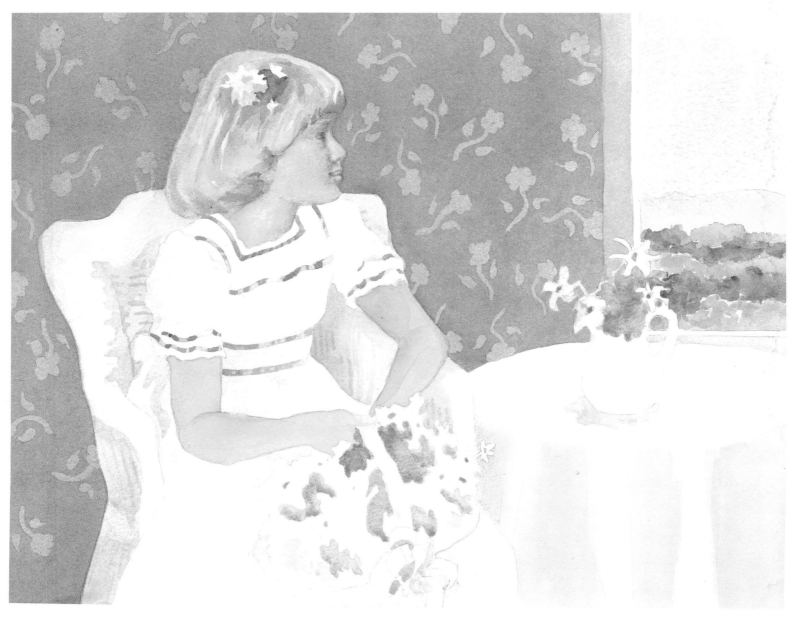

Hand

Apply a mixture of permanent rose and yellow ochre.

Paint the "out of light" area with permanent red.

When dry, use a mixture of antwerp blue and yellow ochre for the shadow.

Apron

Paint in the shadows with antwerp blue and sepia. Remember to soften an edge or two with a wet brush.

Paint the rickrack with cobalt blue, making it lighter where the sun hits.

Daisies

Draw the daisies, then cover them with liquid frisket.

Add leaf forms, varying the color by using mixtures of aureolin yellow, antwerp blue, and yellow ochre. Let the paint dry, then remove the frisket.

Add some darks for accent and the yellow heart of the flower.

Grass

Wet the grass area and apply a wash of aureolin yellow, then add a strip of antwerp blue with some sepia. Let dry.

Paint the areas on top with yellow ochre and antwerp blue mixed with a little aureolin yellow. Add a bit of permanent rose to some of the unpainted areas. Let dry.

Let the heel of a flat brush absorb a mixture of antwerp blue and burnt umber, then blot. Hold the bristles up so only the heel of the brush touches the paper and run it across the surface (this works best on rough paper). Paint negatively behind the grass area to form blades of grass.

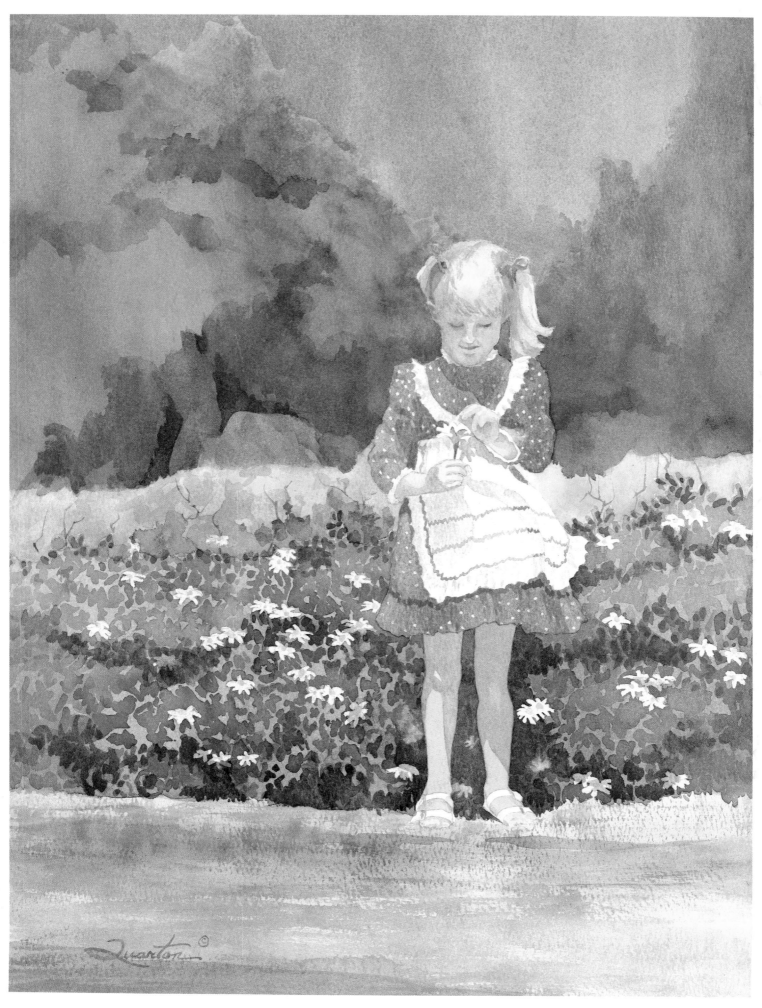

Loves Me

Working from warm to cool, apply a light wash of cobalt blue, cerulean blue, and naples yellow on the cobblestone pavement.

To paint the fountain, add washes of cerulean blue, cobalt violet, and naples yellow. Use a touch of peacock blue at the base. Use naples yellow, cerulean blue, and a touch of cobalt violet in the water.

Add the shadow patterns with blue-gray and violet-gray, then paint the tiles at the water's edge. Add a wash of naples yellow to the flesh. Paint the shadow pattern on the fountain and in the water. Use a little paraffin wax under the water in the pool to add sparkle.

Wash in the foreground with yellow ochre. While still damp, spot in the cobblestones with some cobalt violet, cobalt blue, and yellow ochre. Work in some yellow ochre and gray-blue with a touch of peacock blue on top of the shadows. Go into the water with the same colors, plus more peacock blue and cobalt violet. Add more color to the fountain and deepen the flesh tones.

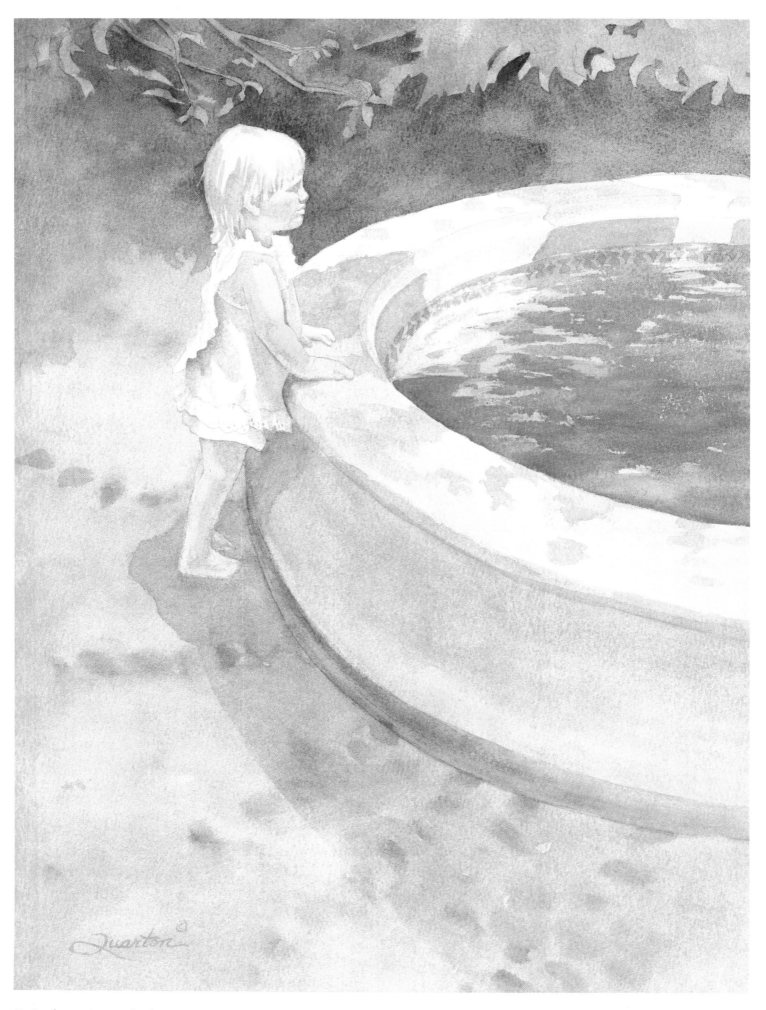

Make A Wish

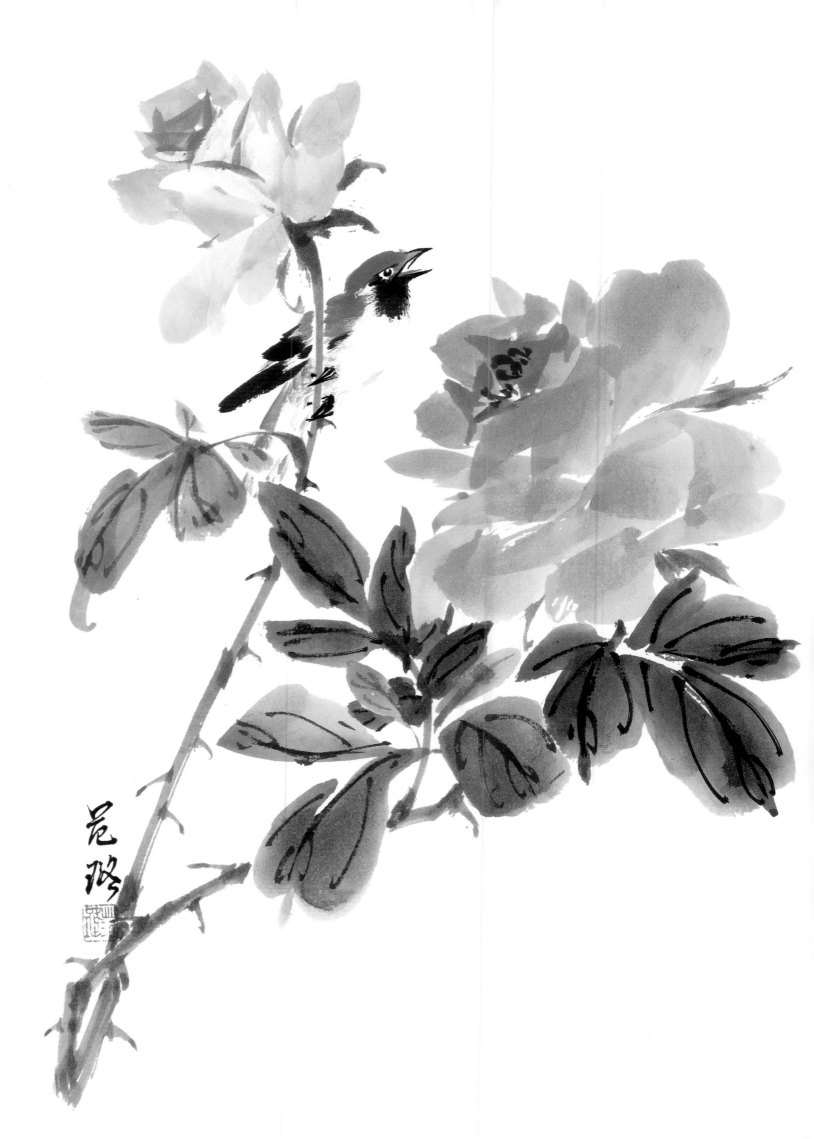

WATERCOLOR
On Rice Paper by Lucy Wang

ABOUT THE AUTHOR

Lucy Wang was born in Taiwan, Republic of China. She showed an interest in art at an early age, but didn't begin formal training until she was twelve years old. Lucy graduated from the National Taiwan Academy of Arts in 1977 and continued her studies with several master artists in Taiwan, including: Yung Liu, Li Chi-Mao, Yu-Hsuan Shao and Mungo K.L. Yao.

Lucy has participated in many prestigious exhibits in Taiwan and the U.S., including an invitation in the spring of 1983 to exhibit and demonstrate at the Museum of Arts and Sciences in Macon, Georgia. She has received many awards and her work is included in many international collections as well as in Taiwan and the United States.

With the experience gained from her years of painting this lovely and expressive form of art and her desire to promote this traditional Chinese art in the community, Lucy maintains a gallery/studio in San Diego, California where she also teaches classes for beginning and advanced artists.

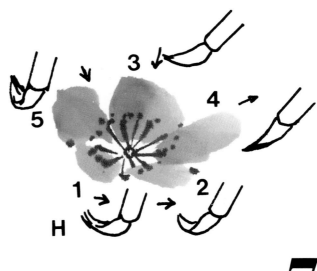

SECTION 7

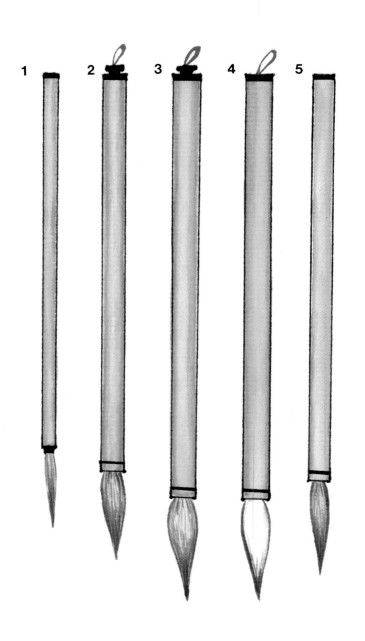

Supplies

Brushes

The #1, #2, and #3 brushes are made from deer and/or wolf hair. These are stiff bristles and are used for petals, leaves and branch strokes.

The #4 brush is made from goat or rabbit hair. It is a soft brush and is used for filling in color in outline and for soft things such as animal fur, petals, etc.

The #5 brush is a stiff brush made from horse hair. It is good for making branches and vines.

How to Choose a Good Brush:

Chinese brushes have long handles made from bamboo stalk. The handle should be straight and smooth, and the hair of the brush should have a good point. When you flatten the tip, the hairs should be even across the top. Good brushes should have spring and be resilient. A student may want to purchase one #1, two #2s, three #3s, one #4, and one #5 so you will not have to wash out the brush each time.

Seal and Calligraphy

After completing a painting, the Chinese artist often writes a poem to explain the painting and his or her feelings. One might also include the date, season, year, hometown, or only the signature, depending on the size and the composition of the painting. The artist then places the imprint of one or more seals identifying him- or herself under the calligraphy. The seal can be his or her name, hometown, studio name, poetic phrases, etc.

The seal is inked with a cadmium red paste made of cinnabar, mineral oil and raw silk. The seal is made of jade, stone or ivory and still plays a important role in the lives of the Chinese today. It is used on marriage certificates, contracts, checks, and many other legal documents. It is actually more important than the signature because the seal is made of soft stone which when carved breaks naturally. There is no way this carving can be duplicated exactly; therefore, it is as good as a fingerprint.

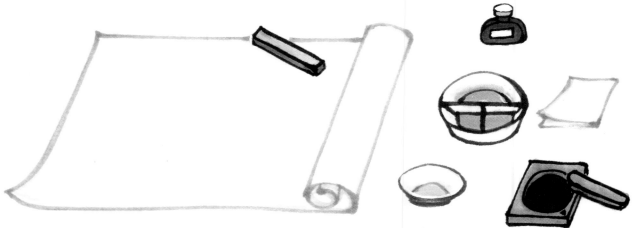

Rice Paper (Absorbent): It takes skill to paint on this surface. If there is too much water on the brush the watercolor will spread when applied. If the brush is too dry it is difficult to complete a stroke. It takes practice to learn to control the water on the brush.

Rice Paper (Non-absorbent): Rice paper treated with alum is best for detailed painting as the strokes are more easily controlled.

Watercolor Paper: If rice paper is not readily available you can use watercolor paper. A light-weight paper with a moderately smooth surface is recommended.

Black Ink and Ink Stone: Use either bottled ink or ink stick with ink stone. Do not use the black ink after it has dried.

Water Containers: Two dishes are needed — one for clean water, one for washing the brush. One with several sections is convenient.

Saucers or Shallow Chinese Dishes: Five to ten dishes are needed — one for each of color of paint and a few extras for mixing the colors. White is preferred.

Paperweight: A paperweight will hold the rice paper securely and prevent curling.

Paper Towels: Paper towels are used for drying the brushes and for testing the colors.

Felt: A piece of white felt is used to cushion the paper and protect the table surface. It should be large enough for a variety of paper sizes.

Kneaded Eraser: A kneaded eraser will not damage the delicate rice paper.

Paints

Chinese pigments are made from semi-precious stones, minerals and/or plants. They are available in both chip and powder forms. The following colors were used for the illustrations in this book: (1) Crimson Lake, (2) Cadmium Red Medium, (3) Vermillion, (4) Aurora Yellow, (5) Indigo, (6) Burnt Sienna, (7) Light Bluish-Green (gouache), (8) Cobalt Blue (gouache), (9) White (gouache). Note — These colors are also available in watercolors at most art supply stores.

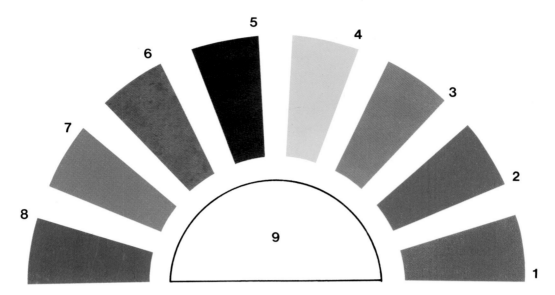

Mixing Colors

1. Pink: the brush is saturated in white then dipped in crimson lake and rotated on the side of the dish to mix.

2. Yellow-green: mix yellow and indigo. For darker green, dip in indigo and rotate brush against side of dish.

Basic color: prepare each basic color in a separate dish with 1/2 teaspoon of water before mixing other colors.

Unless otherwise stated, the brush should be saturated with the basic color.

Dipping: dipping the bristles approximately halfway into the color.

Tipping: touching only the tip of the bristles into the color.

Each time color is applied, rotate the brush on the side of the dish to blend.

3. Young Leaves: yellow-green tipped in burnt sienna or red.

4. Old leaves: yellow-green dipped in indigo, tipped with burnt sienna and blended.

5. Lighten the color by dipping the brush in clean water.

6. Purple: mix crimson lake and cobalt blue. Put paint on two sides of the dish and use a small brush to mix the two colors together. Mix the purple from blue-purple to red-purple. This method will allow you to vary the shades. If preferred, use purple watercolor and add blue or red, as needed.

How to Handle the Brush

Sit up straight and lay the rice paper on the table. (A piece of felt placed under the paper will provide a better work surface and protect the table.) Hold the brush slightly below center; place it between the thumb and index finger, resting the lower part on the nail of the third (ring) finger. The second (middle) finger rests on the handle just below the index finger. The small (pinky) finger supports the third finger. The thumb braces the handle. Use the second finger to pull the brush and the third finger to push the brush.

When held in this manner perpendicular to the paper, only the lightest pressure is required to determine the shape and the width of a stroke. For smaller paintings and more detail, the elbow may rest on the table for better control. When painting larger areas or wider strokes more flexibility will be required in the wrist, the arm and the shoulder.

A Note About Rice Paper: The earliest Chinese painting was done on various weaves and finishes of silk. About 105 A.S., Tsai Lun (an official in the East Han period) invented paper with bark and rag pulp. Later papers included indigenous plant materials such as bamboo stalk, mulberry bark, hemp, linen, and rice straw. The latter probably explains why most Oriental papers are identified as "rice paper" in the west.

The majority of Oriental artists use various forms of rice paper and, even after 2000 years, love to paint on this paper which has a fine, soft texture.

Vertical Stroke: brush held perpendicular to the paper.

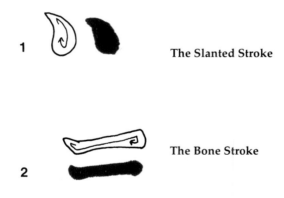

1 The Slanted Stroke

2 The Bone Stroke

Chinese painting strokes were developed from calligraphic strokes thousands of years ago. The relationship between the two art forms is still apparent today.

There are two strokes based on calligraphy: (1) the slanted stroke (water drop stroke), and (2) the bone stroke: vertical stroke for all lines (branches, figure and clothing outline, etc.).

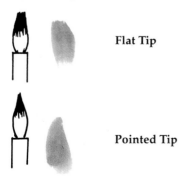

Flat Tip

Pointed Tip

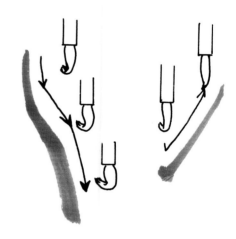

Thicken lines by gradually pressing the brush down on the paper.

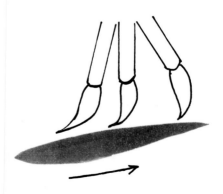

Flat Tip (dry stroke): dip brush into color, press tip of brush against the side of the dish or on a paper towel to flatten and remove excess moisture. This stroke is used for feathers, flower petals, etc.

One stroke requires one movement — press down, stroke and lift. This requires the wrist and hand to be flexible.

Slanted Strokes

Slanted strokes are used for painting large areas, broad shapes, and washes with the flat side of the brush. They can be made light or heavy, fast or slow, depending on the shapes desired.

For the slanted side stroke, hold the brush almost parallel to the paper and use the thumb and fingers to control the movement of the brush. The width of the stroke is determined by the angle of the brush.

The movements of the slanted stroke (one stroke) are shown below.

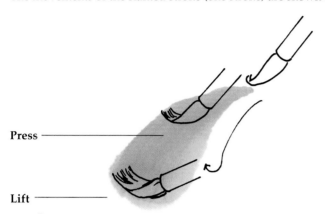

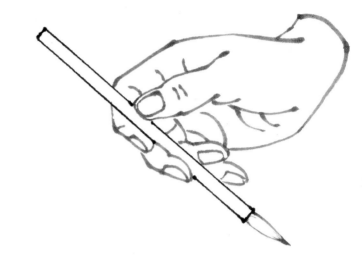

There are seven basic strokes for making petals and leaves. Practice the following strokes: press and lift, push and pull, turn and twist, dash and sweep.

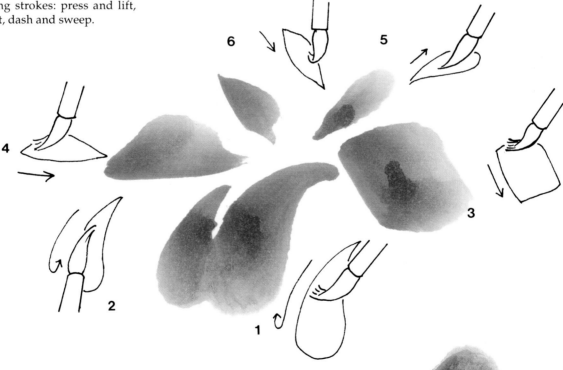

1. Long Water Drop (top to bottom, moving brush to left)

2. Short Water Drop (same as the long stroke, only smaller)

3. Rectangular (even stroke, top to bottom)

4. Triangle (press down at start, lift for tip)

5. Teardrop (press entire brush to paper and lift without moving the brush)

6. Reverse Teardrop (touch tip of brush from top and press down to paper, lifting for tip)

7. Reverse Water Drop (stroke from bottom to top)

Newsprint is recommended for practicing these strokes because it is absorbent and inexpensive. The only way to master these strokes is to practice, practice, PRACTICE!

Morning Glory and Butterfly

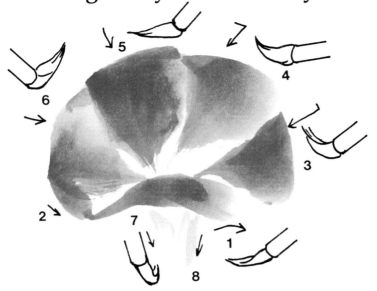

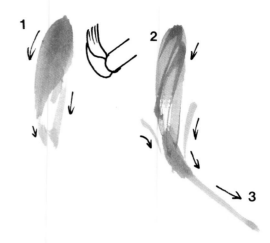

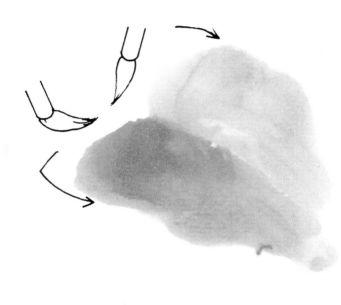

Petals: (1) #3 brush, thin white dipped in cobalt blue (mix colors against side of dish), flat stroke — touch tip to paper and press down as you stroke to the right. (2) Use the tip of the brush. (3 & 4) Move brush left to right, press down to center of paper. (5 & 6) Press brush to paper, top to bottom. Note — Leave white space between strokes to indicate star-shaped center. (7 & 8) Dip water to tip of brush for light base of flower.

Bud: (1) #3 brush, vertical stroke. (2) Tip with crimson lake for fold lines.

Sepal: (3) #1 brush, yellow-green tipped with burnt sienna, vertical stroke.

Leaf: #3 brush, light gray with yellow-green.

Stems and vines: #5 brush, light gray with yellow-green, vertical stroke.

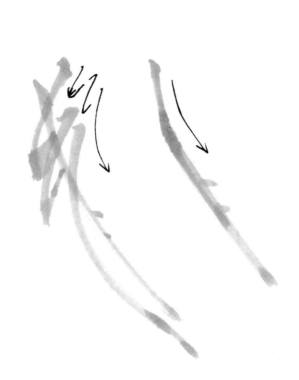

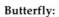

Butterfly:

Wings: #2 brush, yellow dipped with burnt sienna.

Detail on wings: #1 brush, light gray, dry brush. Note — Use dark black for dots while the wings are still moist.

Body, legs and antennae: #1 brush, dark black, dry brush. Use only the tip for the antennae and legs. Note — Butterflies have six legs, but it is not necessary to paint all of them.

The name "Morning Glory" comes from the showy flowers that open in the morning and wilt by late afternoon. The large, funnel-shaped corollas bloom from the axils of broad, heart-shaped leaves on vines that often grow ten feet high. The flowering season is from June to November.

Butterflies are fragile creatures of sunlight and represent spring and summer. They have dazzling colors and contribute much beauty to our flower gardens. Butterflies are a symbol of love.

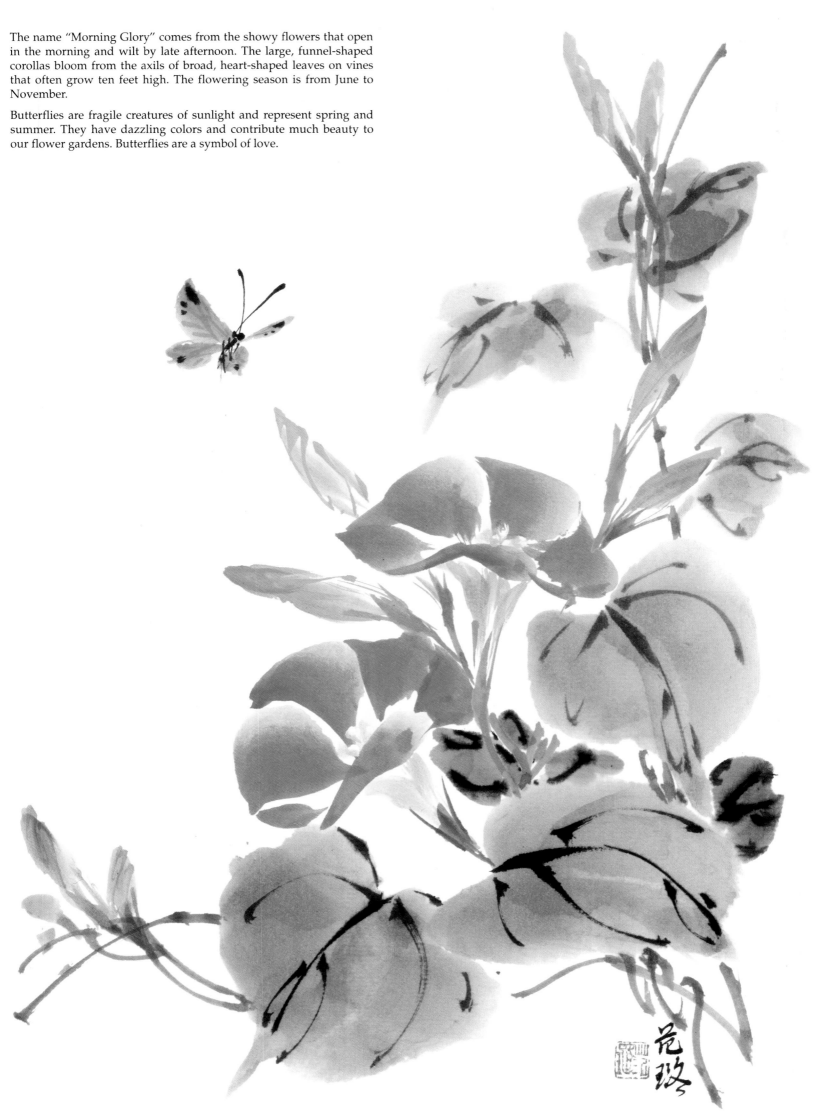

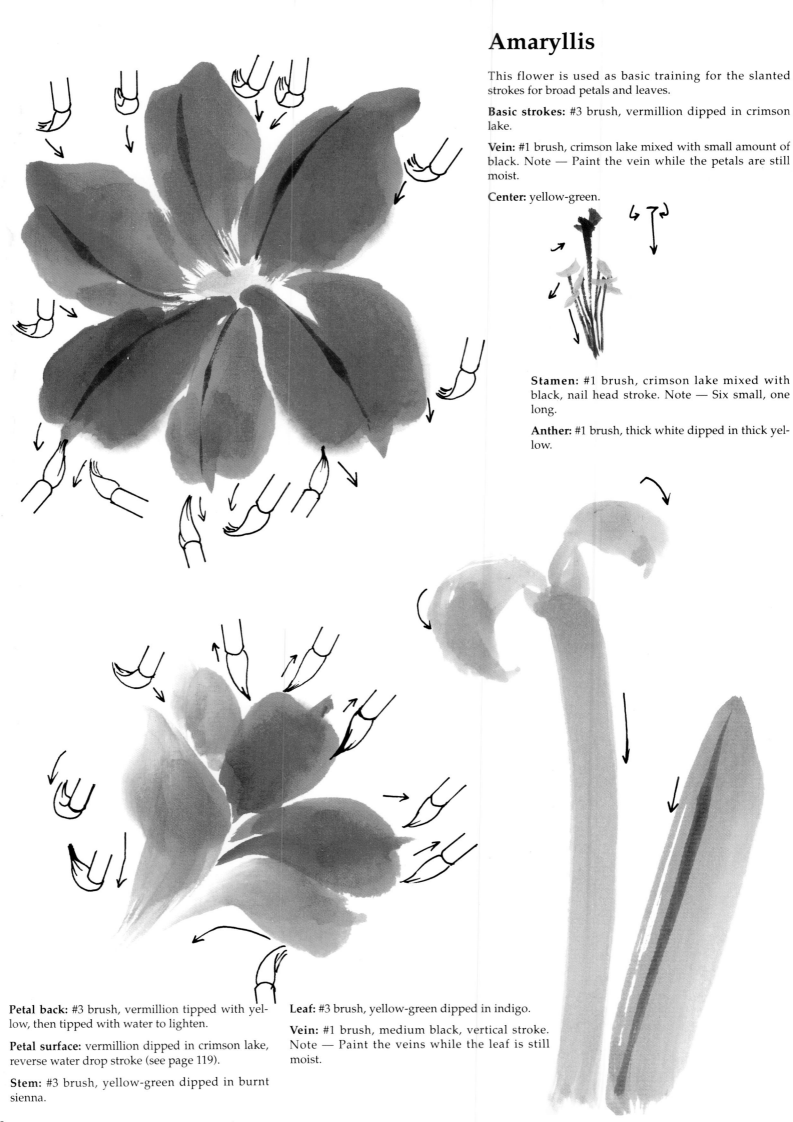

Amaryllis

This flower is used as basic training for the slanted strokes for broad petals and leaves.

Basic strokes: #3 brush, vermillion dipped in crimson lake.

Vein: #1 brush, crimson lake mixed with small amount of black. Note — Paint the vein while the petals are still moist.

Center: yellow-green.

Stamen: #1 brush, crimson lake mixed with black, nail head stroke. Note — Six small, one long.

Anther: #1 brush, thick white dipped in thick yellow.

Petal back: #3 brush, vermillion tipped with yellow, then tipped with water to lighten.

Petal surface: vermillion dipped in crimson lake, reverse water drop stroke (see page 119).

Stem: #3 brush, yellow-green dipped in burnt sienna.

Leaf: #3 brush, yellow-green dipped in indigo.

Vein: #1 brush, medium black, vertical stroke. Note — Paint the veins while the leaf is still moist.

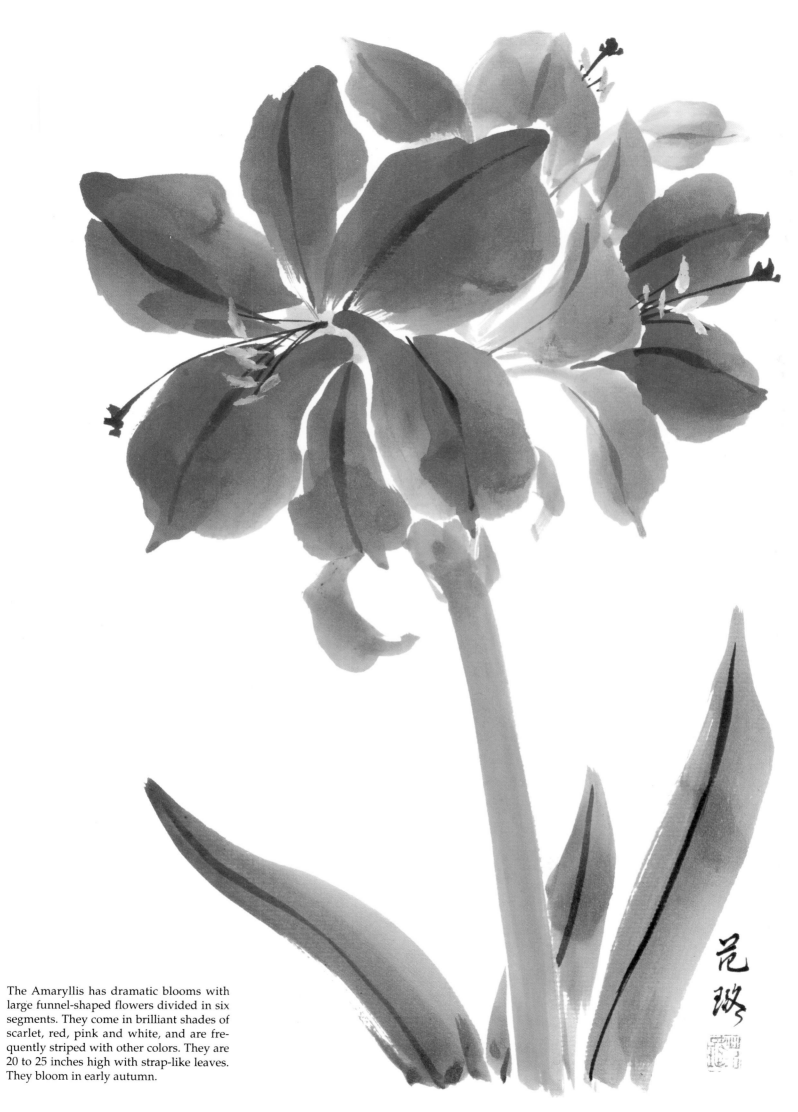

The Amaryllis has dramatic blooms with large funnel-shaped flowers divided in six segments. They come in brilliant shades of scarlet, red, pink and white, and are frequently striped with other colors. They are 20 to 25 inches high with strap-like leaves. They bloom in early autumn.

Eurasian Tree Sparrow

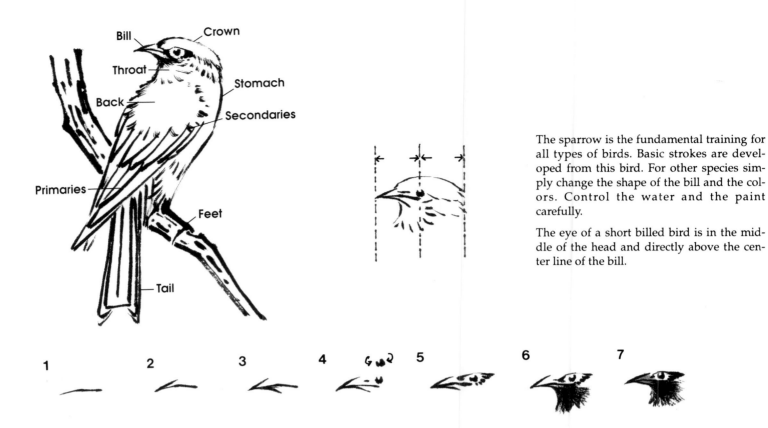

The sparrow is the fundamental training for all types of birds. Basic strokes are developed from this bird. For other species simply change the shape of the bill and the colors. Control the water and the paint carefully.

The eye of a short billed bird is in the middle of the head and directly above the center line of the bill.

1. #1 brush, dark black, vertical stroke, dry brush, press at the end of the line, bone stroke.

2. The upper bill is thicker than the lower bill.

3. Notice that the lower bill is thinner.

4. **Eye:** paint the two dots with the tip of brush.
 Nostril: use tip of brush.

5. **Eye ring and ear feathers:** dry brush with flat tip.

6. **Throat:** #2 brush dark black, radiate stroke from lower bill, dry brush with flat tip.

7. **Bill:** #2 brush, light ink, fill in with fan strokes.

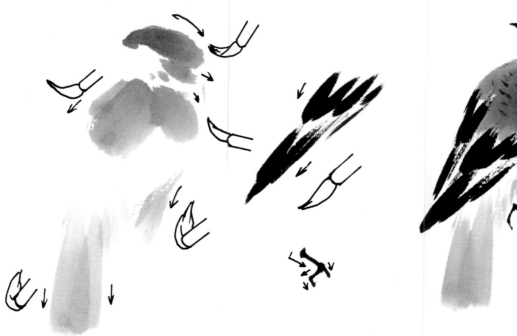

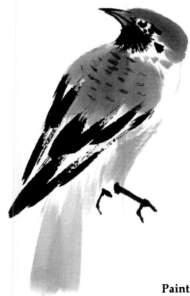

Body: #2 brush, prepare paint — yellow, burnt sienna and black, with small amount of black on tip for the body, light gray for the stomach.

Tail: Tip with clean water for tail stroke. Flatten tip of brush.

Wing: #2 brush, dark black, dry brush, flat tip, vertical stroke.

Feet: #1 brush, dark black, dry brush, bone stroke.

Painting Order:

1. Bill, eye, throat
2. Head
3. Back
4. Wing
5. Tail
6. Stomach
7. Feet

Plum Blossoms

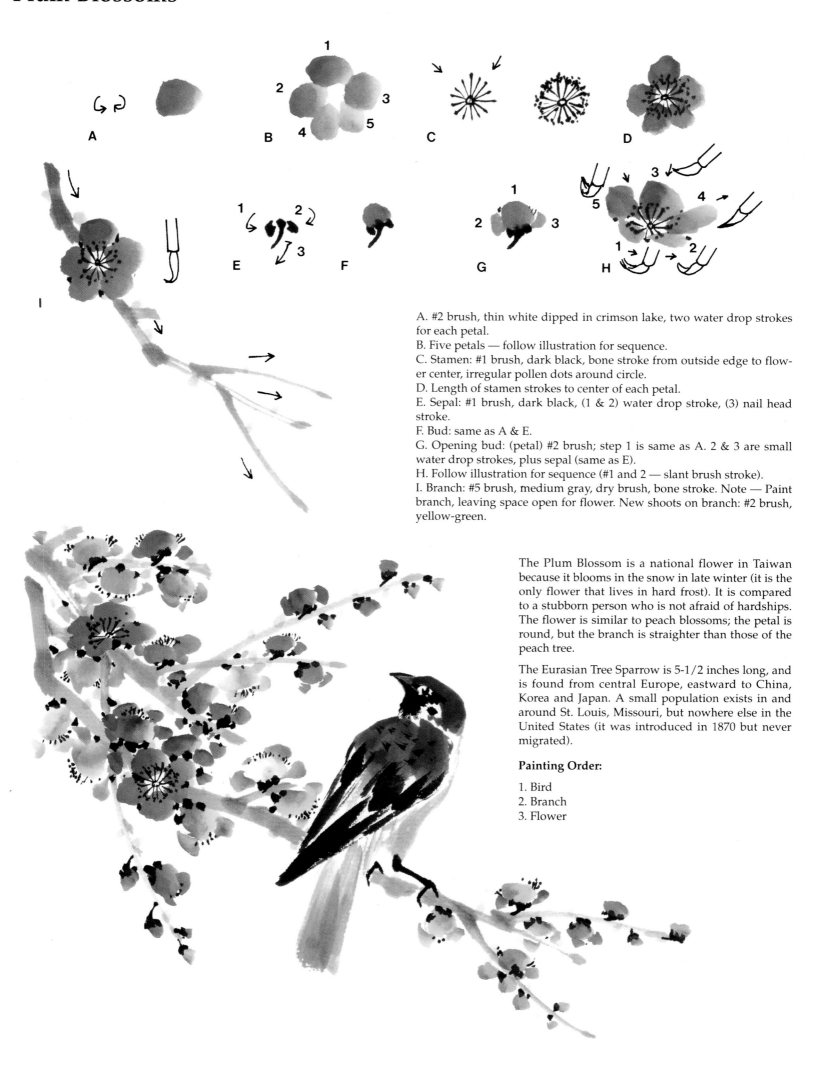

A. #2 brush, thin white dipped in crimson lake, two water drop strokes for each petal.

B. Five petals — follow illustration for sequence.

C. Stamen: #1 brush, dark black, bone stroke from outside edge to flower center, irregular pollen dots around circle.

D. Length of stamen strokes to center of each petal.

E. Sepal: #1 brush, dark black, (1 & 2) water drop stroke, (3) nail head stroke.

F. Bud: same as A & E.

G. Opening bud: (petal) #2 brush; step 1 is same as A. 2 & 3 are small water drop strokes, plus sepal (same as E).

H. Follow illustration for sequence (#1 and 2 — slant brush stroke).

I. Branch: #5 brush, medium gray, dry brush, bone stroke. Note — Paint branch, leaving space open for flower. New shoots on branch: #2 brush, yellow-green.

The Plum Blossom is a national flower in Taiwan because it blooms in the snow in late winter (it is the only flower that lives in hard frost). It is compared to a stubborn person who is not afraid of hardships. The flower is similar to peach blossoms; the petal is round, but the branch is straighter than those of the peach tree.

The Eurasian Tree Sparrow is 5-1/2 inches long, and is found from central Europe, eastward to China, Korea and Japan. A small population exists in and around St. Louis, Missouri, but nowhere else in the United States (it was introduced in 1870 but never migrated).

Painting Order:

1. Bird
2. Branch
3. Flower

Prothonotary Warbler and Wisteria

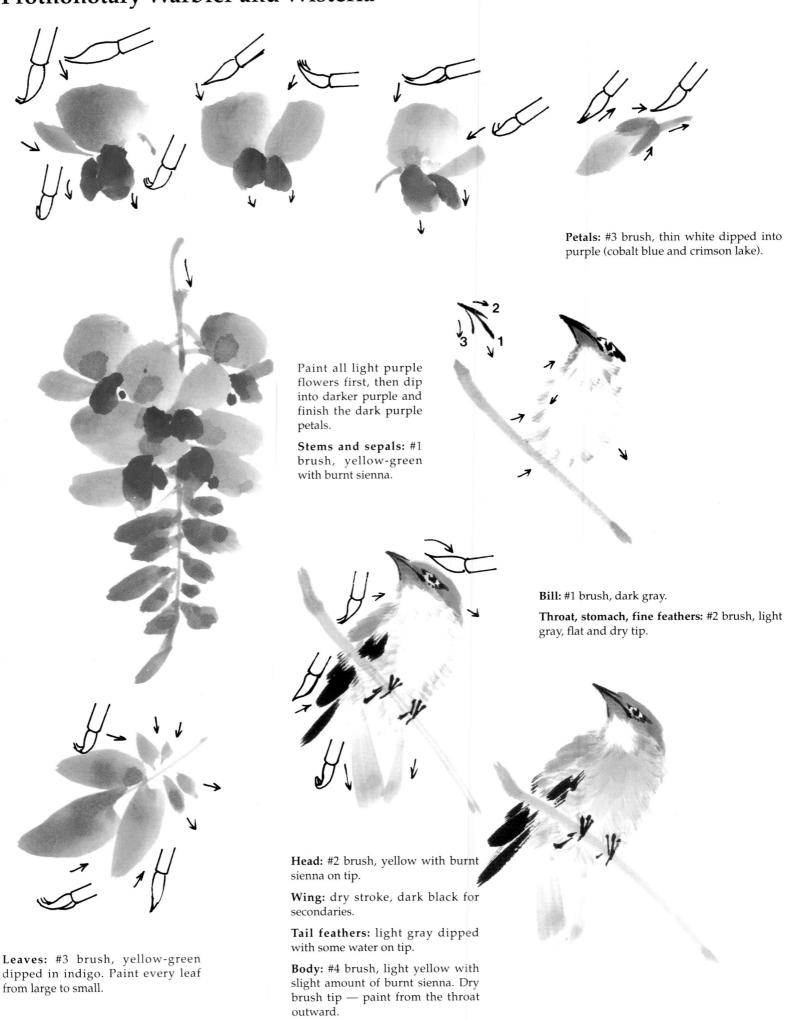

Petals: #3 brush, thin white dipped into purple (cobalt blue and crimson lake).

Paint all light purple flowers first, then dip into darker purple and finish the dark purple petals.

Stems and sepals: #1 brush, yellow-green with burnt sienna.

Bill: #1 brush, dark gray.

Throat, stomach, fine feathers: #2 brush, light gray, flat and dry tip.

Leaves: #3 brush, yellow-green dipped in indigo. Paint every leaf from large to small.

Head: #2 brush, yellow with burnt sienna on tip.

Wing: dry stroke, dark black for secondaries.

Tail feathers: light gray dipped with some water on tip.

Body: #4 brush, light yellow with slight amount of burnt sienna. Dry brush tip — paint from the throat outward.

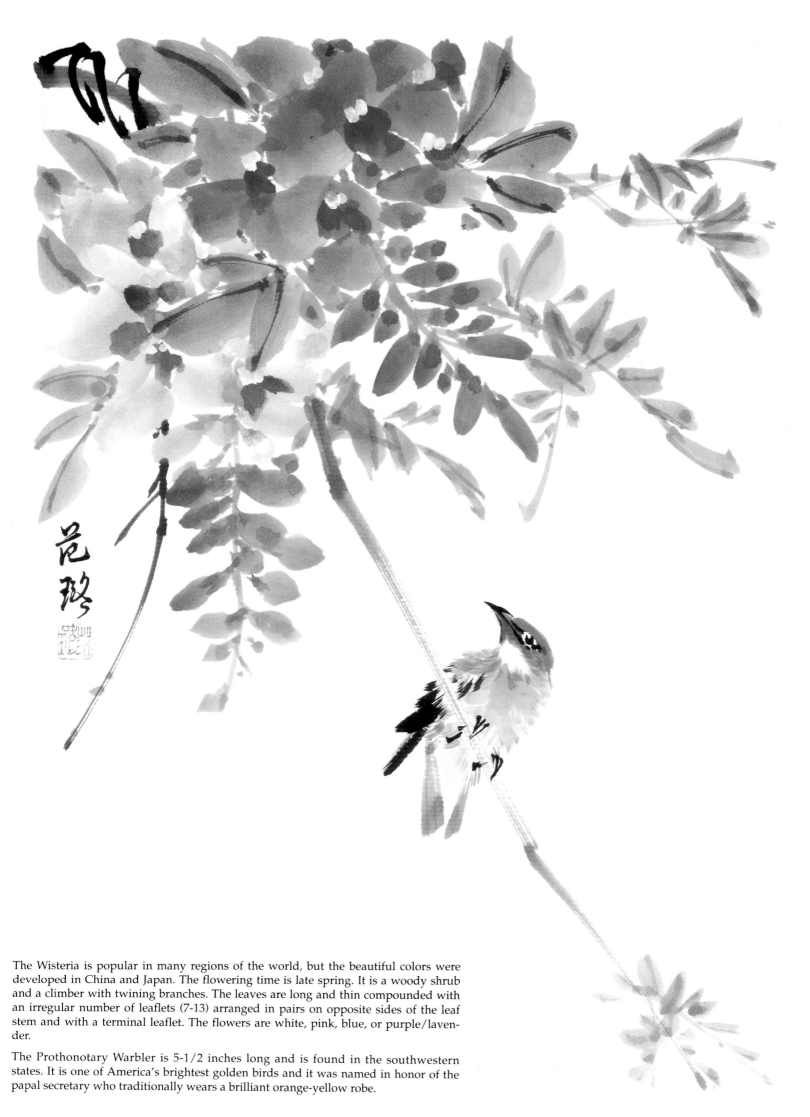

The Wisteria is popular in many regions of the world, but the beautiful colors were developed in China and Japan. The flowering time is late spring. It is a woody shrub and a climber with twining branches. The leaves are long and thin compounded with an irregular number of leaflets (7-13) arranged in pairs on opposite sides of the leaf stem and with a terminal leaflet. The flowers are white, pink, blue, or purple/lavender.

The Prothonotary Warbler is 5-1/2 inches long and is found in the southwestern states. It is one of America's brightest golden birds and it was named in honor of the papal secretary who traditionally wears a brilliant orange-yellow robe.

Flowering Peach and Bananaquit

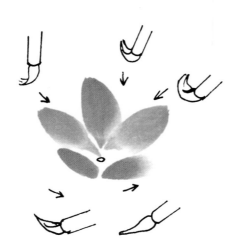

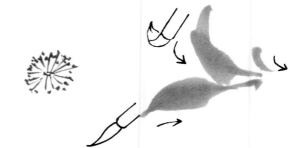

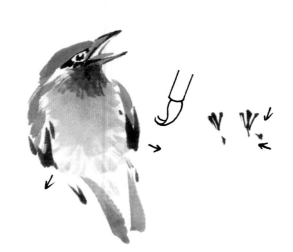

Petals: #2 brush, thin white dipped in crimson lake. Note — Lay the brush flat on the paper for strokes 1 and 2; hold the brush straight for strokes 3, 4 and 5. Press down first and lift up quickly to the center of flower.

Stamen, bud and sepal: #2 brush, same as plum flower (see page 125).

Young leaves: #2 brush, yellow-green tipped with burnt sienna, vertical stroke.

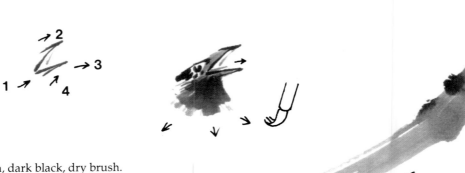

Bill: #1 brush, dark black, dry brush.

Tongue: #1 brush, vermillion, dry and sharp tip.

Throat feathers: #2 brush, medium gray, dry brush, flatten tip and paint from the throat outward.

Branch: #3 brush, mix burnt sienna with a slight amount of black, then tip in black. Dark black dots for broken branches and new growth spots.

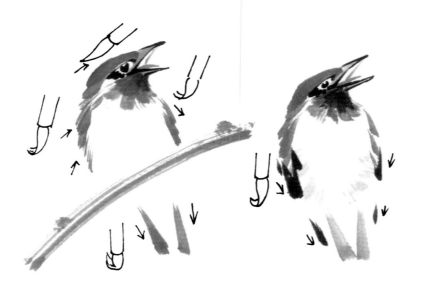

Head, shoulder and tail: #2 brush, cobalt blue tipped with indigo.

Upper wing coverts and secondaries: #2 brush, dark black, light gray for stomach.

Body: #4 brush, yellow tipped with burnt sienna, stroke from the throat outward.

Feet: #1 brush, dark ink, dry brush, bone stroke.

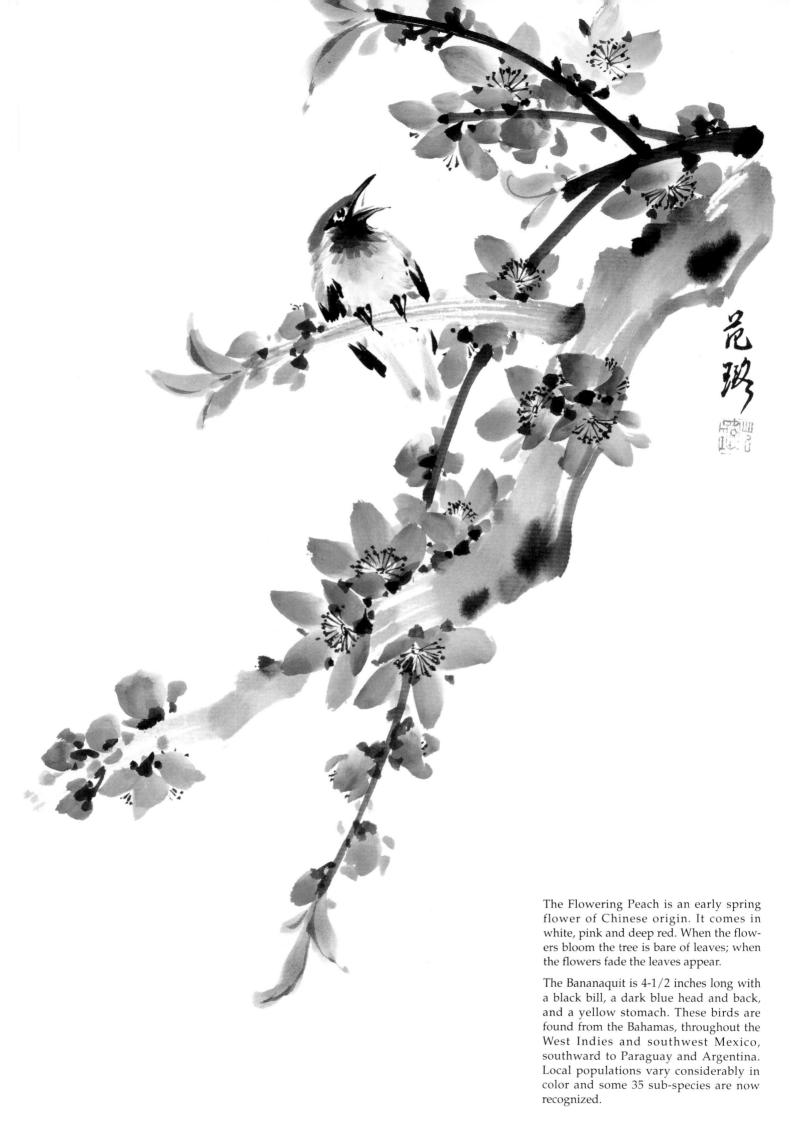

The Flowering Peach is an early spring flower of Chinese origin. It comes in white, pink and deep red. When the flowers bloom the tree is bare of leaves; when the flowers fade the leaves appear.

The Bananaquit is 4-1/2 inches long with a black bill, a dark blue head and back, and a yellow stomach. These birds are found from the Bahamas, throughout the West Indies and southwest Mexico, southward to Paraguay and Argentina. Local populations vary considerably in color and some 35 sub-species are now recognized.

Lucifer Hummingbird and Fuchsia

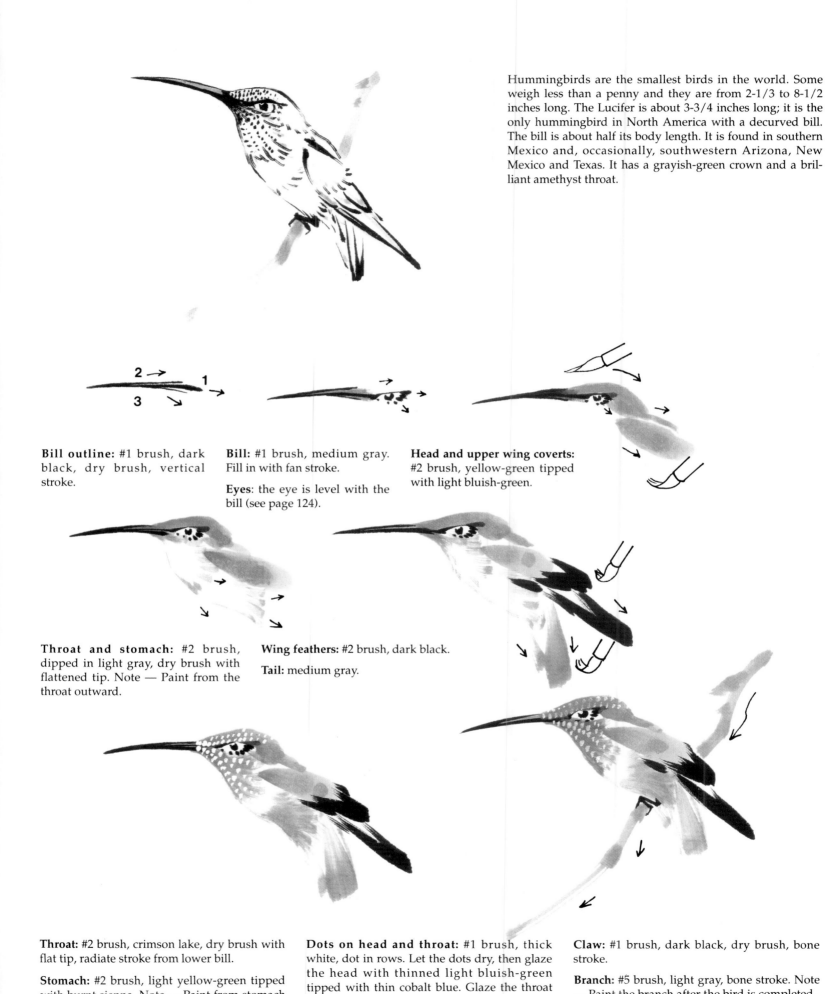

Hummingbirds are the smallest birds in the world. Some weigh less than a penny and they are from 2-1/3 to 8-1/2 inches long. The Lucifer is about 3-3/4 inches long; it is the only hummingbird in North America with a decurved bill. The bill is about half its body length. It is found in southern Mexico and, occasionally, southwestern Arizona, New Mexico and Texas. It has a grayish-green crown and a brilliant amethyst throat.

Bill outline: #1 brush, dark black, dry brush, vertical stroke.

Bill: #1 brush, medium gray. Fill in with fan stroke.

Eyes: the eye is level with the bill (see page 124).

Head and upper wing coverts: #2 brush, yellow-green tipped with light bluish-green.

Throat and stomach: #2 brush, dipped in light gray, dry brush with flattened tip. Note — Paint from the throat outward.

Wing feathers: #2 brush, dark black.

Tail: medium gray.

Throat: #2 brush, crimson lake, dry brush with flat tip, radiate stroke from lower bill.

Stomach: #2 brush, light yellow-green tipped with burnt sienna. Note — Paint from stomach to legs using the same strokes as on the throat.

Dots on head and throat: #1 brush, thick white, dot in rows. Let the dots dry, then glaze the head with thinned light bluish-green tipped with thin cobalt blue. Glaze the throat with thinned crimson lake.

Claw: #1 brush, dark black, dry brush, bone stroke.

Branch: #5 brush, light gray, bone stroke. Note — Paint the branch after the bird is completed.

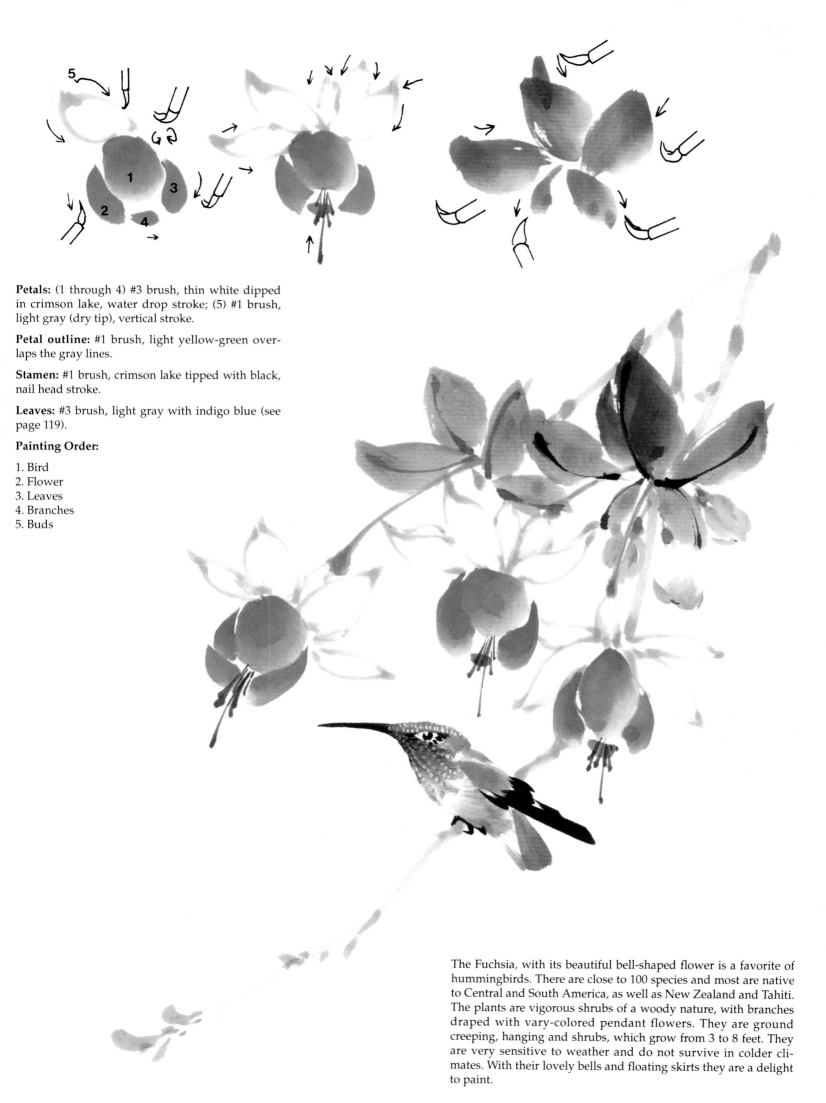

Petals: (1 through 4) #3 brush, thin white dipped in crimson lake, water drop stroke; (5) #1 brush, light gray (dry tip), vertical stroke.

Petal outline: #1 brush, light yellow-green overlaps the gray lines.

Stamen: #1 brush, crimson lake tipped with black, nail head stroke.

Leaves: #3 brush, light gray with indigo blue (see page 119).

Painting Order:

1. Bird
2. Flower
3. Leaves
4. Branches
5. Buds

The Fuchsia, with its beautiful bell-shaped flower is a favorite of hummingbirds. There are close to 100 species and most are native to Central and South America, as well as New Zealand and Tahiti. The plants are vigorous shrubs of a woody nature, with branches draped with vary-colored pendant flowers. They are ground creeping, hanging and shrubs, which grow from 3 to 8 feet. They are very sensitive to weather and do not survive in colder climates. With their lovely bells and floating skirts they are a delight to paint.

Anna's Hummingbird and Agapanthus (Nile Lily)

Petals: #3 brush, white and cobalt blue, vertical stroke. Press down first, then lift tip up gradually. Note — Each flower has six petals.

Flower (side view): (1) #3 brush, press down and lift up tip, ending with a thin line; (2 & 3) small stroke, curved.

Stamen: #1 brush, mix black and crimson lake, dry tip, nail head stroke.

Stems: directed toward center of flower. They are the same as the Amaryllis (see page 122). There are two sepals.

Note — Paint the large flower first, then the bird, then mix purple with cobalt blue for the background flower (it will be lighter than the flower in the foreground).

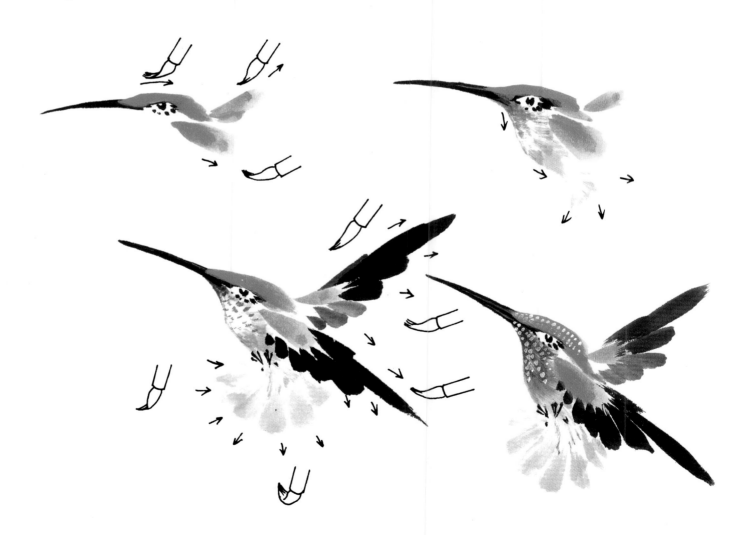

Head and wing coverts: #2 brush, yellow-green with brush dipped in light bluish-green.

Throat and stomach: #2 brush, light gray from throat outward with dry, flat brush tip.

Primary wing feathers: #2 brush, dark black, flatten tip of brush. Don't rest your hand on the table — keep it flexible.

Tail: #2 brush, light gray, dry and flat tip.

Make rows of thick white dots on the head and throat. Allow the dots to dry, then apply a thin light bluish-green glaze on the head and a thin crimson lake glaze over the throat. Apply yellow-green and brown on the stomach.

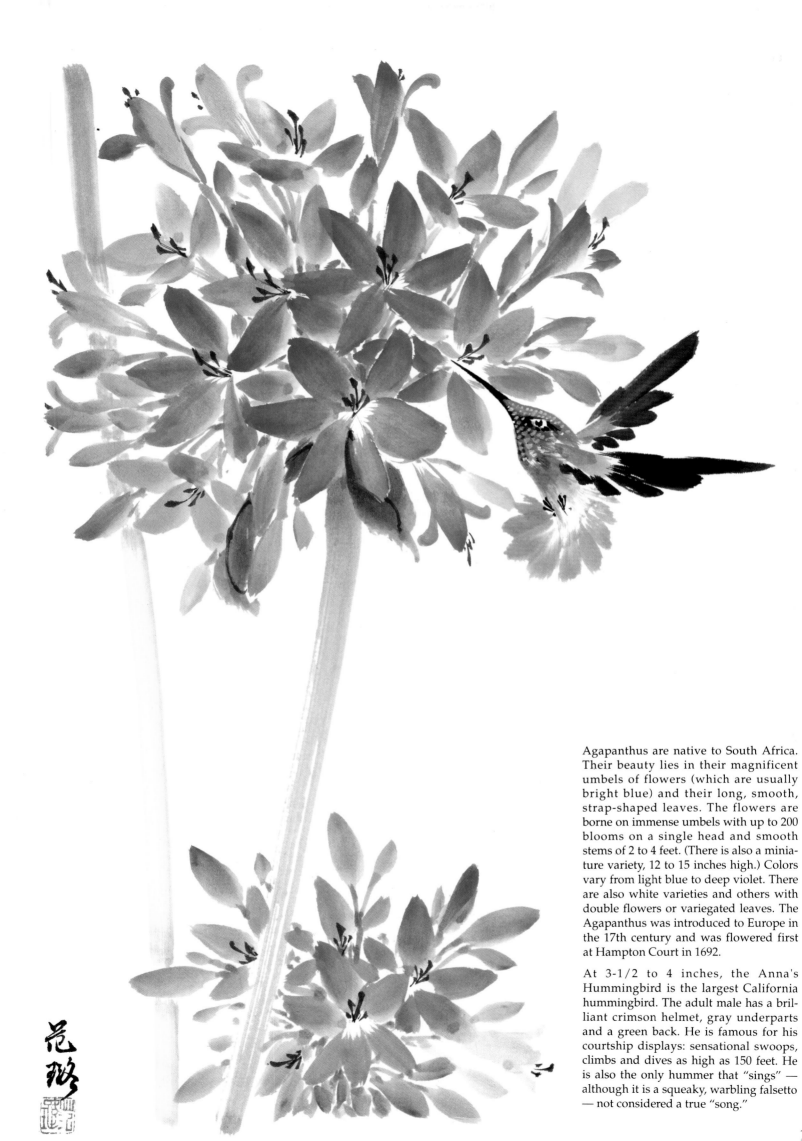

Agapanthus are native to South Africa. Their beauty lies in their magnificent umbels of flowers (which are usually bright blue) and their long, smooth, strap-shaped leaves. The flowers are borne on immense umbels with up to 200 blooms on a single head and smooth stems of 2 to 4 feet. (There is also a miniature variety, 12 to 15 inches high.) Colors vary from light blue to deep violet. There are also white varieties and others with double flowers or variegated leaves. The Agapanthus was introduced to Europe in the 17th century and was flowered first at Hampton Court in 1692.

At 3-1/2 to 4 inches, the Anna's Hummingbird is the largest California hummingbird. The adult male has a brilliant crimson helmet, gray underparts and a green back. He is famous for his courtship displays: sensational swoops, climbs and dives as high as 150 feet. He is also the only hummer that "sings" — although it is a squeaky, warbling falsetto — not considered a true "song."

Peony and White-Crested Laughing Thrush

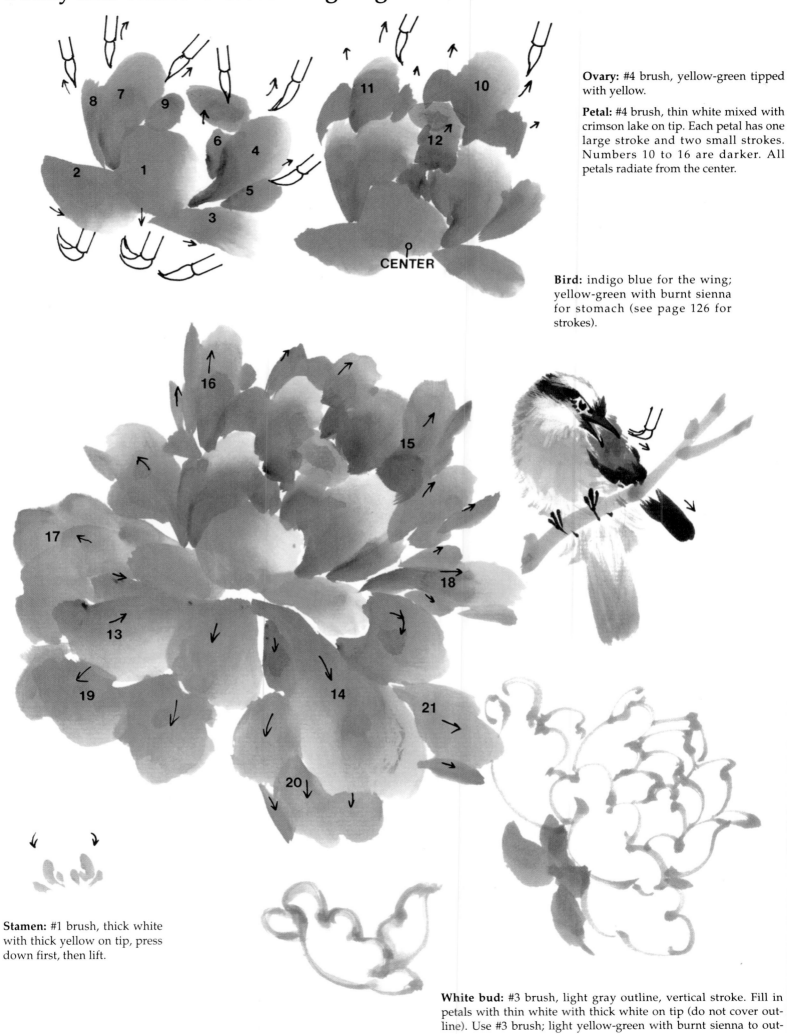

Ovary: #4 brush, yellow-green tipped with yellow.

Petal: #4 brush, thin white mixed with crimson lake on tip. Each petal has one large stroke and two small strokes. Numbers 10 to 16 are darker. All petals radiate from the center.

Bird: indigo blue for the wing; yellow-green with burnt sienna for stomach (see page 126 for strokes).

CENTER

Stamen: #1 brush, thick white with thick yellow on tip, press down first, then lift.

White bud: #3 brush, light gray outline, vertical stroke. Fill in petals with thin white with thick white on tip (do not cover outline). Use #3 brush; light yellow-green with burnt sienna to outline over light gray.

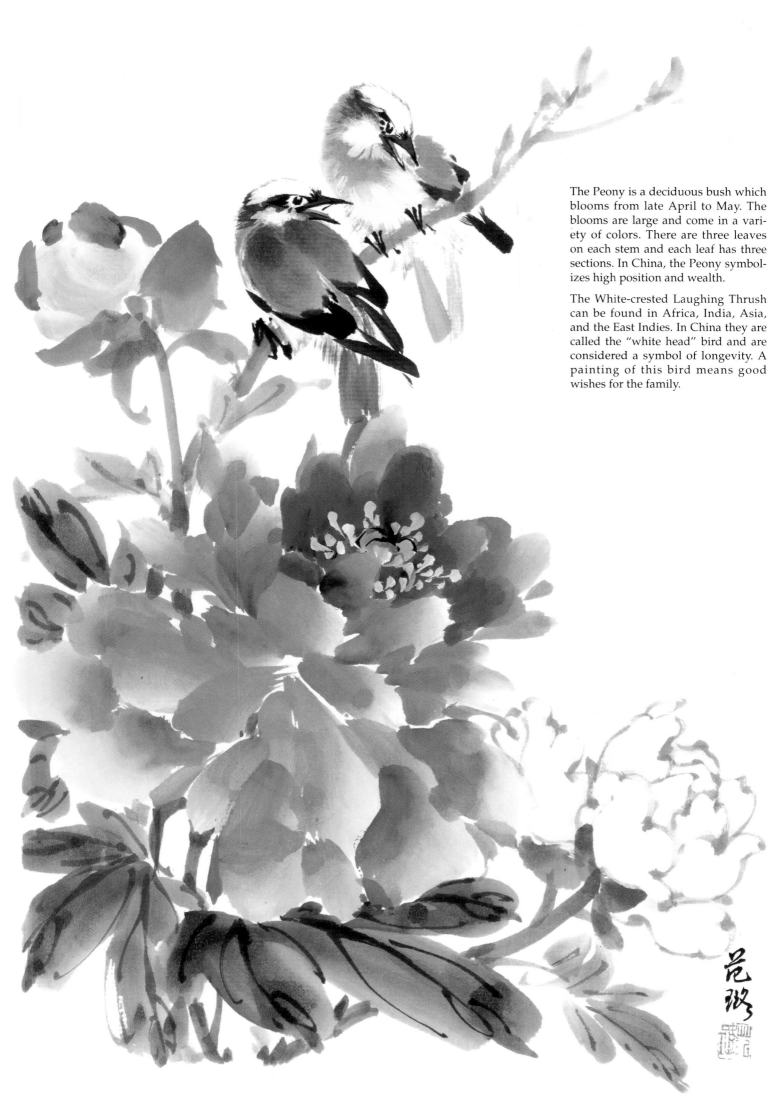

The Peony is a deciduous bush which blooms from late April to May. The blooms are large and come in a variety of colors. There are three leaves on each stem and each leaf has three sections. In China, the Peony symbolizes high position and wealth.

The White-crested Laughing Thrush can be found in Africa, India, Asia, and the East Indies. In China they are called the "white head" bird and are considered a symbol of longevity. A painting of this bird means good wishes for the family.

Narcissus

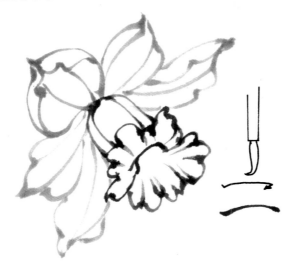

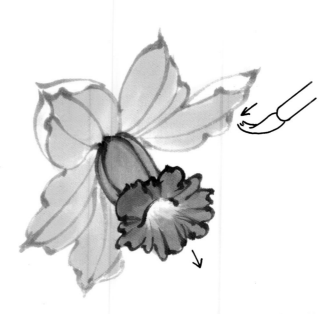

Flower outline: #1 brush held vertically, light gray for petals, darker gray for corona, bone stroke.

Color: (corona) #2 brush, light yellow tipped with vermillion; (petals) #2 brush, thinned white tipped with yellow (blend color against side of dish).

Color outline: use the #1 brush to outline the corona over the dark gray outline with dark vermillion; outline the petals over the light gray outline with light vermillion.

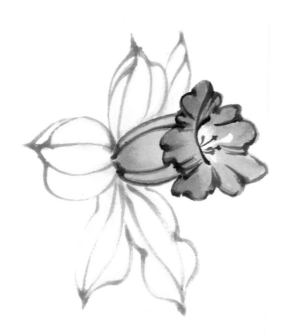

White petals: #2 brush, thin white tipped with thick white. Outline petals over light gray outline with #1 brush, light yellow-green, vertical stroke.

Leaves: (back side of leaf and stem) #3 brush, yellow-green tipped with burnt sienna; (surface of leaves) yellow-green tipped with indigo blue. Highlight one or two leaves in the foreground with light bluish-green glaze.

Stigma: #1 brush, thick white paint.
Stamen: #1 brush, crimson lake mixed with a small amount of black, nail head stroke (press down, lift, and stroke down).

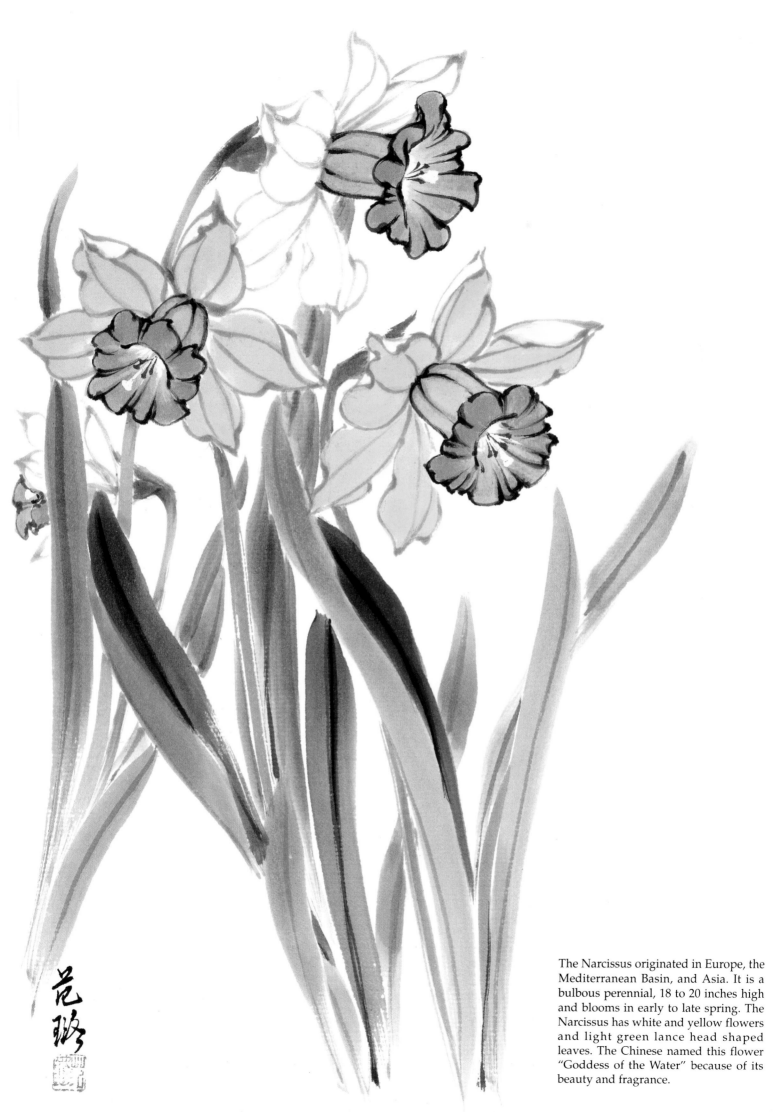

The Narcissus originated in Europe, the Mediterranean Basin, and Asia. It is a bulbous perennial, 18 to 20 inches high and blooms in early to late spring. The Narcissus has white and yellow flowers and light green lance head shaped leaves. The Chinese named this flower "Goddess of the Water" because of its beauty and fragrance.

Draw or trace the figure on a piece of tracing paper. Outline the drawing with a #1 brush and black ink. Let the ink dry, then cover the back of the paper with 4B pencil strokes. Lay the tracing paper (pencil side down) on the rice paper and use an HB pencil to transfer the drawing to the rice paper (similar to carbon paper). Use a #1 brush and light gray paint to outline the drawing on the rice paper (see page 140).

Skin: #4 brush, light vermillion, very light crimson lake for cheeks while paint is still moist, vertical stroke.

Skin outline: #1 brush, light vermillion over light gray, vertical stroke.

White gown: #1 brush, shade with light burnt sienna, vertical stroke.

Robe: fill in outline with #4 brush, cobalt blue. Outline the robe with #1 brush, indigo.

Face Details:

Note — Paint all face details after the paint is completely dry.

Eyes: #1 brush (very dry), dark black. Thick white for reflection dot.

Eyelid: #1 brush (very dry), thick white.

Lips: #1 brush (very dry), vermillion; paint very carefully.

Hair: #2 brush, light gray dipped in dark black, dry brush stroke. Paint from the crown outward and down.

Hair decoration: #1 brush, cadmium red medium, light bluish-green for bracelets and comb.

Curtain: #2 brush, light burnt sienna for shading.

The drapery fold stroke is called the "instrument string" stroke. Use the vertical stroke; concentrate on the fluidity of the line and finish the entire line in one breath — don't stop, even if it is a long line.

The strokes for the drapery folds indicate the person's identity — strong lines for male figures, softer lines for females; strong, long, smooth lines for educated or wealthy people, short, angular lines for ordinary people. The peonies indicate the royalty of the woman (see page135).

Figure painting was developed before flower, bird and landscape painting began in Chinese art history. It was used as illustration for policy, religious, educational and historical purposes. In the beginning, only figures were painted, no backgrounds.

This painting was done on absorbent rice paper. It can also be done on sized rice paper as it is easier to control the outline of the face.

The lady in this painting is Yang Yu-Huan who was a concubine of the Emperor Hsuan Tsung during the Tang Dynasty. She is considered to be one of the four most beautiful women in Chinese history. The Emperor preferred very plump women, so all female figures painted during this period were portrayed in this style.

The peonies indicate the woman's royalty.

Outline: #1 brush, light grey, bone stroke. Note — See page 138 for features, skin and white gown.

Ribbon: #1 brush, thick cobalt blue.

Hair decoration: #1 brush, cobalt blue and crimson lake.

Robe: #2 brush, light vermillion.

Robe details: #1 brush, crimson lake.

Background: (outline) #2 brush, light gray, dry brush, slanted stroke; (grasses) light bluish-green and burnt sienna, flat tip.

Plum Blossoms: #2 brush, light crimson lake tipped with dark crimson lake for some clusters, then light crimson lake for scattered dots.

New Shoots: #2 brush, light bluish-green dots.

This is Chao Fei-Yen, a favorite concubine of Emperor Cheng during the Han Dynasty. She was famous for her slender figure, narrow waist, and graceful dancing. Legend alleges that once while she was dancing on a boat a strong wind almost blew her into the sea. An official caught her by the hand and kept her from falling. In her joy, as light and fragile as gossamer, she continued to dance on the hand that saved her.

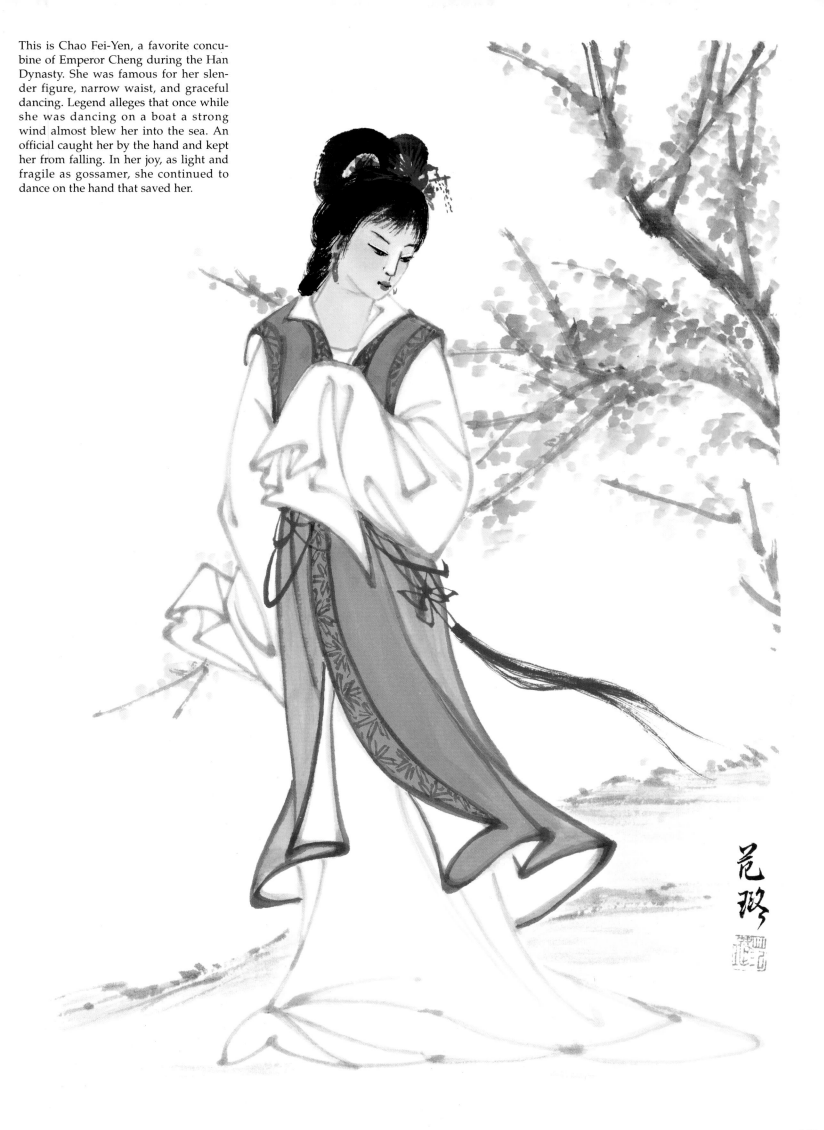

Index